Pop Art

Selections from The Museum of Modern Art

An exhibition organized by

The Museum of Modern Art

in collaboration with the

High Museum of Art

Selections from The Museum of Modern Art

Anne Umland

with texts by

Leslie Jones

Laura Hoptman

Beth Handler

The Museum of Modern Art, New York

Published on the occasion of the exhibition *Pop Art: Selections from The Museum of Modern Art*, shown at the High Museum of Art, Atlanta, October 24, 1998–January 17, 1999. The exhibition was directed by Anne Umland, Assistant Curator, Department of Painting and Sculpture, The Museum of Modern Art, New York.

Pop Art: Selections from The Museum of Modern Art was organized by The Museum of Modern Art, New York, in collaboration with the High Museum of Art, Atlanta.

A lead corporate grant for this exhibition has been provided by Philip Morris Companies Inc.

Produced by the Department of Publications
The Museum of Modern Art, New York
Edited by Harriet Schoenholz Bee
Designed by Bethany Johns Design, New York
Production by Christopher Zichello
Color separation by LS Graphic, Inc., New York/
Fotolito Gammacolor, Milan
Printed by LS Graphic, Inc., New York/
Grafica Comense, Como

Library of Congress Catalogue Card Number: 98-067220
ISBN: 0-87070-084-7 (clothbound)
ISBN: 0-87070-073-1 (paperbound)
Published by The Museum of Modern Art
11 West 53 Street, New York, N.Y. 10019
(www.moma.org)

Printed in Italy

Cover detail: James Rosenquist. *F-111*. 1964–65. Oil on canvas with aluminum, 10 x 86' (304.8 x 2621.3 cm) overall. The Museum of Modern Art, New York. Gift of Mr. and Mrs. Alex L. Hillman (by exchange) and Lillie P. Bliss Bequest (by exchange)

Contents

Among the great collectors of twentieth-century art, The Museum of Modern Art in New York is an institution dedicated to exhibiting and interpreting a complete range of modern art, from Impressionism to the contemporary visual arts.

Among its exemplary holdings, the Museum's collection of Pop art defines a pivotal era in American art, the 1960s, and is shaped by works from such renowned artists as Andy Warhol, Jim Dine, Roy Lichtenstein, Claes Oldenburg, and James Rosenquist. Now, four decades later, this period of raw energy and unsurpassed creativity will be experienced by a new audience at the High Museum of Art in Atlanta.

At Philip Morris, we are pleased to sponsor the presentation of The Museum of Modern Art's excellent collection of Pop art at the High Museum of Art, where we have had several other successful collaborations, including most recently *Picasso: Masterworks from The Museum of Modern Art*. The present exhibition, *Pop Art: Selections from The Museum of Modern Art*, continues a tradition of funding at Philip Morris beginning with our earliest exhibition sponsorship in 1965, *Pop and Op*. In our fortieth year of funding the arts, we are proud to support this outstanding exhibition, which reflects our long-term focus on innovation, creativity, and excellence.

Stephanie French
Vice President, Corporate Contributions and Cultural Programs
Philip Morris Companies Inc.

Foreword

In 1962 Pop art exploded onto the New York art scene. Once hotly argued over, it is now widely acknowledged as one of the most significant art movements to have emerged since World War II. Art audiences of the 1960s found Pop's subject matter shockingly familiar. Paintings and/or sculptures featuring Campbell's soup cans, comic-book pages, advertisements, and common household objects invaded art galleries and museums, challenging preconceptions regarding the look of art. Over thirty years later, the intensity of Pop's imagery still retains its power to provoke, despite the aura of history that now surrounds the Pop artists' works.

The Museum of Modern Art's collection of American Pop art is among the most historically complete representations of this important movement in public or private hands anywhere in the world. Particularly strong in works produced in New York City, the collection was begun in the early 1960s — coincident with American Pop's own origins — testifying to the Museum's ongoing commitment to both contemporary *and* modern art. In recent years, many key works have been added to the Museum's Pop art collection, none more crucial than Andy Warhol's series of thirty-two *Campbell's Soup Cans* (1962) and James Rosenquist's vast environmental painting *F-111* (1964–65).

This exhibition is the first to feature the Museum's exceptionally rich collection of American Pop art. Focusing on the 1960s, the decade essential to definitions of Pop, it offers a valuable opportunity to reconsider the movement's significance. It also allows us to bring together key works that, due to spatial constraints, cannot be accommodated in the Museum's existing galleries. We are particularly pleased to have the chance to integrate well-known paintings and sculptures with drawings, prints, and artists' books, further revealing the depth and variety of American Pop.

Pop Art: Selections from The Museum of Modern Art appears as the sequel to the 1997 exhibition *Picasso: Masterworks from The Museum of Modern Art*. Together with *Henri Matisse: Masterworks from The Museum of Modern Art,* shown in Atlanta in 1996, the three exhibitions continue a relationship between the Modern and the High Museum dating from the 1930s. These recent collaborations have been extremely successful, and it has been tremendously rewarding to see new audiences develop for the extraordinary works of art represented by The Museum of Modern Art's collection.

Working with the High has also, on this occasion, provided us with the gratifying opportunity to explore a pivotal art movement, as opposed to the oeuvre of a single exceptional artist. The ability to move from Matisse to Picasso to Pop testifies to the richness of our collection and to the wide range of possible approaches to the history of modern art.

At the High Museum of Art, it has been a pleasure to work once again with Ned Rifkin, Nancy and Holcombe T. Green, Jr. Director; Michael E. Shapiro, Deputy Director and Chief Curator; Carrie Przybilla, Curator of Modern and Contemporary Art; and Marjorie Harvey, Manager of Exhibitions and Design.

At The Museum of Modern Art, the organization of this exhibition has called on the efforts of numerous members of our staff. Kirk Varnedoe, Chief Curator in the Department of Painting and Sculpture, originally proposed a series of exhibitions drawn from our collection and conceived of organizing a show of Pop art. Anne Umland, Assistant Curator, Department of Painting and Sculpture, directed the current exhibition with great intelligence and imagination, *and* gave birth to twins in the middle of the project. The catalogue was written by Anne Umland in collaboration with Leslie Jones, Curatorial Assistant, Department of Painting and Sculpture; Laura Hoptman, Assistant Curator, Department of Drawings; and Beth Handler, Curatorial Assistant, Department of Painting and Sculpture. The selection of drawings and prints was made with the assistance of Margit Rowell, Chief Curator, Department of Drawings, and Deborah Wye, Chief Curator, Department of Prints and Illustrated Books; additional key works were selected from the Department of Architecture and Design and the Museum's Library. Crucial support was received from Jennifer Russell, Deputy Director for Exhibitions and Collections Support; Elizabeth Addison, Deputy Director for Marketing and Communications; Jerome Neuner, Director of Exhibition Design and Production; Linda Thomas, Coordinator of Exhibitions; Michael Maegraith, Publisher, and Harriet Schoenholz Bee, Managing Editor, in the Department of Publications.

Glenn D. Lowry
Director
The Museum of Modern Art, New York

Preface

Many important dimensions of American life as we know it today emerged during the 1960s. John F. Kennedy, only forty-three years old, ushered in the spirit of "Camelot," defeating Vice President Richard M. Nixon in a closely contested presidential election in 1960, which many believe was decided on television through a series of debates between the candidates. The new president embodied optimism and a sense of adventure as the United States entered the so-called Space Race, in which Americans took on the Soviet Union to compete in the discovery of new, advanced rocket technology. Concurrently, there was a nuclear-arms buildup that culminated in the Cuban Missile Crisis, the ominous showdown of October 1962, when Americans discovered the construction of nuclear-missile bases on Cuba and confronted the Russians at the United Nations. Indeed, the Cold War was ripening, and the threat of World War III loomed large. Many Americans debated whether to build fallout shelters in their backyards.

The stage was also set for domestic upheaval by the increasing polarization in the area of race relations. In 1962 James Meredith became the first African American to attend the University of Mississippi against a clamorous background of hatred and bigotry. The civil rights movement thus came to the fore with a political agenda that would forever change the complexion of the United States.

Increasingly, the early 1960s witnessed the stress on American culture that augured long-awaited endings and new beginnings. At the same time that the unprecedented prosperity of post–World War II America appeared, a shadow of despair and excess began to exhibit itself. Nowhere is this more evident than in Pop art. Artists influenced by the European Dada movement during World War I began to make their mark in the 1950s. Robert Rauschenberg, Jasper Johns, Jim Dine, Larry Rivers, and Claes Oldenburg, among others, created works out of detritus and recognizable scraps of everyday life. Theirs was a counter-aesthetic, one that reflected the turbulence of the times, yet engendered a new sensibility. From this point a cooler critique of American culture surfaced, with the emergence of Andy Warhol, Roy Lichtenstein, James Rosenquist, and Tom Wesselmann, as well as those whose use of identifiable subject matter flew in the face of Abstract Expressionism, the dominant style of the 1940s and 1950s. It was no longer of primary

importance to these rebellious artists to embody the aspirational reach of the action painters (Jackson Pollock, Willem de Kooning, Franz Kline, and others) but rather to generate commentary on the most familiar subjects, whether they were soup cans or comic books, billboard posters, or highway signs. This new phenomenon attracted the attention of the mass media in part because of the way leading artists employed and examined the techniques of publishing and advertisement.

Pop art in America, like its older cousin in Great Britain and the Continent (where it was called *nouveau réalisme*), signaled a new day for visual art. The entire Pop sensibility found its way into the ultraglamorous sectors of society, including fashion and music. There was, for a brief period, a merging of fine art and popular culture. Andy Warhol and his cronies became known as "superstars," an ironic term he used for his entourage. At a time when everyone was to be "famous for fifteen minutes," a Warhol quip began to acquire serious implications as a motto for Pop culture.

The High Museum of Art is fortunate to have the opportunity to host works from this period. For many of us these events, once current, have now taken on the historical vintage of "thirtysomething." Thanks to our collaboration with The Museum of Modern Art, we are able to present a collection of works that is important, both for representing this significant strain of American art and for ushering in a new day in contemporary art. Unlike our previous two efforts with our friends at the Museum — comprehensive showings of works by Matisse and Picasso — this exhibition focuses on a movement rather than the accomplishments of a particular artist. While many of the artists included in this exhibition occupy important places in the history of twentieth-century art as individuals, it is the part they played in this group movement, rather than their singular importance, that is celebrated here. There was a rarefied quality to the art of these artists, yet there was a significant aspect of their work that gave access to new and different audiences of collectors and visitors to galleries and museums.

As with any major exhibition presented at the High, we are extremely grateful to the donors that have enabled us to bring great art to audiences in Atlanta. We are most appreciative of Philip Morris Companies Inc. for its lead sponsorship of the exhibition. Philip Morris has long

supported the High Museum of Art and The Museum of Modern Art through its sponsorship of exhibitions and programs at both museums. In particular, we would like to thank Stephanie French, Vice President, Corporate Contributions and Cultural Programs, and Henry Turner, Director, State Government Affairs, Philip Morris Companies Inc., for their leadership on this project.

In addition to the sponsors, I am deeply grateful to Glenn D. Lowry, Director, The Museum of Modern Art, Anne Umland, Assistant Curator, Department of Painting and Sculpture, and the organizing curator at the Museum, the High Museum of Art's Michael E. Shapiro, Deputy Director and Chief Curator, and Carrie Przybilla, Curator of Modern and Contemporary Art, for the work that they have done to realize this fine and stimulating exhibition.

During the past thirty-five years much has changed, both in art and in society, but the true measure of important art is how it continues to resonate, not only for those of us who recall the cultural context and moment of Pop art but for how fresh and vital these works now feel to new audiences, young and old alike. It is a testament to the vision of the artists whose works are represented in this exhibition that their efforts remain potent and, as the details of the history of the 1960s fade from public consciousness, that their images and objects stand strong and present, bearing witness to the spirit of America during those difficult and changing times.

Ned Rifkin
Nancy and Holcombe T. Green, Jr. Director
High Museum of Art, Atlanta

Pop Art and The Museum of Modern Art: An Ongoing Affair

Anne Umland

Beginning in the early 1960s, American Pop art rapidly became both hotly debated and genuinely popular. The artists most closely identified with Pop, among them Roy Lichtenstein, Claes Oldenburg, James Rosenquist, and Andy Warhol, seized upon and transformed the visual and verbal energies of American consumer culture in unprecedented ways. Employing bright, bold commercial colors, evoking mechanical techniques, using strategies of serial repetition and divergent scale, and emphasizing emblematic objects in a way that echoed advertisements, the American Pop artists changed the look of art. The issues raised by their work continue to reverberate in our own time.

The Museum of Modern Art has been involved in Pop art's history from its onset, although the nature and degree of this involvement has changed over the years. On December 13, 1962, culminating what has been characterized retrospectively as "the year of Pop,"[1] the Museum held a symposium devoted to the subject. Moderated by Museum of Modern Art curator Peter Selz, it sought to respond to an "interest in pop art" that had "spread quickly not only from 77th Street to 57th Street but indeed from coast to coast."[2] This event effectively, and very publicly, announced the start of the relationship between the Museum and the Pop art movement — an ongoing affair.

The word "affair" has been carefully chosen to connote commercial overtones, romance or passion, and allusions to matters or episodes occasioning public anxiety or dispute. Pop art's connections with the world of commerce, advertising, marketing, and display have long fueled its controversial status, often eliciting emotional reactions on the part of both its supporters and detractors. All of these factors have played a part in Pop's more than thirty-year-old association with the Museum.

This essay, the individual entries that follow, and the exhibition this catalogue accompanies tell a story that is both specific and general: it relies exclusively on selections from The Museum of Modern Art's collection to present a picture of American Pop art in the 1960s. The movement's history and ongoing significance are inextricably connected to the Museum — a New York cultural institution that contributed to the social and intellectual circumstances in which New York Pop art and the Museum's Pop art collection developed. The 1962 symposium along with other aspects of the Museum's program during the 1960s — specifically, acquisitions and exhibitions — furnish essential background for better understanding the kind of modern art commonly referred to today as Pop.

Not surprisingly, the Museum's Pop art collection reflects its own geographical location. Its strengths lie in works made in the United States rather than in Europe, Latin America, or Asia. Even more specifically, it is strongest in those works created and first shown in New York City (with few exceptions, neither Chicago nor Los Angeles artists are represented in any depth). At the same time, however, the collection's current shape and emphases parallel and support dominantly held critical, historical, and curatorial convictions as to the centrality of New York artists to Pop. In this sense, the Museum's Pop collection now stands among the most historically complete representations of American Pop art in public or private hands. It testifies not only to American Pop's New York origins but to its importance to the Pop movement as a whole.

Numbering over a hundred objects, including not only paintings and sculptures, but drawings, prints, and illustrated books, the Museum's Pop collection today is very different from what it was in the 1960s. Similarly, the Museum's approach to Pop art has, over the decades, radically shifted. Once a contemporary participant in the Pop art debates of the 1960s, the Museum now presents Pop art as art history, with all of the distance the word "history" implies. This shift, from of-the-moment engagement to retrospective chronicler, consolidator of history, and purchaser of Pop icons, is reflected in the Museum's recent acquisition of what are now widely acknowledged to be major examples of the Pop art movement — James Rosenquist's monumental *F-111* of 1964–65 (pages 90–91) and Andy Warhol's thirty-two *Campbell's Soup Cans* of 1962 (page 109). This transaction raises questions and issues that inform and contribute to the Museum's Pop collection and the image it presents of American Pop art in the 1960s. A number of these questions and issues were first addressed at the Pop art symposium of December 1962.

The Museum of Modern Art's 1962 Symposium on Pop Art

At the time the Pop art symposium was held (fig. 1), the Museum's painting and sculpture collection included only six "Pop" artworks and would, indeed, have been unlikely to describe or present them as such. Only in 1963 did the label "Pop art" as opposed to "neo-Dada," the "New Sign Painting," or the "New American Dream" painting begin to be commonly accepted and used. The curators responsible for the Museum's collection during this period, principally Alfred H. Barr, Jr., and Dorothy C. Miller, were not among the symposium's participants. And, unlike the panel discussion the Museum had organized the previous year in conjunction with its exhibition *The Art of Assemblage*, the Pop art symposium seems to have been staged in relative isolation. No attempt was made, in other words, to connect it directly to either the Museum's collecting activities or exhibition program.

With hindsight, this can be read as one indication of the nature of the Museum's commitment to Pop in the early 1960s. In organizing its Pop symposium, for example, the Museum aimed — according to Selz — to generate discussion rather than to settle, promote, or even define issues. Instead the symposium was intended to be quintessentially of its moment, a bit of contemporary spontaneity, tied directly to its own period — much like Pop art itself. Somewhat paradoxically, therefore, because the proceedings were recorded on tape, transcribed, and quickly published in *Arts Magazine*, they entered the historical record, fixing for posterity what was far from a dry and academic discussion. Even in printed form, the debate's spirited nature created a forceful impression, registering the remarks and words of Pop art's contemporary audience and docu-menting the Museum's engagement with the art of its time.

Several years later the New York critic Sidney Tillim faulted the Museum for its restraint in regard to Pop art: "The Museum acknowledged Pop Art principally by a symposium . . . but has attempted no general survey."[3] Nonetheless, he acknowledged, in his opinion museums should not necessarily reflect changes in taste immediately; to do so would be to risk distorting the market and has-tening the "obsolescence of living art."[4] The questions of what constituted an appropriate response on the part of The Museum of Modern Art to contemporary art in general, and in particular to Pop, were raised a number of times during the course of the symposium; they are ones that continue to be debated today.

Henry Geldzahler, a young assistant curator at The Metropolitan Museum of Art, was the only true Pop enthusiast on the Museum's panel; he believed that if the Museum wanted to remain involved in what he called "the hurly-burly"[5] of twentieth-century art, it could hardly be expected to ignore the Pop phenomenon. Other older and more conservative panelists, specifically Hilton Kramer and Stanley Kunitz, expressed concern that newness was becoming the only criterion for admission to the Museum (in fact, by 1962 the Museum had actually acquired very few Pop works). Kramer went so far as to recommend that a five-to-ten-year waiting period be observed before the Museum did anything about the art of the current moment. Even convening the symposium was perceived by Kramer and Kunitz as excessive, placing the Museum in the position of creating rather than reflecting history; in their view only the latter was acceptable. This issue took on particular urgency in relation to Pop art, for the one thing both enthusiasts and opponents agreed upon was its

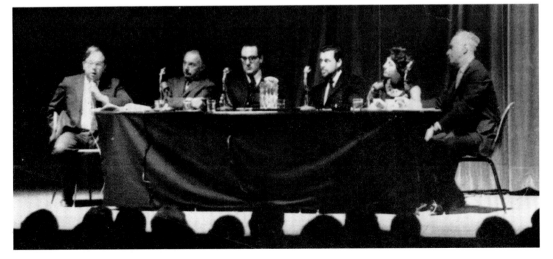

1. Pop Art Symposium, The Museum of Modern Art, December 13, 1962, as reproduced in *Arts Magazine*, April 1963. Left to right: Henry Geldzahler, Stanley Kunitz, Hilton Kramer, Leo Steinberg, Dore Ashton, and Peter Selz.

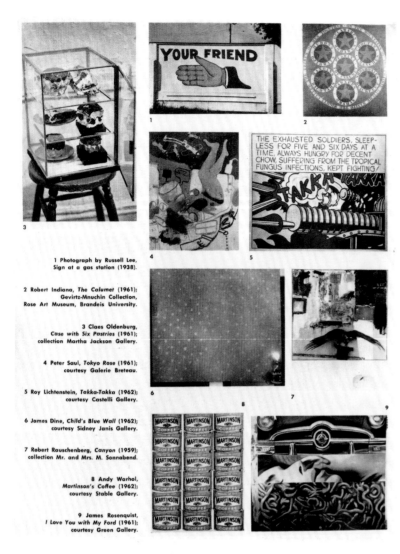

1 Photograph by Russell Lee,
Sign at a gas station (1938).

2 Robert Indiana, *The Calumet* (1961);
Gevirtz-Mnuchin Collection,
Rose Art Museum, Brandeis University.

3 Claes Oldenburg,
Case with Six Pastries (1961);
collection Martha Jackson Gallery.

4 Peter Saul, *Tokyo Rose* (1961);
courtesy Galerie Breteau.

5 Roy Lichtenstein, *Takka-Takka* (1962);
courtesy Castelli Gallery.

6 James Dine, *Child's Blue Wall* (1962);
courtesy Sidney Janis Gallery.

7 Robert Rauschenberg, *Canyon* (1959);
collection Mr. and Mrs. M. Sonnabend.

8 Andy Warhol,
Martinson's Coffee (1962);
courtesy Stable Gallery.

9 James Rosenquist,
I Love You with My Ford (1961);
courtesy Green Gallery.

2. A survey of Pop images similar to those shown by Peter Selz at the Pop Art
Symposium, The Museum of Modern Art, as reproduced in *Arts Magazine*, April 1963.

remarkably rapid acceptance. Whether this was to be viewed
positively or negatively, however, was another source of
profound disagreement.

Kramer and Kunitz feared that the Museum, merely by
sponsoring a discussion, was forcing contemporary art in a
particular direction. It is difficult, if not impossible, to gauge
with any degree of accuracy the Pop art symposium's ulti-
mate impact on the movement: did it, for instance, accelerate
its acceptance, raise prices, or legitimize it in some way that
altered its course? While these issues are not easy to trace,
the proceedings, as published in *Arts Magazine*, along with
a series of images related to the slides shown by Selz at the
opening of the symposium, do present a verbal and visual
snapshot of how Pop art was initially perceived (fig. 2).

The participants ranged in age, attitude, and demeanor,
projecting a seriousness completely at odds with the lively
tone of their discussion, not to mention the often (although
far from exclusively) colorful or boldly graphic appearance

of the artworks that brought them together and provoked
their debate. Geldzahler was Pop's only unqualified sup-
porter; Kunitz (a Pulitzer Prize–winning poet, critic, and
editor) and Kramer (an art critic) represented the other
extreme. Leo Steinberg (then a professor at Hunter College),
while forced by Kramer into qualifying most Pop art a
failure, was second to Geldzahler in keeping an open mind.
Dore Ashton (an art historian and author) also was among
Pop's critics as was Peter Selz (then Curator of Painting
and Sculpture Exhibitions at the Museum), perhaps more
surprisingly given his role as moderator and organizer. The
panel was thus heavily weighted with those less than favor-
ably disposed toward Pop.

The slides Selz used to introduce the subject were limited
to Pop's American practitioners and included those artists
who, by the end of 1962, were generally classified as Pop.
As indicated by the works reproduced in *Arts Magazine*, Selz
presented a relatively expansive and inclusive image of Pop
art at the beginning of the 1960s, including Oldenburg's
painterly, unappetizing pastry sculptures; Rosenquist's
smooth-surfaced yet steamy conflation of sex, cars, and
spaghetti; the cool, verbal violence of Lichtenstein's comic-
book-style painting *Takka-Takka*; and Warhol's gridded,
repetitive stacks of *Martinson's Coffee* cans.

Selz, who contended that the Pop artists presented their
subjects almost unaltered, began therefore with a selection
of Russell Lee's 1930s Farm Security Administration pho-
tographs featuring window displays, billboards, and other
signs. He then projected what he described as "relevant
work"[6] by Pop precursors Robert Rauschenberg and
Jasper Johns. The Pop artists proper were divided into three
categories: the "so-called sign painters" (Robert Indiana,
Roy Lichtenstein, James Rosenquist, Wayne Thiebaud,
and Andy Warhol), a group labeled "diverse" (Jim Dine,
Claes Oldenburg, Peter Saul, and Tom Wesselmann), and
sculpture and assemblages by artists "only iconographically"
related to Pop art (among them Edward Kienholz, Marisol,
and H. C. Westermann).[7]

Each of these artists has, to varying degrees, remained
associated with the Pop label through to the present day.
Judging, however, from the individual panelists' presentations
following Selz's slide introduction and from the general
discussion thereafter, even at this early date, four or five
artists had emerged as central. It was their work, as opposed
to that of other, implicitly more peripheral figures, that
provided the basis for identifying the salient characteristics
of Pop art. Leo Steinberg, for example, based most of his
comments on the work of Roy Lichtenstein, while Stanley
Kunitz had Andy Warhol in mind. Geldzahler referred not
only to Lichtenstein and Warhol but to Rosenquist and

Wesselmann, and an unidentified audience member (possibly the critic Gene Swenson) added Oldenburg's name to this group. What the unstated yet general panel consensus suggested was that, by December 1962, Lichtenstein, Oldenburg, Rosenquist, Warhol, and Wesselmann were already perceived as the main Pop artists. With the possible exception of Wesselmann, these are the same artists who remain essential to definitions of Pop art today. That they contributed critically and decisively to Pop art has consistently remained a given, even as interpretations of their contributions continue to shift.

Not surprisingly, Geldzahler (who, alone among the panelists, mentioned having visited a number of the Pop artists' studios — specifically Lichtenstein's, Rosenquist's, Warhol's, and Wesselmann's) supplied the best overview of Pop's characteristic features and attitudes as evident at the time. Describing the Pop artists' aspirations toward anonymity and ambivalence of attitude, their interest in "everyday objects and images isolated, typified, and intensified,"[8] and their play with transformations of scale, Geldzahler, unlike Selz (or for that matter most of the other panelists), wholeheartedly believed that the Pop artists acted upon their subject matter. Not only content was involved, in other words, but form.

Nonetheless, the Pop phenomenon was, in Geldzahler's opinion, content-driven, reflecting changes in America's visual culture at large. Specifically, he argued, a new mass-media imagery found in newspapers, movies, billboards, and television had become so prevalent as to prove impossible for artists to ignore. As a result, the Pop artists' "*primary visual data*" was paradoxically, he observed, mostly "*secondhand*" or mediated;[9] although Pop artworks featured recognizable objects, these objects were frequently drawn not from life but from media representations of life. This is but one of the many senses in which Pop art can be said to traffic in substitutes and stand-ins, or, semiotically speaking, in a world of signs.

While the individual panelists diverged widely in their assessments of Pop art's aesthetic significance, potential for longevity, philosophical implications, overarching meaning, and worth, all agreed on one thing: it was Pop's *subject matter* that was so shocking, exciting, disheartening, or banal. Steinberg summarized this generally held opinion most succinctly: "One characteristic of pop art as a movement or style [is to] have pushed subject matter to such prominence that formal or aesthetic considerations are temporarily masked out."[10]

Leaving aside, for the moment, Steinberg's contention that formal or aesthetic considerations were only *temporarily* masked out — a subtly polemical statement in keeping with

Geldzahler's assertion that the Pop artists' subjects were in some way transformed — at least two intertwined factors contributed to the highly controversial nature of Pop's content or iconography. The first had to do with the latter's low, everyday, common sources or origins in commerce, the mass media, advertising, product promotion, and commercial display. The second, even more basically, revolved around the fact that Pop art's subject matter was simply recognizable. This was an art picturing things that could be identified and named. Arriving at a moment within the art world when Abstract Expressionism still held exceptional sway, the fact that — as Geldzahler reported — the Pop artists were out "looking around again"[11] and painting what they saw was perceived in and of itself as radical, while their particular choice of subject matter and often deadpan style exacerbated their works' inflammatory impact.

The specter of New York School abstraction, in fact, haunted many of the comments made at the Pop symposium. It, along with the writings of one of its most influential proponents, the critic Clement Greenberg, clearly constituted the point of reference and standard against which Pop was positioned and measured, both by the Pop artists themselves and by the critics who spoke and wrote about their work. One of the questions returned to over and over during the course of the symposium was: "Is Pop art?" Its unspoken, more specialized, corollary was: "Is Pop *modern* art?" Of course, modern art, at the time, was defined and epitomized by abstract, as opposed to blatantly representational, painting and sculpture. "Transgression," after all, "is only as powerful as the norm it seeks to subvert,"[12] and in New York in the early 1960s, modernist abstraction as theorized and promoted by Greenberg was, indeed, a very powerful norm. If the Abstract Expressionists were, as one journalist put it, "painters without regard for the ready-made world,"[13] the Pop artists were their antithesis: the ready-made world claimed their undivided attention, providing the basis for the making of their art.

It is against this background that Steinberg's proposition that "formal and aesthetic considerations" were present in Pop art but temporarily imperceptible takes on its polemical cast. According to the other panelists, Pop artists — for all that they presented objects taken out of context, isolated, repeated, or even enlarged — merely transposed or re-arranged their subject matter without transforming it. Unique, painterly gestures were routinely banished, as were all traces of individual, subjective feelings, in favor of an anonymous, hands-off, cool, and distanced approach. According to Selz, for example, Lichtenstein presented his comic-strip sources "almost directly,"[14] while Warhol's "*Campbell's Soup* labels," claimed Kunitz, were not painting

because the image had been "mechanically reproduced with the aid of a stencil."[15] As evidence of the panelists' and the audience's disregard for the differences between a Lichtenstein painting and its source image (see *Drowning Girl*, for example, page 51), Geldzahler's insistence on the visibility of the artist's aesthetic interventions was greeted not only with laughter but by Dore Ashton's remark that he (Geldzahler) must have used "a magnifying glass."[16]

The Pop artists' so-called refusal to transform their subjects as well as their desire to represent "something which is almost the object itself"[17] constituted a serious affront, in the eyes of Ashton, Kramer, Kunitz, and Selz, to notions of artistic authorship, originality, and aesthetic integrity. Instead of playing the conventionally sanctioned role of what Ashton described as "master image-maker,"[18] the Pop artists showed an unadmirable willingness to cede authority and control to the vagaries of chance, the dictates of subject matter, and the unpredictable responses of an audience. Rather than create works complete unto themselves — as had, for example, the Abstract Expressionists — Pop artists left their art open to the world, acting as a passive mirror instead of an active agent. In what was characterized as these artists' diffident, ambivalent attitude, their critics saw not only troubling aesthetic but serious social, even ideological, implications. Instead of protesting the status quo or taking a critical stance, Pop art promoted cathartic capitulation. Its "social effect," Kramer claimed, was "indistinguishable from advertising art"; both served "to reconcile us to a world of commodities, banalities and vulgarities," and were to be resisted at all costs.[19]

Pop failed, simply stated, to be revolutionary in any traditional sense, as Steinberg pointed out. This was, however, in his opinion not necessarily a negative thing. Describing the development of twentieth-century art as "just one damn rebel after another," a historical progression where "nonconformity is the norm," Steinberg suggested that one of Pop's signature contributions was to present an alternative mode of conduct, that of "the *non-dissenter*." Could it be, he ironically speculated, that "the extraordinary novelty and the shock and the dismay and the disdain that is felt over [this] movement is that it doesn't *seem revolutionary* like every other."[20]

Related to this, Steinberg proposed, was another of Pop's achievements, specifically that of discovering a new way to approach the relation between artist and bourgeois. His fellow panelists, of course, could not have agreed more. Pop art's "signs and slogans and stratagems come straight out of the citadel of bourgeois society, the communications stronghold where the images and desires of mass man are produced," sneered Kunitz.[21] The Pop artists were for "the

spirit of conformity and the *bourgeoisie*," complained Selz.[22] Despite these and other similar comments, however, the real problem for these speakers resided in the Pop artists' ambivalence, which ultimately frustrated attempts to classify their work as assent or dissent, embrace or rejection, conformist or nonconformist, pro- or anti-bourgeois.

At the same time that Kramer argued that Pop art was purely contextual — dependent on things outside itself for meaning — he acknowledged that among those things was abstract art. While evidently intending to belittle the issue, his observation that Pop did not create new forms (borrowing instead from the conventions of abstract art) or new modes of perceiving subject matter (relying upon precedents of window display and advertising design) admitted the possibility that Pop art involved a degree of formal or aesthetic transformation. Instead of being simply negative, in other words, Pop art's relationship to abstraction acknowledged and set into play an interdependency of abstract form and loaded content, putting each to good use.

Where Kramer drew attention to parallels between Pop and abstract art in a very general sense, intending only to demonstrate the former's utter and deplorable lack of originality, Steinberg and Geldzahler explored more positive aspects. Geldzahler, for instance, connected the Pop artists' use of scale and enlarged formats to those of the Abstract Expressionists' vast canvases. Steinberg — in clear reference to Greenberg's theories — raised the possibility that the Pop artists' choice of subjects was artistically determined. "Since the elements employed . . . are known and seen to be flat (being posters, cartoons, ads, etc.), the overall flatness of the picture-as-object is taken care of," allowing the artist not to worry about the "integrity of the picture plane."[23] Geldzahler went a step further, presenting the flip side of Kunitz's and others' "transposition" as opposed to "transformation" extreme. Despite Pop's external references to the observed world, Geldzahler argued, it still carried on art's task of self-criticism as conceived by Greenberg, maintaining "a dialogue with itself" and taking its place in art's "internal sequence," and was therefore connected to "the most advanced contemporary art."[24]

Geldzahler sought to defend and legitimize Pop art in other ways as well. He countered claims that because of its rapid recognition Pop art was not serious, with the contention that one of the heroic achievements of the New York School had been to "win acceptance for the high and serious purpose of American painting."[25] A new social situation had emerged as a result of that battle, Geldzahler contended, manifested in a new audience and a new community supportive of advanced art. Both rendered old myths of the alienated artist irrelevant. Pop art was, more-

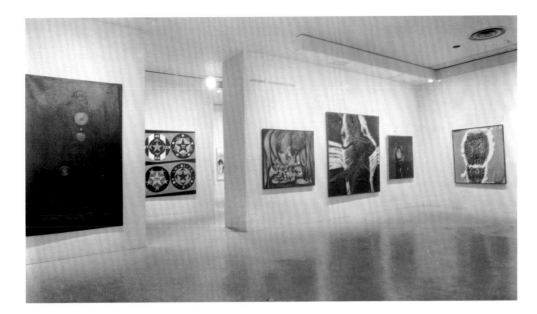

3. Installation view, *Recent Acquisitions: Painting and Sculpture,* The Museum of Modern Art, December 1961– February 1962.

over, he insisted, a formal art of decisions, choices of composition, and the like. By the latter half of the 1960s, many other critics joined him in emphasizing Pop's formal qualities over its subject matter, drawing attention to the parallels its hard-edged style presented with the decade's nonrepresentational art. By attempting to focus on form and formal issues alone, thereby relegating Pop's imagery, or popular component, to a lesser position, these critics followed a pattern observed in both late nineteenth- and early twentieth-century art history, assimilating Pop's rambunctious subject matter into mainstream accounts of the development of modern art.

Collecting Pop Art at the Museum in the 1960s

Where the Pop art symposium raised questions concerning Pop's relation to, and position within, modern art's history, it was, of course, in the Museum's galleries that its view of Pop art in the 1960s first began to take on physical shape.

The real Pop artists, Kunitz had claimed, were its "promoters who have made a new kind of assemblage out of the assorted and not necessarily related works of dozens of painters and sculptors, to which they have given the collective title (substitute brand name) 'pop art.' "[26] Accusing The Museum of Modern Art, in particular, of "a rapacious historicity . . . an indefatigable search for novelty,"[27] Kunitz left little doubt as to what his reaction would have been had Barr and Miller pursued, purchased, and exhibited numerous examples of Pop art. In retrospect, however, it seems odd that he made no specific mention of the Museum's collection as vulnerable to an invasion by Pop. For where the symposium aligned with notions of fleeting contemporaneity, the collection symbolized permanence, the place where art begins the process of becoming history.

As noted, by December 1962 the presence of Pop art in the Museum's collection was limited to only six works. The Museum then owned two Robert Indianas, *Moon* of 1960 (page 43), an assemblage purchased through the Philip Johnson Fund, and what is now considered to be a classic Pop painting, *The American Dream, I* of 1961 (page 45), acquired through the Larry Aldrich Foundation Fund, and two Claes Oldenburgs, *Red Tights with Fragment 9* of 1961 and *Two Cheeseburgers with Everything (Dual Hamburgers)* of 1962 (page 67), the latter also purchased through the Philip Johnson Fund. Marisol, the only female artist associated with any frequency with Pop, was represented by *The Family* of 1962 (page 55) and Warhol by *Gold Marilyn Monroe* of 1962.

Given the date, this list is far from unimpressive, suggesting among other things a fairly even balance between hard-edged (Indiana and Warhol) and hand-painted (Marisol and Oldenburg) Pop. However, when considered within the overall context of the Museum's contemporary acquisitions program in the early 1960s, these works represent a very small fraction of a large, unwieldy, and far from unified whole. This point is vividly illustrated in installation photographs of what were then annual exhibitions of *Recent Acquisitions*, which usually served as the first occasions on which newly acquired Pop works, along with many others, were presented and displayed.

On December 19, 1961, for example, Indiana's *The American Dream, I* was shown at the Museum for the first time (fig. 3). In comments attached to the exhibition's press release, Barr noted: "Because I do not understand why I like it so much, Robert Indiana's *The American Dream* is for me one of the two most spellbinding paintings in the show. Its bitter humor appears again in the painter's answer to the Museum's questionnaire."[28] Indiana's replies to questions concerning the painting's subject matter and the relevancy

of his "ancestry, nationality or background . . . to an understanding of [his] art"[29] were also appended to the press release and subsequently quoted in an early and important article written by Sidney Tillim that touched on a number of issues and artists pertinent to Pop. Tillim did not, however, characterize the new movement as "Pop." Instead, he coined the phrase "New American Dream" painting,[30] drawing upon Indiana for inspiration in naming what he perceived as a new trend in art.

Barr should, of course, be credited for his foresight in singling out a work by a relatively unknown artist that would prove important in defining Pop. Yet the installation photograph shows that *The American Dream, I* was surrounded and literally outnumbered by painterly abstractions. Rather than being presented as part of a new and dominant trend, shown in the context of formally or iconographically related works, *The American Dream, I* was isolated stylistically from the other paintings.

In fact, it would have been absolutely antithetical to Barr's and Miller's intentions to single out a movement or trend in the 1960s, particularly as concerned contemporary art. Describing the November 20, 1962–January 13, 1963, *Recent Acquisitions* exhibition that presented for the first time Marisol's *The Family* and Oldenburg's *Two Cheeseburgers with Everything (Dual Hamburgers)* and that overlapped chronologically with the Museum's Pop symposium, Barr wrote: "This showing of paintings and sculptures from 20 countries acquired over the past year obviously could not have been planned as a harmonious, unified exhibition. It is, in fact, extremely varied, for artists everywhere in the free world work as they choose; and their goals are manifold. Some are mystics, some are assertive realists; some aim to please, others to shock — or to amuse, alarm, mock, reveal, persuade, explore, warn, delight. He who has eyes, let him see."[31] Similar statements by Barr accompanied many other *Recent Acquisitions* exhibitions held at the Museum during the late 1950s and 1960s. In them he usually linked the pluralism of contemporary art practices to an espousal of individualism and freedom of expression.

Dorothy Miller's series of Americans exhibitions followed a comparable pattern, emphasizing differences rather than similarities. In the press release that accompanied her *Americans 1963* show, for example, appeared the following caveat: "The exhibition offers little comfort to trend-spotters since, as in past years, the emphasis is on variety rather than on a single style or movement. 'As on preceding occasions,' Miss Miller points out in the foreword to the catalog, 'strongly contrasting personalities and points of view have been brought together. The exhibition is not designed to illustrate a trend, make classifications or favor any age group. The artists have been selected simply as individuals — fifteen painters and sculptors of such consequence that they should, I believe, be more fully known to the Museum's public.'"[32]

Ironically, Miller's disclaimer notwithstanding, *Americans 1963* was interpreted by many in the New York art world as an endorsement of the Pop movement, despite the fact that out of fifteen artists only four — Indiana, Marisol, Oldenburg, and Rosenquist — were associated with Pop. Moreover, as critics such as Irving Sandler pointed out, the selection of Pop artists, with the exception of Oldenburg, erred on the side of caution. Notably absent, in other words, were the other key and arguably more radical Pop artists identified at the 1962 symposium, namely Lichtenstein, Warhol, and Wesselmann.

While there were undoubtedly many different reasons behind Miller's choices, with the exception of Rosenquist, three of the four artists were already represented in the Museum's collection by the time of the exhibition. So, too, were Warhol and Wesselmann, although in each case by only one work. Warhol's *Gold Marilyn Monroe*, furthermore, while accepted by the Museum on December 11, 1962, had been returned to its donor Philip Johnson a few days later and was not actually displayed at the Museum until May 1964. As for Lichtenstein, it is difficult to determine when Barr might first have brought this artist's work before the Committee on the Museum Collections and whether or not he met with resistance. What is certain, however, is that it took until January 1966 for the Museum to acquire its first Lichtenstein, a 1962 painting titled *Flatten — Sand Fleas!*, presented by Barr and purchased through the Philip Johnson Fund. The Museum's endorsement of Pop in 1963 extended to some artists more than others, and those artists were Indiana, Marisol, and Oldenburg.

Nonetheless, by May 1964, when "five hundred and fifty paintings and sculptures from the Collections of The Museum of Modern Art, offering a panoramic view of art from Cézanne and Rodin to the present" went on view in the Museum's "new and remodeled galleries,"[33] there was a definite, albeit highly selective, proto-Pop and Pop presence in the last of the third-floor galleries where the most contemporary works were to be found. According to a description of the new collection installation issued at the time: "The last three galleries are devoted to post- and sometimes anti-abstract expressionism from the past 10 years: collage and assemblage by Burri, Rauschenberg, Stankiewicz; commonplace signs and symbols in paintings by Johns and Indiana; provocative images of everyday things and people in works by Oldenburg and Warhol; geometrical and hard-edge abstraction sometimes with optical devices

and mysterious or strident dissonances in color and form by such artists as Vasarely, Reinhardt, Kelly and Anuszkiewicz."[34]

Following a selection of mid-century European abstract paintings and two galleries devoted to American Abstract Expressionists (Clyfford Still, Mark Rothko, Jackson Pollock, Willem de Kooning, Franz Kline, Robert Motherwell, and others), the contents of the final three galleries signaled several things. First, they demonstrated that Abstract Expressionism — referred to in the press release as "the dominant style of the mid-century"[35] — was considered a thing of the past, superseded, in a familiar, well-established pattern of action and reaction, by post–Abstract Expressionist and sometimes anti–Abstract Expressionist works dating from the mid-1950s on. Second, they made it clear that the curators' vision of art made during the past ten years was relatively expansive, including not only different strains of post-painterly abstraction but figurative and representational works, along with others that fell somewhere in between. Third, they showed that at this point the Museum was still reluctant to adopt existing labels for movements or trends. Despite the fact, for example, that by May 1964 Johns and Rauschenberg were often discussed in contemporary art criticism as Pop precursors and that Indiana, Oldenburg, and Warhol were firmly connected with Pop, no mention of what Kunitz had labeled a "brand name" appeared in Museum accounts of the collection installation. The references to pop culture, mass media, commercialism, and commodities, which were present in very different ways in Indiana's, Oldenburg's, and Warhol's work, were charac-terized in the far more neutral terms "commonplace" and "everyday."

Three years later on June 30, 1967, Alfred Barr retired after thirty-seven years at The Museum of Modern Art, where he had served first as Director of the Museum and then as Director of the Museum Collections. In the same week, the exhibition *The 1960s: Painting and Sculpture from the Museum Collection* opened (figs. 4–8). While the 127 works included were selected and beautifully installed by Dorothy Miller, Barr was "primarily responsible for the Museum's collection from which she made her selections."[36] *The 1960s* marked the end of an era; Miller left the Museum only two years later in 1969. As a result, the exhibition stands as a summary statement of sorts, providing an overview of, and fascinating glimpses into, what Barr and Miller believed to be "the contemporary movements, styles and the forms of expression which seem most characteristic of the current decade."[37] Among them was Pop art.

Barr wrote: "My 1960s began in the fall of 1957 when I saw a Jasper Johns target on the cover of *Art News*."[38] In *The 1960s* exhibition visitors were confronted upon entering not only with the Johns target that had been pictured on the *Art News* cover (*Target with Four Faces*, 1955), but with two other Johns paintings, *Green Target* (1955) and *Flag* (1954–55) (page 47). Barr's level of commitment to, and early faith in, Johns's work are unquestionably remarkable. He bought three paintings from Johns's first one-person exhibition in 1958 (*Green Target*, *Target with Four Faces*, and *White Numbers*) and at the same time encouraged Philip

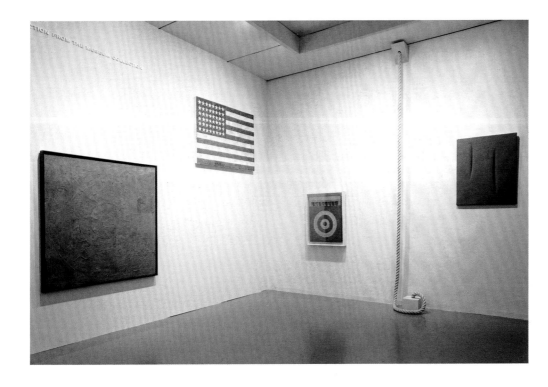

4. Installation view, *The 1960s: Painting and Sculpture from the Museum Collection*, The Museum of Modern Art, June–September 1967, including works by Jasper Johns, Robert Morris, and Lucio Fontana.

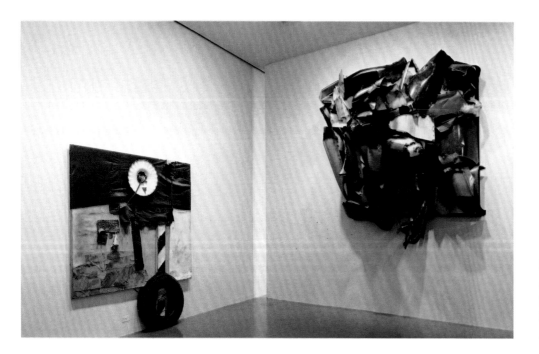

5. Installation view, *The 1960s: Painting and Sculpture from the Museum Collection*, The Museum of Modern Art, June–September 1967, including works by Robert Rauschenberg and John Chamberlain.

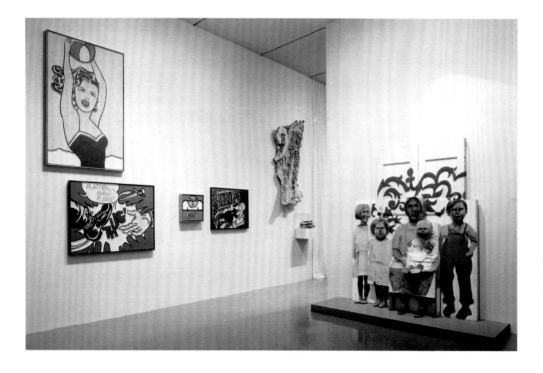

6. Installation view, *The 1960s: Painting and Sculpture from the Museum Collection*, The Museum of Modern Art, June–September 1967, including works by Roy Lichtenstein, Kirsten Kraa, William Copley, Claes Oldenburg, and Marisol.

Johnson to buy *Flag* for a future gift to the Museum. By 1973, when *Flag* was given in honor of Barr, it had "come to be recognized as a work of seminal importance for all that followed in American art."[39]

Hilton Kramer, reviewing *The 1960s*, found it odd that an exhibition ostensibly devoted to the current decade should include one room dominated by 1954–55 works by Johns. Barr's convictions concerning Johns's centrality to art of the 1960s go a long way toward explaining what Kramer termed "a curiosity,"[40] as do the artworks themselves. Among many other things, Johns's Flags, Targets, and plaster casts announced the Pop artists' interest in ready-made imagery and in the transformation of everyday objects into

works of art. At the same time, the simple geometries, use of repetition, and serial implications in these works can be read as harbingers of aspects of Minimalist art.

Robert Rauschenberg's work too, during the 1960s and after, was seen as providing a touchstone for Pop. While Barr and Miller have been said to have "missed the mark" on his work,[41] and this is certainly true relative to their support of Johns, they can hardly be said to have overlooked Rauschenberg. It is clear from the Committee on the Museum Collections minutes, for instance, that Barr tried presenting a Rauschenberg painting-construction called *Winter Pool* to the trustees as early as January 1963; a few months later, he asked Johns which Rauschenberg the

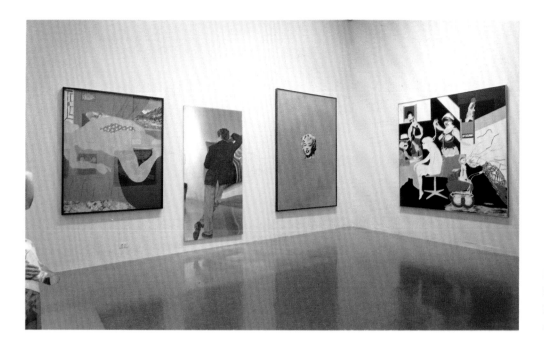

7. Installation view, *The 1960s: Painting and Sculpture from the Museum Collection*, The Museum of Modern Art, June–September 1967, including works by Tom Wesselmann, Michelangelo Pistoletto, Andy Warhol, and R. B. Kitaj.

artist thought the Museum should have. By May 1964, Barr had apparently convinced Philip Johnson to promise Rauschenberg's Combine painting *First Landing Jump* of 1961 (page 83) to the Museum. Included in the 1964 collection installation and again in Miller's *The 1960s* show (see fig. 5), *First Landing Jump* drew attention to the important role assemblage played within the history of Pop.

As for Pop art proper, by 1967 Miller seems to have been ready to name movements, styles, and trends. While no catalogue was published to accompany *The 1960s* exhibition, it included, according to the press release, "works influenced by dada and surrealism, many of them using assemblage technique; 'stain' or 'color-field' painting; systemic painting; hard-edge abstraction and the shaped canvas; optical and kinetic art; 'primary' sculpture; and various forms of realism and pop."[42] Demonstrating Barr's and Miller's continued commitment to a pluralistic view of contemporary art practices, *The 1960s* nonetheless presented a view of the decade's art that, for all its variety and mixing together of artworks by artists of different nationalities, was dominated by American artists and American movements, including Color Field Painting, Minimalism (referred to as "primary" sculpture), and Pop.

Still, for a museum often criticized in subsequent years as the "Kremlin of Modernism"[43] and castigated for promoting abstract painting — both that of the Abstract Expressionists and later artists — at the expense of all other forms of art, *The 1960s* provided a very different sort of image of the Museum's interests, in particular those of Miller and, especially, of Barr. Harold Rosenberg, a staunch supporter of the Abstract Expressionists and their followers, published a scathing review of *The 1960s* in *The New Yorker* magazine, taking Miller (and by implication, Barr) to task for their selections and omissions. The most serious and telling flaw

was, in his opinion, the decision made not to include 1960s works by still-living, still-working Abstract Expressionists but instead to relegate these artists and their current production to the past. In a related vein, he observed an overall predilection for what he described as "an aesthetic of neatness, of clean edges, smooth surfaces" that he believed had political dimensions.[44] In minimizing "painterliness," together with "those disorderly presences whose Happenings and public manifestations . . . have gone beyond the encompassment of art by museums," he felt the Museum affirmed "middle-class tidiness and security" and chose to ignore artworks that reflected "social intransigence and resistance to the war in Vietnam."[45]

Among the many other charges Rosenberg made, one in particular provoked Barr to write a letter of response. Dated October 6, 1967, it sets out to refute Rosenberg's claim that since "two-fifths of [the exhibition's] hundred and twenty-seven paintings and sculptures emanate from two sources — Philip Johnson and the Larry Aldrich Foundation . . . the concept of the decade presented by the show owes much to their judgment; only a handful of the works were bought by the Museum itself."[46] Barr's reply is worth quoting at some length, since it clarifies issues of responsibility for the shape of the Museum's collection of 1960s art in general, and, in particular, for its representation of Pop: "All the works in *The 1960s* bearing Larry Aldrich's name were chosen by the Museum *without* his advice and purchased by the Museum with money donated by the Larry Aldrich Foundation. Philip Johnson has been buying paintings *selected* by the Museum, as gifts to the Museum, since 1932. Some of them such as the Rauschenberg in *The 1960s* show have already passed into the Museum's permanent possession. Others such as the Johns, Dine, and Artschwager were selected by the Museum staff and then

bought by Johnson for eventual gift to the Museum, mean-while keeping them in his own collection. Thirteen more works borrowed for *The 1960s* were bought by Johnson with no advice by the Museum; they are now among works selected by the Museum as promised gifts. Johnson's name is also attached to a fourth category, the Philip Johnson Fund, a few thousand dollars a year used for purchases entirely selected by the Museum."[47]

A cursory review of the checklist for Miller's *The 1960s* exhibition reveals the degree to which the foundations of the Museum's Pop art collection were based on Philip Johnson's generosity. By 1967, he had already given Warhol's *Gold Marilyn Monroe* (1962) (see fig. 7) and promised Dine's *Still Life Painting* (1962), Johns's *Flag* (1954–55), Lichten-stein's *Girl with Ball* (1961), and Rauschenberg's *First Landing Jump* (1961). The Philip Johnson Fund, moreover, had made possible the purchase of Lichtenstein's *Flatten — Sand Fleas!* (1962) (see fig. 6), Oldenburg's *Two Cheeseburgers with Everything (Dual Hamburgers)* (1962), Segal's *The Bus Driver* (1962), and Warhol's *Campbell's Soup* (1965).

These works, along with a number of others visible in installation photographs from *The 1960s* (figs. 4–8), specifi-cally D'Arcangelo's *U.S. Highway 1, Number 5* (1962), Indiana's *The American Dream, I* (1961), Marisol's *The Family* (1962), Oldenburg's *Red Tights with Fragment 9* (1961), and Wesselmann's *Great American Nude, 2* (1961), combined to create a conspicuous, if less than overwhelming, Pop pres-ence in the Museum.

In January 1968, only four months after *The 1960s* closed, recently donated works from The Sidney and Harriet Janis Collection went on view at the Museum. Constituting one of the most important gifts ever received by the institution, works from the Janis collection ranged from such classics of twentieth-century art as Picasso's *Painter and Model* (1928) to European and American works of the 1960s, including a number of major works of Pop art (the Janis gallery had played a crucial role in the launching of the Pop move-ment). While it was William Rubin, Barr's successor in the Department of Painting and Sculpture, who first suggested to Janis that he donate his collection to the Museum, many quotes by Barr accompanied the January 1968 exhibition announcement, including the following: "Six of the best younger Americans — Kelly, Lichtenstein, Marisol, Oldenburg, Segal, and Wesselmann — are represented in the Museum by one or two works each, dated between 1959 and 1962; works by the same six in the Janis collection were completed in 1966 or 1967; and, it may be added, almost all are of exceptional interest and quite different in style."[48]

With the exception of Ellsworth Kelly, all of the artists Barr singled out for mention were associated during the 1960s with Pop, making clear what a boost the Janis collec-tion provided to the Museum's Pop art representation while at the same time revealing, possibly, Barr's own biases as to Pop. Unmentioned by Barr, yet included in the Janis dona-tion, for example, were important works by Rosenquist and Warhol. This suggests, when combined with the Museum's decision to stage an Oldenburg retrospective in 1969, a certain institutional preference during the 1960s for Pop's more painterly side.

Taken as a group, however, the works Barr purchased and the gifts solicited under his direction suggest an early and relatively substantive commitment to the area of Pop art. Far from indicating inattention to the movement, *The 1960s* exhibition makes clear that Barr had acquired at least one work by each of the major Pop artists identified at the Museum's 1962 symposium, along with often excellent examples of works by less central yet nonetheless important peripheral figures. While preserving a pluralistic approach that seems entirely appropriate when dealing with the unruly arena of contemporary art, he nonetheless left suc-cessive generations of curators a strong Pop base to build upon, provided this was an option that interested them. In so doing, he began the process of writing Pop art into modern art's history as represented in the Museum's galleries.

Pop Art and the Museum in the Late 1990s

At the Museum's Pop art symposium of December 1962 Hilton Kramer had contended that Pop art was only relevant in a climate where pure abstraction held sway. According to this logic, the "poverty of visual incident in abstract painting [had] given rise to practically every new development of the last couple of years; happenings, pop art, figure painting, monster-making, kinetic art."[49] All had in common, "whatever their differences, the desire to restore to complex and recognizable experience its former hegemony over pure aestheticism."[50] "Place [Pop art] in any other visual context and it fades into insignificance,"[51] he wrote.

Thirty-six years later, Pop art has been placed in many contexts other than one where abstract painting dominates. Far from fading into insignificance, however, or proving to be nothing more than, in Kunitz's words, "a nine days' wonder,"[52] Pop art has demonstrated remarkable longevity and staying power even as its significance has been con-stantly reevaluated, debated, discussed, and redefined. Paradoxically, then, an art often regarded as inextricably tied to its own times has proved to be enduring, even as it —

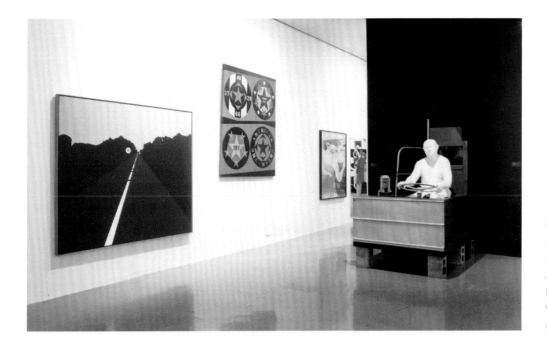

8. Installation view, *The 1960s: Painting and Sculpture from the Museum Collection*, The Museum of Modern Art, June–September 1967, including works by Allan D'Arcangelo, Robert Indiana, Tom Wesselmann, Michelangelo Pistoletto, and George Segal.

like no other kind of modern art before or after — continues to bring issues of obsolescence to the fore.

The French painter Fernand Léger, frequently mentioned by art historians as a key European precursor to Pop, often remarked on "the American obsession with premature obsolescence. Automobiles, household utensils, machinery of all kinds, even people," he claimed, "were ready for the ash heap in the United States."[53] Léger's general observations concerning American consumer culture serve to highlight its intimate connection with Pop. Both products and people, Pop art suggests, can be perceived as packaged, marketable, consumable, and hence vulnerable. This insight is not only tied to the inherent nature of mass production and of life in capitalist societies, but it accounts for the peculiarly coexisting moods of celebration, nostalgia, and loss often found within Pop. Perhaps more than any other of the Pop artists, Warhol's work and the "products" Oldenburg created during his Store period insist that artworks, too, are subject to commodification, engaging the subjects of consumables, consumerism, and obsolescence in very different ways. In Warhol's case, in particular, this is often linked to a preoccupation with the subject of death.

To shift from Pop's subject matter to its current historical position is to pass from the 1960s to the 1990s, and back again. "To view a moment historically is to kill it," wrote Barbara Rose in the early 1960s, speaking of the Abstract Expressionists' passage into history.[54] "Verdicts of the utmost gravity [are] being delivered," warned Harold Rosenberg, reviewing Miller's *The 1960s* show. "Living artists [are] being expelled from the present and relegated to the Museum proper — that is, to the past."[55] In October 1996 Chief Curator Kirk Varnedoe, speaking to the Committee on

Painting and Sculpture regarding the proposed purchase of Rosenquist's *F-111* of 1964–65 (pages 90–91) and Warhol's thirty-two *Campbell's Soup Cans* of 1962 (page 109) said: "I want to insist that these pictures are unique masterpieces. They are pictures that are now a part of history."[56]

Geldzahler would have insisted that this had always been so. "This is instant art history,"[57] he had observed at the Museum's Pop art symposium, capturing the sense in which Pop — at the very moment of its inception — was already perceived as passing into history. His words evoked a tension built into the very core of Pop, one that has to do with the effect of time and its passage, with the positive and negative ramifications of categorizing something as "history," and with the differences between things that are living and those that are over, legitimized and enduring but no longer of immediate, vital concern.

The nature of the Museum's relationship with Pop, the character of this "ongoing affair," has, over the years, embodied similar tensions. In the gap between the 1962 symposium and the multimillion-dollar purchase of *F-111* and the *Campbell's Soup Cans*, many changes have occurred both within the Museum and without. Warhol's death in 1987 and, more recently, Lichtenstein's underscore the aging of Pop. The Museum's role has shifted in emphasis from direct, hands-on immersion in a particular moment (as symbolized by both the symposium and Barr's and Miller's collection and exhibition activities during the 1960s) to retrospective assessment, to surveying Pop from a distance, and to committing it to history, while at the same time ensuring that it lives on.

Also, between Alfred Barr's 1960s and the present there have been not only decades but several generations of

curators in the Museum's Department of Painting and Sculpture: William Rubin was chief curator, then director (1968–88), and Kirk Varnedoe took over for Rubin a decade ago. Beginning with the Janis collection, any number of important Pop works were added to the collection during Rubin's years. Speaking in October 1996, however, Rubin acknowledged: "Although we have wonderful examples of Pop Art, I don't think it would be unfair to say that I never gave it as much emphasis as it probably deserved."[58] Where Rubin gave precedence to the formal development of abstraction in art, Varnedoe is deeply convinced of Pop art's importance and committed to making the Museum's Pop collection specifically, and the Museum's representation of the 1960s in general, a priority, picking up the narrative thread of modern art's history where his predecessor left off. During Varnedoe's tenure Pop acquisitions have accelerated, both in terms of purchases and gifts, while Senior Curator Kynaston McShine's 1989 Warhol retrospective and Varnedoe's and Adam Gopnik's 1990 *High & Low: Modern Art and Popular Culture* have granted Pop art, artists, and related works unprecedented prominence within the Museum's exhibition program as a whole.

The current exhibition is the first to exclusively feature The Museum of Modern Art's collection of American Pop art. Based primarily upon the Department of Painting and Sculpture's holdings, the show focuses on the 1960s and is restricted to works made in the United States (with an even more specific concentration on those made in New York) rather than attempting an international survey of Pop. Within these chronological and geographical parameters, however, the exhibition aims to present an in-depth and varied picture of American Pop. Ranging in facture from cool, clean impersonality to the messy and painterly, and in scale from miniature to oversized, the works are all by artists associated with the Pop label in the 1960s, including central figures, precursors, offshoots, and sidebars. They comprise variations on Pop's distinctive — and in the 1960s, shocking — iconography, ranging from images of common-place everyday objects to blatantly commercial consumer products and mass-media representations, iconically isolated, enlarged, or repeated, all drawn from American consumer culture.

Behind all the generalizations that have been made about the Pop art movement lie individual artists and complex powerful objects that have retained their ability to fascinate for three decades and more. The Museum of Modern Art's Pop art collection presents one of many possible groupings of Pop objects, formed from particular institutional and individual vantage points and one that presents a unique image of the Pop movement as a whole. The historical coincidence between Pop art's beginnings and those of the Museum's Pop art collection provides the opportunity to examine the two as parallel or intersecting phenomena, which, considered in tandem, provide an overview of Pop from its inception.

At the same time, however, lest the wrong impression be given, it is important to stress Pop's intimate connection with its own time and culture, with, in other words, not only the Museum, but the broader social and political world. James Rosenquist's monumental *F-111* (pages 90–91) is a key work partly for this reason. Measuring ten feet in height and eighty-six in length, *F-111* is an icon of American Pop and of its era, combining political content and domesticated advertising imagery on a vast billboard scale. Completed in 1965, *F-111* marks the moment at which, according to Andy Warhol, "the basic Pop statements had already been made."[59] While there are any number of works in the exhibition dating from the second half of the decade, there is no question that by that point not only the mood of Pop but the political, social, and cultural climate had changed.

Taking the F-111 fighter bomber as his subject, Rosenquist created a modern-day history painting, responding to the link between commerce and militarism made by the Vietnam War. Combining antiwar politics with a form of commodity critique, *F-111* pointed to Pop's sometimes caustic, political side, acknowledging the dominant public issue of the late 1960s, the war in Vietnam. At the same time, it drew attention to the flip side of postwar prosperity and to the darker aspects of American consumer culture that often permeate the brightly colored surfaces of Pop. Enveloping the viewer, *F-111* stands as a major environmental work, as installation art *avant la lettre*, and creates a theater of consumption and display. Weaving together the varied subjects of consumerism, politics, commodification, and audience engagement, *F-111* — much as do all the works in the exhibition — catches Pop coming and going, tied to its moment and as a result, now history, yet with an immediate, visceral impact that engages viewers of the 1990s no less than those in the past.

Notes to the Text

1. Bruce Altshuler, *The Avant-Garde in Exhibition: New Art in the 20th Century* (New York: Harry N. Abrams, 1994): 214.
2. "A Symposium on Pop Art," *Arts Magazine* 37, no. 7 (April 1963): 36.
3. Sidney Tillim, "Further Observations on the Pop Phenomenon," *Artforum* (November 1965); repr. in Steven Henry Madoff, ed., *Pop Art: A Critical History* (Berkeley, Los Angeles, and London: University of California Press, 1997): 137.
4. Ibid.: 139 (n. 2).
5. "A Symposium on Pop Art": 42.
6. Ibid.: 36.
7. Ibid.
8. Ibid.: 37.
9. Ibid. (emphasis mine).
10. Ibid.: 40.
11. Ibid.: 37.
12. Richard Vine, "Report from Denmark, Part One: Louisiana Techno Rave," *Art in America* 84, no. 10 (October 1996): 47.
13. Will Grohmann, "Die neue amerikanische Malerei," *Der Tagesspiegel* (September 7, 1958); quoted in Lynn Zelevansky, "Dorothy Miller's 'Americans,' 1942–63," in *Studies in Modern Art 4: The Museum of Modern Art at Mid-Century, At Home and Abroad* (New York: The Museum of Modern Art, 1994): 88.
14. "A Symposium on Pop Art": 43.
15. Ibid.: 41.
16. Ibid.: 44.
17. Unpublished portion of the discussion recorded on tape.
18. "A Symposium on Pop Art": 39.
19. Ibid.: 38–39.
20. Ibid.: 44.
21. Ibid.: 42.
22. Ibid.: 44.
23. Ibid.: 40.
24. Ibid.: 37.
25. Ibid.
26. Ibid.: 41.
27. Ibid.
28. "Recent Acquisitions: Painting and Sculpture," Press release (no. 151a), The Museum of Modern Art, New York, December 19, 1961–February 25, 1962.
29. Ibid.
30. Sidney Tillim, "Month in Review: New York Exhibitions," *Arts Magazine* 36, no. 5 (February 1962); repr. in Madoff, *Pop Art*: 27.
31. "Recent Acquisitions," Press release (no. 131), The Museum of Modern Art, New York, November 20, 1962–January 13, 1963.
32. "Americans 1963," Press release (no. 69), The Museum of Modern Art, New York, May 22–August 18, 1963.
33. "Painting and Sculpture from the Museum Collection," Press release, The Museum of Modern Art, New York, beginning May 27, 1964.
34. Ibid.
35. Ibid.
36. Alfred H. Barr, Jr., letter to Harold Rosenberg, October 6, 1967 (Exhibition Files, Department of Painting and Sculpture, The Museum of Modern Art, New York).
37. "The 1960s: Painting and Sculpture from the Museum Collection," Press release, The Museum of Modern Art, New York, June 28–September 24, 1967.
38. Barr, letter to Rosenberg. Johns's *Target with Four Faces* was published on the cover of the January 1958, not Fall 1957, issue of *Art News*.
39. Kirk Varnedoe, "Philip Johnson as Donor to the Museum Collection: An Overview," in *Studies in Modern Art 6: Philip Johnson and The Museum of Modern Art* (New York: The Museum of Modern Art, 1998): 13.
40. Hilton Kramer, "The Sixties in Retrospect," *The New York Times* (July 2, 1967): D19.
41. Zelevansky, "Dorothy Miller's 'Americans'": 104 (n. 158).
42. "The 1960s: Painting and Sculpture from the Museum Collection," Press release.
43. Francis Frascina, "The Politics of Representation," in Paul Wood et al., *Modernism in Dispute: Art since the Forties* (New Haven and London: Yale University Press in association with the Open University, 1993): 77.
44. Harold Rosenberg, "The Nineteen-Sixties: Time in the Museum," *The New Yorker* 43, no. 23 (July 29, 1967): 78.
45. Ibid.: 81, 82.
46. Ibid.: 76.
47. Barr, letter to Rosenberg.
48. "The Sidney and Harriet Janis Collection," Press release (no. 8), The Museum of Modern Art, New York, January 17–March 4, 1968.
49. "A Symposium on Pop Art": 38.
50. Ibid.
51. Ibid.
52. Ibid.: 42.
53. Katharine Kuh, "Remembering Léger, Champion of Nuts and Bolts," *The New York Times* (February 8, 1998): 37.
54. Barbara Rose, "Dada, Then and Now," *Art International* 7, no. 1 (January 1963); repr. in Madoff, *Pop Art*: 62.
55. Rosenberg, "The Nineteen-Sixties": 76.
56. Committee on Painting and Sculpture minutes, The Museum of Modern Art, New York, October 7, 1996.
57. "A Symposium on Pop Art": 37.
58. Committee on Painting and Sculpture minutes.
59. Andy Warhol and Pat Hackett, *POPism: The Warhol '60s* (New York and London: Harcourt Brace Jovanovich, 1980): 115.

Pop Art: Selections from The Museum of Modern Art

The following works of art are organized alphabetically by the name of the artist and chronologically within each grouping. In the captions to the works in the exhibition, the title of the work appears in bold-face type, and is followed by the date. The medium appears before the dimensions, which are given in feet and inches and in centimeters; height precedes width precedes depth. All works in the exhibition, represented as color plates, are in the collection of The Museum of Modern Art, New York; the means of acquisition is given at the end of the caption.

Collateral illustrations are given with a number of the texts; they comprise related works of art, source materials, installation views, and images of artists at work.

The commentaries on the works of art were written by Anne Umland, Leslie Jones, Laura Hoptman, and Beth Handler, whose initials appear at the end of their texts. Reference notes can be found at the end of the plate section on pages 126–29.

Allan D'Arcangelo

(American, born 1930)

Allan D'Arcangelo.
U.S. Highway 1, Number 5. 1962.
Synthetic polymer paint on canvas,
70" x 6' 9 ½" (177.8 x 207 cm).
Gift of Mr. and Mrs. Herbert Fischbach

A bright, white broken line plunges deep into the space of D'Arcangelo's painting *U.S. Highway 1, Number 5*, pulling the eye toward a vanishing point located at the tip of a dark empty road. Foreground details are eliminated. Both viewer and painter are positioned, metaphorically, in the driver's seat, drawn as though magnetized toward the beckoning star of a Texaco sign and the highway marker that identifies the road. Basic perspectival devices, gas station logo, and federal roadside sign complement each other, functioning visually as "come-ons" in both a pictorial and a commercial sense.

U.S. Highway 1, Number 5 is one of D'Arcangelo's earliest highway paintings. It introduced what became his trademark image together with the other hallmarks of his style: unmodulated uninflected surfaces, sharply demarcated shapes, and an interest in basic geometries. At the time of the artist's first one-person exhibition in New York City in 1963, the iconography of this work along with others featuring signs, median lines, and other aspects of highway culture quickly led critics to associate D'Arcangelo with the rubric of "Pop." The surface blankness and hard, clean finish of his paintings were also seen as connected to Pop aesthetics.

Landscapes such as *U.S. Highway 1, Number 5* provoke an uncanny sense of fluctuation between the illusion of rapidly receding space and the unyielding surface of the picture plane. Their effect ranges, as Lawrence Alloway wrote, between that of a streamlined tunnel, pulling us in, and a flat wall stopping us short. The ensuing tension between

the fictive and the real, and between descriptive and symbolic form, contributes to the unsettling character of D'Arcangelo's work. Although this painting's title, and the black-and-white, shield-shaped sign that appears within it, identify the highway as U.S. 1 — a road that stretches from Maine to Florida — no further clues are provided as to location. Roadside details are not given. As a result, the picture appears strangely antiseptic, as though it had been vacuumed clean. This impression is underscored by D'Arcangelo's cool style.

In sacrificing local color, the artist aimed to present not *a* highway but *the* highway — an instantly recognizable and conventionalized image replacing observed reality with a generalized symbol or sign. The aura of artificiality that pervades *U.S. Highway 1, Number 5* highlights the effect of the artist's, and of man's, standardizing of the natural environment. While preserving a sense of the nighttime highway's potentially haunting allure and of America's ongoing fascination with the open road, D'Arcangelo painted a picture where man-made gas station signs have displaced celestial constellations and where familiar elements of roadside culture have been isolated and thereby rendered disquieting and strange.

U.S. Highway 1, Number 5 is the last in a series of five paintings completed in 1962. When positioned at the end of the sequence of the four works shown here, the fifth painting takes on a critical dimension only hinted at when viewed alone. *U.S. Highway 1, Number 1* is almost identical

Allan D'Arcangelo. *U.S. Highway 1, Number 1*. 1962. Synthetic polymer paint on canvas, 70" x 6' 9" (177.8 x 205.7 cm). Whereabouts unknown

Allan D'Arcangelo. *U.S. Highway 1, Number 2*. 1962. Synthetic polymer paint on canvas, 70" x 6' 9" (177.8 x 205.7 cm). Collection Armand and Celeste Bartos

Allan D'Arcangelo. *U.S. Highway 1, Number 3*. 1962. Synthetic polymer paint on canvas, 70" x 6' 9" (177.8 x 205.7 cm). Virginia Museum of Fine Arts, Richmond. Gift of Sydney and Frances Lewis

Allan D'Arcangelo. *U.S. Highway 1, Number 4*. 1962. Synthetic polymer paint on canvas, 70" x 6' 9" (177.8 x 205.7 cm). Whereabouts unknown

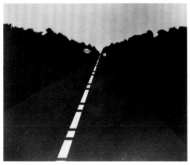

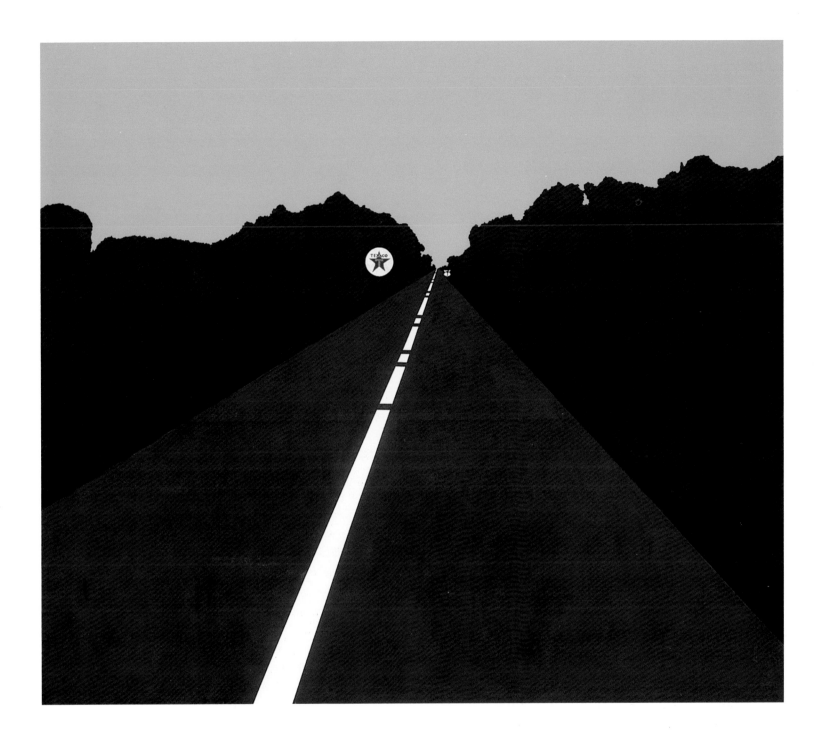

to *U.S. Highway 1, Number 5* except that a bright yellow Sunoco sign is substituted for Texaco's red star. In the three other paintings the Sunoco sign changes in size and position, which signals narrative action and temporal movement. Commenting on the last canvas, the artist noted the shift from Sunoco to Texaco: "There is a change in place, but as you look at it it's a superficial change. . . . The suggestion is that, with the passage of time, nothing has happened anyway."[1]

Considered as a group, D'Arcangelo's highway paintings present a variation on the strategies of repetition and seriality of Andy Warhol's thirty-two *Campbell's Soup Cans* (page 109) by calling attention to standardization's leveling of differences. What we are left with is a less-than-celebratory image of the American road as "a conveyor belt that runs through a repetitive, vacuous . . . environment" leading only to "replicas of the already known and familiar."[2] — A.U.

Jim Dine

(American, born 1935)

Jim Dine.
Tattoo. 1961.
Oil on canvas, 60 ¼ x 48 ¼" (153 x 122.5 cm).
Mary Sisler Bequest

Tattoo is one of a number of paintings created by Jim Dine in 1961 and 1962 that focus on details of the body. Although the body part featured in *Tattoo* remains ambiguous (as does the gender), the effect is similar to looking closeup at a bicep or buttock that has been scarred in blue ink with the word "tattoo." In choosing to represent the generic word, as opposed to a conventional anchor or pierced heart, Dine introduced language into the pictorial realm; "tattoo" assumes a dual function as image and label. As a label, "tattoo" may also refer to the "skin" of the canvas, which has been branded by the painter's mark.

Dine moved to New York City from his native Cincinnati in 1958. By the following year he had become associated with a group of artists — including Allan Kaprow, Claes Oldenburg, Lucas Samaras, and George Segal — who created performance-art events called Happenings. Dine staged his first Happening, *The Smiling Workman*, at the Judson Gallery in March 1960. As described by Barbara Haskell: "Lasting slightly more than thirty seconds, it consisted of Dine,

dressed in a paint-splattered smock, with his face painted red, his mouth black, rapidly scribbling, 'I love what I'm doing,' in orange and blue paint on an empty canvas; he then drank from the jars of paint, drenched himself with what remained and finished by diving into the canvas."[1]

This theatrical parody of the Abstract Expressionists' creative process would find a plastic counterpart in paintings like *Tattoo*, completed the following year, when Dine stopped doing Happenings and poured all his energies into painting. The swirling strokes, paint deposits, and drips on the surface of *Tattoo* are clearly evocative of the Abstract Expressionists' painterly style, but the crudely written "tattoo" turns similarity to parody in hinting at the "macho" reputation of his artistic predecessors. The "myth of masculinity"[2] surrounding Abstract Expressionism is also parodied in Dine's *Hair*, shown here, in which curly strands of brown hair fill the canvas in the allover painting style of Jackson Pollock. Despite this light-hearted mockery of Abstract Expressionism, Dine never denied the movement's influence on his own work. "I tie myself to Abstract Expressionism like fathers and sons," Dine has said.[3]

The richly impastoed surface of *Tattoo* reveals the expressionist tendencies of an artist who once proclaimed: "I'm always thinking about van Gogh."[4] There is, however, an irregularity and casualness in the application distinct from the consistently coiling patterns of van Gogh and the bold dynamic strokes of the Abstract Expressionists. Here the strokes are like traces of a caress across the surface of skin, while the painting's overall pinkish color also conjures body-related images.

The use of a monochrome, skin-toned or otherwise, that has been slowly and carefully built up recalls Jasper Johns's single-color encaustic paintings. But where the coolness of Johns's signs (his Targets and Flags, for example) may initially divert bodily connotations, Dine invited them — not only through his choice of subject matter and pigment but by purposely avoiding, as Alan Solomon pointed out in 1964, "the conventional and accepted ways of producing beautiful surfaces in search of new, more complex sources of interest which depend on visual or tactile irritation. The discomfort stirred by these irritants inevitably results in kinds of response which suggest a scatological preoccupation on the part of the artist. . . . Dine's colors raise the same problem since

Jim Dine. *Hair*. 1961. Oil on canvas, 6 x 6' (182.9 x 182.9 cm).
Collection Onnasch, Berlin

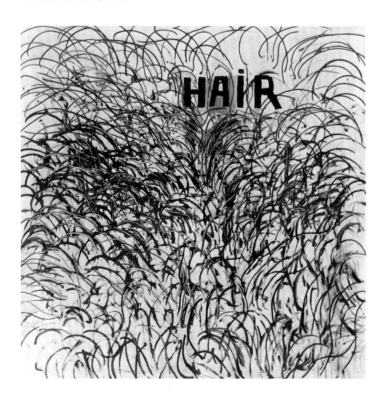

most of the time they are quite disagreeable and 'tasteless,' nasty browns, outrageous pinks."[5]

Dine's disagreeable colors and textures, Solomon argued, confront viewers with societal taboos related to the body. The visceral and deliberately handmade surface of *Tattoo* also distinguishes it from the mechanically reproduced or simulated forms typical of Pop's cool aesthetic (as in works by Lichtenstein and Warhol, for example). And distinct from Tom Wesselmann's and Mel Ramos's fetishistic treatment of the female body, Dine's body parts are sexually ambiguous. These distinctions point to the formal diversity of art that we have come to know as Pop as well as to Dine's eventual rejection of the Pop label. — L.J.

Jim Dine.

Five Feet of Colorful Tools. 1962.

Oil on unprimed canvas surmounted by a board on which thirty-two painted tools hang from hooks, overall 55 ⅝ x 60 ¼ x 4 ⅜" (141.2 x 152.9 x 11 cm).

The Sidney and Harriet Janis Collection

In 1962 Jim Dine's *Five Feet of Colorful Tools* was included in a landmark exhibition held at the Sidney Janis Gallery and at a nearby store on Fifty-seventh Street in New York City. For many this exhibition, *New Realists*, signaled the official explosion of Pop art in the United States. Dine was thus associated with Pop art as a recognized movement from its very beginnings. His use of everyday objects and seeming repudiation of Abstract Expressionism linked his work to that of contemporaries such as Warhol, Lichtenstein, and Rosenquist. Despite these apparent shared concerns, however, Dine ultimately rejected the Pop affiliation, declaring: "Pop is concerned with exteriors. I'm concerned with interiors when I use objects, I see them as a vocabulary of feelings."[1]

Tools, in Dine's vocabulary, have a personal significance related to his childhood memories of amusing himself in his grandfather's hardware store and in his father's paint and plumbing-supply store. "The tools were always available for me to play with," Dine recalled. "From the time I was very small I found the display of tools . . . very satisfying. It wasn't or isn't the craftsmanship that interests me, but the juxtaposition of tools to ground or air or the way a piece of galvanized pipe rolls down a flight of gray enamel steps. . . .

From the age of nine until I was eighteen I worked in these stores. I was completely bored by the idea of selling but in my boredom I found that daydreaming amongst objects of affection was very nice."[2]

In *Five Feet of Colorful Tools* a single board hung with thirty-two individual implements has been mounted on an unprimed canvas, as if relocated from the wall of a hardware store. The canvas is empty save for several drips and a frieze of paint-sprayed tool silhouettes that play off the solidity of their three-dimensional counterparts. The tools are painted in colors of the rainbow, and the total visual effect is a fanciful and animated parade of Dine's "objects of affection."

Less fanciful and perhaps more philosophical is the relationship Dine set up between real objects and their representations, between the tools and their sprayed silhouettes. The distinction between the plane of representation — the canvas — and that of reality — the board and tools — is emphasized by the refusal of the two to line up. This may also suggest a temporal separation, with the silhouettes reading as vague outlines of memories of tools past.

Below this densely packed register of colorful tools the vast expanse of natural unprimed canvas provides visual relief from the conspicuous materiality of the objects and evokes the contemplative, seemingly metaphysical, canvases of Color Field painters like Mark Rothko, for example. Nonetheless, allusions to intangible realms are kept in check by the physical evidence of the force of gravity, whose downward pull is marked by tools held in suspension and by occasional paint drips.

A tool is designed as an extension of the human hand, intended to assist in the creation of things. Unlike the

Installation view, *New Realists*, Sidney Janis Gallery, New York, November–December 1962.

Jim Dine. Untitled (Pliers) from *Untitled Tool Series*. 1973. Graphite and charcoal on paper, 25 ⅝ x 19 ¾" (65.1 x 50.2 cm). The Museum of Modern Art, New York. Gift of the Robert Lehman Foundation, Inc.

Jim Dine. Untitled (Dry Wall Hammer) from *Untitled Tool Series*. 1973. Graphite and charcoal on paper, 25 ⅝ x 19 ¾" (65.1 x 50.2 cm). The Museum of Modern Art, New York. Gift of the Robert Lehman Foundation, Inc.

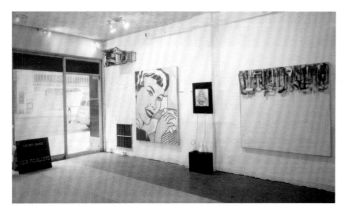

painter's tool — a paintbrush — however, hammers, saws, and drills have the capacity to cleave, sever, and puncture; they can serve not only to construct, in other words, but also to destroy. Dine's thirty-two suspended tools, so handily arranged, are thus potential threats to the unprotected, vulnerable canvas and, as has been pointed out in relation to a similar work, are "like an invitation to understand all constructive energy as containing its opposite."[3]

In delivering ordinary objects from their everyday settings, Dine often gives them life. This animation of the inanimate is evident not only in the early 1960s but in Dine's return to the tool theme in the 1970s, most notably in his *Untitled Tool Series* (1973). In each of the seven graphite and charcoal drawings in the series, a single tool is isolated and rendered

with the precision and detail of academic studies. Each stands erect and takes on a singular personality; Pliers, for example, appears to rear its head, while Dry Wall Hammer poses nobly. These uncanny "portraits" may confound one's imagination, and even haunt one's nightmares. Envisioned on a grand scale, as implied by the low horizon line, these late tool drawings not only suggest the monumentality of the everyday (in the manner of Oldenburg's oversized constructions, for example), but also an immense destructive force with strong sexual connotations. A recurring theme in Dine's work, tools are portrayed — in paintings, drawings, and assemblages — as meaningful devices capable of provoking interpretations ranging from the personal to the philosophical to the uncanny. — L.J.

Conventional still-life painting often presents viewers with visually enticing and appetizing images of consumables — apples, pears, oysters, and half-peeled lemons, for example. While the title of Dine's *Still Life Painting* may lead one to expect similarly appealing fare, the painting presents instead a plastic glass full of slightly used toothbrushes; any promise of gustatory pleasure is, like the bristles of the toothbrushes, choked with dried paste and dust. Nonetheless, Dine shares with traditional still-life painters an interest in objects drawn from domestic life. In *Still Life Painting* he isolated the toothbrushes against a black backdrop, which, when combined with a plastic cup and metal holder, functions as a secular altar for the veneration of these common objects. And, as in earlier examples of the still-life genre, there is a conscious display of various textures; the glint of the metal holder plays off the matte of the black surface, which in turn contrasts with the colorful array of toothbrushes.

While Dine's title evokes a long-standing tradition, the work may also be related to Marcel Duchamp's subversive use of the "found object" early in the twentieth century.

Jasper Johns. *Painted Bronze*. 1960. Oil on bronze, 13 ½ x 8"
(34.3 x 20.3 cm) diameter. Collection the artist

Representing the commonplace, Dine's toothbrushes in the 1960s, like the infamous urinal Duchamp exhibited in 1913, challenged prevailing notions of high art. What Cubism was for Duchamp, theories concerning contemporary abstract art were for Dine. In the wake of Abstract Expressionism, the notion developed that painting's subject matter should reflect its essential formal components; in other words, painting should be about paint (and thus nonrepresentational) and its support (and thus two-dimensional). The limits of this concept of pure painting may have provoked Dine to sully the surface of his black canvas with gray marks suggestive of dust or footprints, as well as to attach specifically non-art-related sculptural elements. In addition, the plastic glass is pitted, and the brushes and bristles are covered with grime, thereby negating any sense of artistic "hygiene."

Still Life Painting also evokes the work of Jasper Johns, whom Dine saw frequently in 1962. In 1960 Johns had taken a Savarin coffee can filled with paintbrushes soaking in turpentine from his studio and cast it and its contents in bronze. The result, *Painted Bronze*, shown here, was an expression of Johns's life in the studio, a self-portrait of sorts. In *Still Life Painting* Dine performs a similar act by packing twelve toothbrushes into a plastic glass. The deposits of dried paint found in their bristles suggest further parallels with *Painted Bronze*: these toothbrushes, Dine not so subtly hints, have also been used as paintbrushes, which, like the traditional artists' tools arrayed in Johns's Savarin can, bear traces of wear and tear on their surfaces. Distinct from the just-off-the-shelf newness simulated in the clean "packaging" of Warhol's *Campbell's Soup Cans*, *Brillo Box*, or other prototypically Pop products, for example (pages 109, 115), the overall appearance of *Still Life Painting*, like *Painted Bronze*, implies a history of use. While both toothbrushes and paintbrushes are personal items with intimate connotations drawn from private life rather than from the public realm of commercial imagery, each have implications as distinct as their traditional functions. In *Painted Bronze* Johns presents the tools of his trade as emblematic of his life as an artist. Perhaps as a parody of this somewhat romantic representation of studio life, Dine offers his toothbrushes as mundane alternatives, underscoring their prosaic qualities by presenting them as real objects, deteriorating with time, not as art objects cast in bronze for perpetuity.

Still Life Painting is one of several bathroom-related paintings Dine created in the early 1960s and was included in the artist's 1963 show at the Sidney Janis Gallery. Dine's interest in domesticity and his partiality for hygienic space was observed by Öyvind Fahlström in his description of this exhibition: "Dine . . . focused on that primeval unit of society, the family. . . . Here the room-elements project the home. . . . For living and eating there is one room or suite of rooms. For children's play there are four rooms. For cleanliness there are three showers and five bathrooms."[1] One art historian noted: "Not since Degas and Bonnard has this private realm been so minutely scrutinized,"[2] referring not only to Dine but to any number of other Pop artists. Yet Dine did not approach the private space of the bathroom as a voyeur, nor did he depict it in the clean-lined, "antiseptic" style generally associated with Pop art. Instead, in *Still Life Painting* he thwarted expectations of cleanliness (as depicted in commercial advertising, for example) by allowing chrome to corrode and scum to crust against a backdrop more suggestive of a doormat than a glistening medicine cabinet or polished tile splash. In so doing, Dine addressed the myths not only of "Mr. Clean" but of "pure" modernist painting through a language of use and of the less-than-sanitary. — L.J.

Jim Dine.

Untitled Black Suit Picture. 1964.

Three wood boxes with incised plexiglass, containing oil on paper, fabric suit, metal hook, and metal clothes hanger, overall 6' x 6' 1 ½" x 3 ⅛6" (182.8 x 186.6 x 7.8 cm).

Gift of Douglas S. Cramer

Clothing was one of the predominant themes of Jim Dine's work in the early 1960s. His 1962 show at the Martha Jackson Gallery featured works that incorporated suspenders, shoes, hats, and neckties. At the Sidney Janis Gallery in 1964, he displayed a number of suit pictures (similar to *Untitled Black Suit Picture*) and introduced the painted robe imagery that would, from then on, become the sole clothing item in his artistic repertoire. Shirt sleeves, pants legs, and especially ties were recurring collage elements in Robert Rauschenberg's Combines. But Dine's shoes, ties, and suits were not pieces of a whole in an allover collage; rather, they were isolated centrally as icons, often protruding from, or, as in the case of *Untitled Black Suit Picture*, suspended in front of the painted surface. Dine once remarked: "I always have to find some theme, some tangible subject matter besides the paint itself . . . I always have to find something to hang the paint on."[1]

In their function as a second "skin," clothes at once mark the absence of the body and suggest its presence. For this reason, shoes, ties, and hats often serve as tangible stand-ins for lost love-objects. In the case of *Untitled Black Suit Picture*, however, the absent (but suggested) body is most likely that

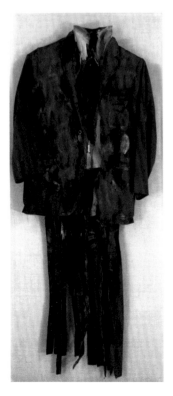

Jim Dine. *Green Suit*. 1959. Oil and cloth, 62 x 24" (157.5 x 61 cm). Collection the artist

of the artist, who first began using suits as surrogates in his 1959 *Green Suit*, shown here. Other than providing hints as to his approximate size and stature, however, these works tell us little about Dine's physical appearance and more about his shifting perceptions of his role as an artist. *Green Suit* and *Untitled Black Suit Picture* (1964), despite their shared iconography, are strikingly different visually and reflect the artist's ongoing engagement with art-world debates about the nature of painting. The 1959 ensemble of paint-soiled coat, shredded pants, and phallic protuberance, for example, seems tailor-made to "fit" a particular kind of artist: one who works in an overtly painterly style, and whose creative potency is seen as directly related to notions of masculine prowess. This ironic portrayal of the Abstract Expressionist artist was characteristic of Dine's early assemblages and his Happenings; both were made at a moment when artists such as Jackson Pollock and Willem de Kooning were widely accepted as America's greatest painters.

Five years later, when Dine painted *Untitled Black Suit Picture*, the predominant art movements were Pop, Minimalism, and hard-edge and post-painterly abstraction — all distinct, but, generally speaking, "cleaner" than Abstract Expressionism. A new type of artist had also emerged. No longer an isolated and angst-ridden outsider, the artist of the 1960s was, in general, social, intellectual, and perhaps a bit of a dandy — someone who might wear a brand-new, double-breasted fine wool suit like the one encased in *Untitled Black Suit Picture*. Admired by many Pop artists, Marcel Duchamp, who "always looked his Sunday best,"[2] may have provided a fashion alternative in addition to an alternative conception of art. Dressing well was "a way of countering expectations," Ed Ruscha has observed. "We were used to paint-splattered pants and all of that, and here [Duchamp] would always be in a suit and tie."[3]

Shifting from sartorial issues to those of pictorial structure, the tripartite rectilinear display and perspectival diagrams etched in plexiglass in *Untitled Black Suit Picture* are clear references to the new "lines" of contemporary art. Proportionally related 3-to-2-to-1, the dimensions of the individual cases evoke the mathematical rigor of Minimalism. And the subtraction of orthogonals from the plexiglass panels left to right suggests the changing conceptions of pictorial space from the Renaissance to the modern

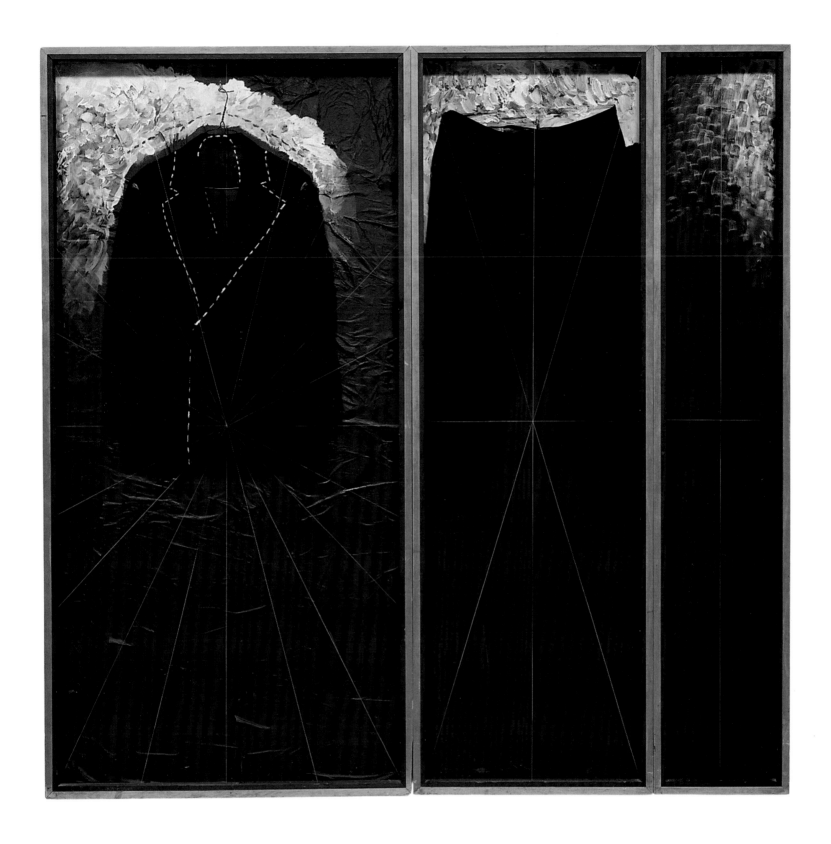

era. (The spiderweb of lines verging on a vanishing point seen in the two left panels indicates recession into space, while the horizontal and vertical axes that appear on the right indicate only two dimensions; the former seems typical of the Renaissance conception of a picture as a window, while the latter corresponds with the modernist notion of picture as surface.) The highly reflective plexiglass further heightens the viewer's awareness of the picture's surface, making it difficult to see beyond one's own reflection and

into the case where, above the coat and pants, traces of gestural brushstrokes create a halo effect. Between this painted background surface and the series of etched linear diagrams hangs the artist's suit. Encased within a calculated construction, yet surrounded by loosely brushed strokes of paint, the placement of Dine's surrogate self suggests that the artist remains an integral presence within any and all forms of art making, evidence, perhaps, of his residual Abstract Expressionist side. — L.J.

In 1966 the great proletarian cultural revolution began in the People's Republic of China. Initiated by Chinese Communist leader Mao Tse-Tung, a primary objective was a nationwide purge of capitalists. The image of Chairman Mao in Jim Dine's *Drag — Johnson and Mao*, made the following year, casts a sideward glance at the figurehead of capitalist America, President Lyndon B. Johnson, who committed American troops to fight against the Chinese-supported Communist insurgents in Vietnam in 1965. Archenemies on the political world stage, Johnson and Mao would seem to make an odd couple. In Dine's dual portrait, however, the defenders of capitalism and communism find a literal common ground.

Viewed in the context of Dine's work as a whole, *Drag — Johnson and Mao* is somewhat of a departure. Both before and after Dine made this work, his subjects were primarily everyday objects, often imbued with personal connotations. The political turmoil and social crises of the mid- to late 1960s, however, pushed Dine and other artists to expand Pop iconography into the realm of politics. Earlier in the decade, Rauschenberg had combined images of well-known political figures such as Johnson with other imagery in his layered prints. Like Rauschenberg's prints, Dine's portrait of Johnson and Mao is based on reproductions found in the mass media, but the media's surrounding barrage of imagery is eliminated. Adopting a strategy from Warhol, Dine isolated the faces of his subjects to emphasize their status as icons. Enlarged and then transferred to the paper support via a process of photoetching, Johnson and Mao became larger than life, like billboards, reflecting the magnitude of their political power and/or its propagandistic display. Johnson's public recognition in the United States was unlike Mao's status as an idol in China, but the American president's head, juxtaposed with Mao's, functions as an emblem of capitalism. At the same time, a few cosmetic touches applied to the eyes, cheeks, and lips with a stencil suffice to travesty the devices of political propaganda and compromise the aura of masculine authority projected by the original images. In a nonpartisan spirit Dine "paints" the faces of Johnson and Mao, fashioning drag queens and cabaret posters out of heads of state. In *Drag — Johnson and Mao* the subjects are presented as featured stars in a political burlesque: Mao's sideward glance and passive demeanor suggest that he is the straight man to Johnson. Simultaneously, these masklike disembodied faces call attention to the disguises regularly adopted in the arena of political posturing.

For his image of Mao, Dine appears to have used the photograph that appeared in Quotations from Chairman Mao — also known as the "little red book" — published in English in 1966. This same image was used by Warhol in his 1972 Mao Tse-Tung series, as shown here. As a result of the etching process, however, Dine's image of Mao is reversed. (The Chairman's distinguishing mole, here daintily covered by a heart, should appear on the left side of his chin.) By repeating the shape of the face Dine emphasized affinity, rather than opposition, between the two world leaders. Embodying power and national identity, the capitalist Johnson and the communist Mao appear in drag as actors whose antic performances affect a world audience. — L.J.

Drug- 1965 to you dear

Öyvind Fahlström

(Swedish, born Brazil. 1928–1976. In Sweden 1939–61; to U.S.A. 1961)

Öyvind Fahlström.
Eddie (Sylvie's Brother) in the Desert (Collage). 1966.
Variable collage: sixteen movable serigraphed paper cutouts over serigraphed cutouts pasted on painted wood panel, 35 ¼ x 50 ½" (89.5 x 128.1 cm).
The Sidney and Harriet Janis Collection

Öyvind Fahlström once described *Eddie (Sylvie's Brother) in the Desert (Collage)* as an "erotical-political parable on USA and the world."[1] As the work's title suggests, however, there is another layer to the tale. "Sylvie" refers to the French pop singer Sylvie Vartan and "Eddie" to her brother, a band leader and pop composer, who is shown in the upper-middle part of the picture upside down and wearing a white tuxedo and sunglasses. The setting is the desert, designated by muted yellow areas featuring pyramids, date palms, and villages along with other less neutral images of industrial equipment and various human figures maliciously tortured.

Why, exactly, Eddie is in the desert is unclear. Characteristically, Fahlström hinted at a narrative, rather than describe it. Like a comic strip without text bubbles, *Eddie (Sylvie's Brother)* invites the viewer to "read" his or her own story through the juxtaposition of varied images. In 1966, however, when Fahlström made this picture, the desert's most immediate reference was to North Africa and Algeria's

Öyvind Fahlström. Study for *Eddie (Sylvie's Brother) in the Desert*. 1966. Pen and ink and pencil on paper, 12 x 9" (30.4 x 22.7 cm). The Museum of Modern Art, New York. The Sidney and Harriet Janis Collection

barely four years of existence independent of French colonial rule. By placing Eddie, a well-known French entertainer, in a landscape evocative of the bitter struggles of a recent anti-colonial war, Fahlström symbolically embroiled pop culture with global politics. While Fahlström, like many Pop artists, embraced recognizable, everyday imagery to escape the hermeticism of abstract painting, what his "brand" of Pop made visible were not soap pads and celebrities, but the grotesque world of contemporary political events.

Executed in an illustrational, cartoonlike style, Fahlström's images, unlike Lichtenstein's, are not directly derived from comic books. Instead, they are drawn in a style particular to underground comics with a political edge, such as those in *Mad Magazine*. What may initially appear as innocent cartoon drawings are, upon closer observation, often violent, perverse images. In the upper left-hand corner, for example, five "bubbles" contain scenes of animal torture: in one, a string of tin cans has been attached to a dog's tail; in another, a figure taunts two monkeys with a whip. Equally brutal are the various images of human bodily orifices stuffed with foreign objects that appear throughout the picture. Directly underneath the scenes of animal torture, for example, is a row of buttocks, each penetrated successively by an oil rig, test tube, and lightning bolt. By isolating body parts rather than representing entire figures, Fahlström emphasized the act of penetration and implicitly equated it with invasive militaristic and economic strategies. This point is most directly illustrated in the image of a human mouth stuffed with a phallic American flag at the lower left.

Eddie (Sylvie's Brother) is a collage of printed elements, cut from one of Fahlström's own prints. Like the images of his Pop colleagues, Fahlström's simulate the look of the popular media; they are flat, brightly colored, and often repeat serially. But his use of the recurring image, as in this collage's aligned tombstones, most often evokes notions of mass death rather than mass production.

The populist potential of mechanical production appealed to Fahlström much as it had attracted the Berlin Dadaists immediately after World War I. Their pronouncements are reinvigorated, some four-and-a-half decades after the fact, in Fahlström's *Manifestos* of 1966: "Painting, sculpture, etc., today represent the most archaic art medium, depending on feudal patrons who pay exorbitantly for uniqueness and

fetish magic. . . . It is time to incorporate advances in technology to create mass-produced works of art, obtainable by rich or not rich."[2]

Fahlström's populist aims also led to his conception of art as a game. In this work, for example, sixteen of the images are mounted on a spongy material and are movable. These "variable" paintings and collages, as Fahlström described them, invite viewers to rearrange their component elements. In his essay "Manipulating the World," Fahlström explained: "The finished picture stands somewhere in the intersection of paintings, games (type Monopoly and war games) and puppet theater. . . . The role of the spectator as a performer of the picture-game will become meaningful as soon as these works can be multiplied into a large number of replicas, so that anyone interested can have a picture machine in his home and 'manipulate the world' according to either his or my choices."[3]

Eddie (Sylvie's Brother) remains always open to change, its meaning never fixed. Nonetheless, the viewer is restricted by the givens of the playing field and its filmic, action-adventure images of violence, destruction, and sex. As Dore Ashton has pointed out: "Grade B movies and television schmaltz also come in for oblique criticism in [Fahlström's] serialized sagas such as *Eddie in the Desert*. Eddie's adventures (and either Eddie or one of his friends looks suspiciously like Mao Tse-Tung) are linked with those of Ian Fleming, which in turn are linked with Fahlström's favourite theme, the Cold War."[4] Playing his own special game, Fahlström manipulated popular fiction to reveal what he saw as the malevolent comedy existing within a sometimes self-deluded society. — L.J.

Öyvind Fahlström.

Notes 4 (C.I.A. Brand Bananas). 1970.
Synthetic polymer paint and pen and ink on paper,
16 ⅝ x 14" (42.2 x 35.3 cm).
Mrs. Bertram Smith Fund

Plan for World Trade Monopoly. 1970.
Synthetic polymer paint, pen and ink, colored pencil,
and pasted paper on paper, 16 ⅝ x 14" (42.2 x 35.3 cm).
Mrs. Bertram Smith Fund

Drawing was an essential process in the genesis of the symbols and characters that populate Fahlström's work. Filling the page top to bottom, left to right, in *Notes 4 (C.I.A. Brand Bananas)* and Plan for *World Trade Monopoly*, the artist suggested preliminary sketchbook drawings. While both are, in fact, related to other works, they also function independently. By the late 1960s, the political content apparent in works such as *Eddie (Sylvie's Brother) in the Desert (Collage)* had become more pronounced. As indicated by its parenthetical title, *Notes 4 (C.I.A. Brand Bananas)* addressed the economically motivated American presence in Third World banana-growing countries. In Plan for *World Trade Monopoly*, Fahlström tackled the issue of Western capitalist trade on a global scale.

Fahlström wanted to make art that would arouse political awareness. Taking the failure of his predecessors to heart, he fashioned a style formally and theoretically distinct from the overtly didactic and propagandistic styles of Social Realism. Rather than paint heart-wrenching portraits of the poor, or heroic representations of the working class, Fahlström employed a visual language of signs and systems that, he hoped, would encourage the viewer to arrive at his or her own conclusions. At the upper left in *Notes 4*, a skull and crossbones, the international symbol for poison, appears — its aspect only slightly modified by the substitution of a banana and a Coca-Cola bottle for the traditional bones. Nasty and comic at once, the intersection of jungle fruit and American cultural icon none too subtly urges its beholders to reflect on the toxic implications of trade agreements to the welfare of Third World countries. Another banana at the upper right lies in a pool of blood. The fact that all the bananas are green relates not to their state at export, but rather to Fahlström's color-coding system, which designates green as representative of Third World countries and blue as the United States. Other green "exports" include marijuana and worker ants (low-wage labor?) filing dutifully to the north. In the lower-middle part of the page, a blue-suited American enjoys a smoke reclining atop a group of seated "suits," all supported on the bowed backs of green people.

Like Lichtenstein, Fahlström derived his illustrational style from comic strips. Whereas Lichtenstein drew almost exclusively from mainstream comic books, Fahlström appropriated the style and often sordid antics of the underground strips found in *Mad Magazine* and *Zap Comix*. His use of scatological humor to caricature the political opposition is a tradition as old as the genre itself. To take but one example, in the lower right-hand corner of *Notes 4*, a rocket is launched from the anus of a nude figure, very likely a mean send-up of the funneling of trade profits into armaments. Juxtaposing his unsettling imagery in an allover composition, Fahlström emulated a hieroglyphic tablet. In fact, Fahlström's university studies were in archeology and art history, and through them he became acquainted with pre-Columbian codices and calendar hieroglyphs. Fahlström's pictograms, like hieroglyphs, are autonomous but also related to the whole and, displayed as they are in a nonhierarchical composition, could be read as "democratic."[1] From another point of view, the crowded and apparently illogical display of images evokes the experience of being bombarded by headlines, news flashes, and advertising in the media age.

Fahlström's commitment to viewer participation led to his notion of games as art. In discussing his Monopoly game series, Fahlström explained: "They deal with world trade, world politics, the left and right in USA, Indochina, and CIA vs. Third World liberation forces. They can all be played, according to the rules written on the paintings, as variants of the classical Monopoly game, which is of course the game of Capitalism: a simplified, but precise presentation of the trading of surplus value for capital gains."[2] In Plan for *World Trade Monopoly* the four players are the three major economic powers — West Germany, Japan, and the United States (dealing in guns as one player, in dollars as the other). They occupy the four corners of the game board while Communist countries (designated by yellow-red colors) and Third World countries (green-brown) are sandwiched in between. The color of the country on which you land determines your overall trading patterns, which are, however, subject to such chance impositions as adjustments for foreign taxes, political unrest, and multinational mergers. Playing Fahlström's games or piecing together meaning from his pictographic puzzles, the viewer/player becomes involved in a "miniature political psychodrama."[3] — L.J.

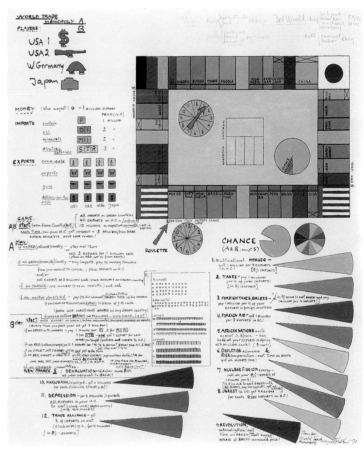

Robert Indiana

(American, born 1928)

Robert Indiana.
Moon. 1960.
Assemblage: wood beam with iron-rimmed wheels, white paint, and concrete, 6' 6" (198.1 cm) high, on base 5 x 17 ⅛ x 10 ¼" (12.7 x 43.5 x 26 cm).
Philip Johnson Fund

When asked in 1961 if his sculpture *Moon* had any special personal, topical, or symbolic significance, Indiana replied: "Topically this piece may have something to do with Man's intrusion on Orb Moon — an heraldic stele, so to speak, but a definite statement is out of keeping with the times, therefore let it stand as 'A Formal Study in Wood, Gesso and Iron.' "[1]

Weaving together allusions to current events, the classical past, and a tongue-in-cheek jibe at contemporary art theories, the artist's words capture *Moon*'s uncanny quality, its

peculiar blend of a sense of immediacy combined with that of déjà vu. In the years immediately preceding the completion of *Moon*, America's space program was created, and President John F. Kennedy subsequently vowed to put a man on the moon before the decade's end. The four white letters stenciled at *Moon*'s summit connect the work to this particular moment in American aerospace history. The four white spheres that appear below these letters depict the moon's various phases, evoking the repetitive nature of lunar cycles and mankind's age-old fascination with the moon. Topicality meets timelessness, a combination essential to this and Indiana's other early constructed works.

Robert Indiana. *French Atomic Bomb*. 1959–60. Assemblage: polychromed wood beam and metal, 38 ⅝ x 11 ⅝ x 4 ⅞" (98 x 29.5 x 12.3 cm). The Museum of Modern Art, New York. Gift of Arne Ekstrom

Robert Indiana. *Law*. 1960–62. Assemblage: painted wood and metal, 44 ⅛ x 10 ⅞ x 3 ⅛" (111.9 x 27.6 x 7.8 cm), including wood base 3 ¼ x 10 ¾ x 10 ⅝" (8 x 27.2 x 26.7 cm). The Museum of Modern Art, New York. Gift of Philip Johnson

Referring to *Moon* as a "stele" or "herm," Indiana conjured associations with classical antiquity and with stoic sentinels standing guard at tombs or roads. "Stele" is a word of Greek origin for column. In ancient Greece and Rome, "herms" were quadrangular pillars of stone, usually topped by the head of Hermes, that served to mark streets and crossroads and often functioned as guardian figures. Two other works by Indiana from this period, *French Atomic Bomb* and *Law*, share *Moon*'s upright orientation and rectilinear contours. Owing to their broader and shorter dimensions, however, they have a more slablike quality and, because of this, are less powerfully anthropomorphic than *Moon*. The square apertures that pierce *Moon*'s surface at regular intervals suggest vertebrae, while the four wheels attached to each side of the wood column appear as static appendages with the potential for whirling movement. Carefully poised, ready to spring into action, they add an animate dimension to *Moon*'s inanimate, totemic form.

Indiana used weathered and rusted materials to point to another sort of history, the kind inherent in found objects marked by age and previous use. In 1954 Indiana arrived in New York City, and in 1956 he rented a loft on the waterfront, joining a growing community of artists living and working at the tip of Manhattan on Coenties Slip. Among his neighbors were the painters Ellsworth Kelly, Agnes Martin, and Jack Youngerman; Jasper Johns and Robert Rauschenberg lived around the corner on Pearl and Front streets. Indiana has often credited Kelly's hard-edged, organic geometries as a major influence during these years. Johns's target imagery and use of stenciled letters and numbers must have had an impact upon his work as well. Equally important, however, the Slip provided him with a rich visual array of cost-free materials. Like the sculptor Constantin Brancusi decades before him, Indiana salvaged old wood beams, along with boards, rusted metal plates, and other items from demolished structures, prizing them for their aged surfaces and patinas evoking time, place, and change.

Describing his use of found objects in *Moon*, Indiana wrote: "The technique, if successful, is that happy transmutation of the Lost into the Found, Junk into Art, the Neglected into the Wanted, the Unloved into the Loved, Dross into Gold, hence: ALCHEMY.... Otherwise, the technique might be described as 'latter-day craft on early-day craft.' "[2]

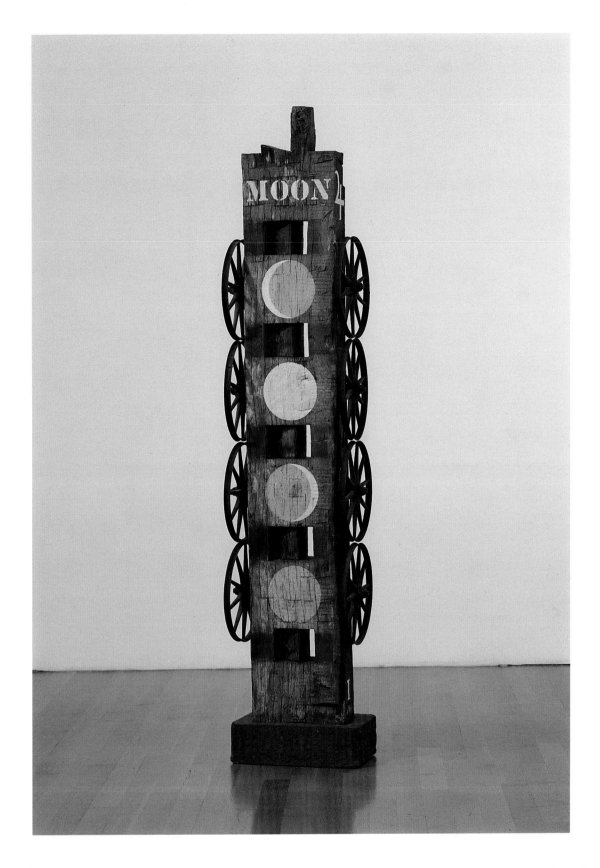

Leaving intact the wood beams he scavenged, Indiana transformed them by adding other found elements (such as metal wheels) or by covering carefully circumscribed surface areas with thinly painted, white stenciled letters, numbers, and circular shapes ("latter-day craft"). *Moon* was the first work by Indiana to be included in a major museum exhibition: it was shown at The Museum of Modern Art in 1961 as part of *The Art of Assemblage* and was purchased for the collection at the same time as his painting *The American Dream, I*

(page 45). Although the subdued tonalities and weathered materials of *Moon* strike a different note from the hard, bright colors of Indiana's "sign" painting and from the style that sealed his association with Pop, the artist has often pointed to the importance of his early constructions for all his subsequent production. Words first appeared in his work on their timeworn surfaces, while the narrow format of the beams encouraged a terse economy of language akin to that of directional or commercial signs. — A.U.

Robert Indiana.
The American Dream, I. 1961.
Oil on canvas, 6' x 60 ⅛" (183 x 152.7 cm).
Larry Aldrich Foundation Fund

Words punctuate the surfaces of Indiana's canvases and, figuratively speaking, surround them as well. The artist once considered a career as a poet and, beginning in the early 1960s, his verbal statements, both written and oral, have supplemented and complemented their painted counterparts, playing a pivotal role in determining the various interpretations and meanings ascribed to his works. According to the artist, the subject of *The American Dream, I* is "obviously A★M★E★R★I★C★A★N★, and loaded with 'personal,' 'topical,' and 'symbolic' significance, namely all those dear and much-traveled U.S. Routes: #40, #29, #37 (on which I have lived) and #66 of U.S. Air Force days; those awful five bases of The American Game; the TILT of all those millions of Pin Ball Machines and Juke Boxes in all those hundred of thousand of grubby bars and roadside cafes, alternate spiritual Homes of the American; and star-studded Take All, well-established American ethic in all realms — spiritual, economic, political, social, sexual and cultural. Full-stop."[1]

Linking the painting's bright brash colors, stenciled numbers and letters, and ricocheting and "ping-ponging" visual effects to the signs of America's highways and byways and to popular forms of entertainment found in roadside cafes, Indiana's words were quickly seized upon by critics and commentators seeking to make sense of a new, as yet unnamed, movement that would come to be known as Pop.

In subject matter, style, title, and theme *The American Dream, I* proved key to early definitions of Pop. Referring to an article by Sidney Tillim that began with quotes from Indiana's statements concerning this painting, Barbara Rose wrote: "Tillim . . . was the first to correctly identify the subject matter of new Dada as the American Dream. Rosenquist's billboard fantasies, Lichtenstein's cartoons, Robert Indiana's pinball machines, Wesselmann's nostalgic collages, Rauschenberg's coke bottles and Johns's American flags . . . illustrate a longing for and recognize the betrayal of that unobtainable dream."[2] Indiana, too, underscored the connection between the American Dream and Pop. Responding a few months later to an interviewer's question, "What is Pop?" he replied: "Pop is everything art hasn't been for the last two decades. It is basically a U-turn back to a representational visual communication . . . a re-enlist-

ment in the world. . . . It is the American Dream."[3] In *The American Dream, I* Indiana combined crisply contoured, clearly legible words and images in a format reminiscent of the presentational structures and designs of commonplace signs.

Of all the artists who would come to be associated with the Pop art label, Indiana was the one who invariably insisted on the "American-ness" of his work. In 1958, he changed his surname from Clark to Indiana, emphasizing his American identity by conflating his own personal history with that of his birthplace and home state. While proclaiming, "I am an American painter of signs charting the course. I would be a people's painter as well as a painter's painter,"[4] Indiana consistently wove private meanings and autobiographical references into the seemingly public language of signs, undermining their communicative clarity. At the same time, he cast a critical light on his subject, the American Dream. The word TILT is, after all, pinball jargon for cheating, and to TAKE ALL suggests surrender to the voracious appetites and conspicuous consumption caused by greed. *The American Dream, I* is the first of a series of paintings, some far more caustic in tone, on a theme that would preoccupy Indiana for a number of years.

Indiana drew attention to his use of stencils "as an 'art' technique" in *The American Dream, I*. Rather than citing the high-art precedents provided by the Cubists or Jasper Johns, Indiana connected stenciling with "the craft of the sign-painter, particularly of that lowest breed who enhances the sides of crates, the cheapest shops, litter baskets, dust bins and steamer trunks."[5] In this way he set into play the tension between high and low, art and craft, that characterizes Pop. Like the wood beams he used in his constructions, the stencils Indiana employed were found in buildings on Coenties Slip. They contributed to the anonymous appearance of his canvas surfaces, so different, as the artist remarked, "from those rather oily, messy jobs of the 1950's."[6] Identifying himself early on with what he described as "hard-edge Pop,"[7] Indiana fulfilled Robert Rosenblum's criteria for an "authentic Pop artist," with a coincidence of "style and subject," while at the same time bridging the gap between Pop and contemporary abstract art.[8] — A.U.

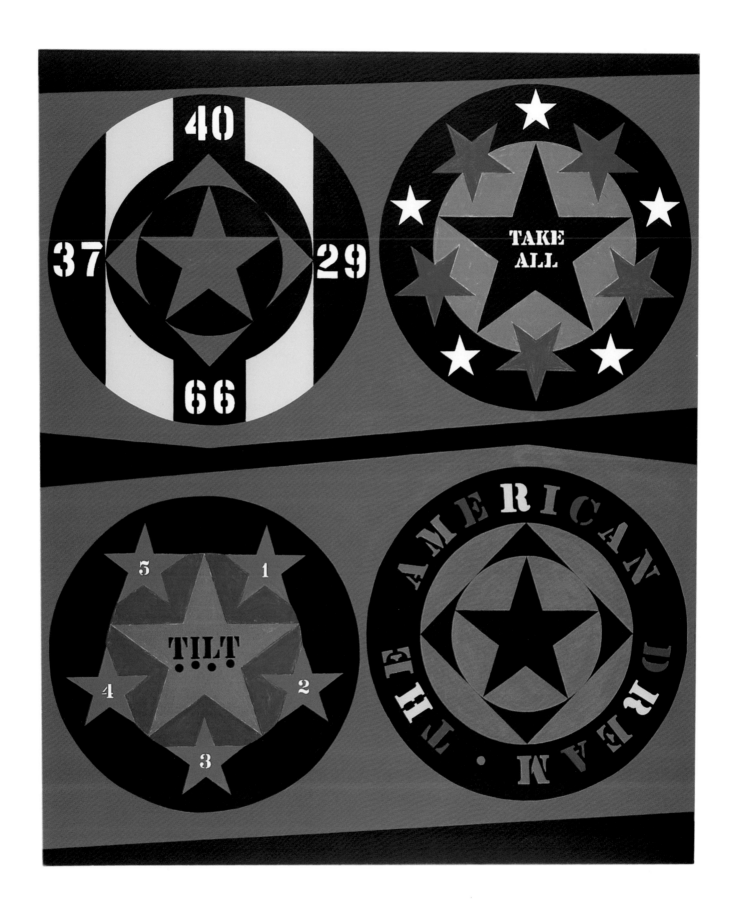

Jasper Johns

(American, born 1930)

"Stars and Stripes," "Red, White, and Blue," "Star-spangled Banner," and "Old Glory" are affectionate names for the quintessential emblem of American patriotism that Jasper Johns refers to simply as *Flag*. The matter-of-fact title complements a matter-of-fact image of the American banner that (rather than waving majestically in the wind) fills the picture plane completely. As described by artist Robert Morris in 1969: "The Flags were not so much depictions as copies. . . . Johns took the background out of painting and isolated the thing. . . . What was previously neutral became actual, while what was previously an image became a thing."[1]

"One night I dreamed that I painted a large American flag," recounted Johns, "and the next morning I got up and I went out and bought the materials to begin it. And I did."[2] *Flag* represents the artist's first exploration of the motif and was subsequently followed by a series of paintings and prints, including *Flag I*, *Flag II*, and *Flag III*, shown here. In addition to its blatantly American subject matter and subsequent serial reproduction, the expressive clarity of *Flag*, like that of his Targets and Numbers, has led many to identify Johns as a harbinger of Pop art. Others, in particular,

Jasper Johns. *Flag I*. 1960. Lithograph, printed in black, 22 ¼ x 30" (56.5 x 76.2 cm). The Museum of Modern Art, New York. Gift of Mr. and Mrs. Armand P. Bartos

Jasper Johns. *Flag II*. 1960. Lithograph, printed in white, 23 ⅞ x 32 ⅟₁₆" (60.7 x 81.5 cm). The Museum of Modern Art, New York. Gift of Leo and Jean-Christophe Castelli in memory of Toiny Castelli

Jasper Johns. *Flag III*. 1960. Lithograph, printed in gray, 22 ⅟₁₆ x 30 ⅛" (57 x 76.5 cm). The Museum of Modern Art, New York. Gift of the Celeste and Armand Bartos Foundation

critics of the late 1950s and 1960s lacking historical distance, perceived his use of everyday imagery as hearkening back to the work of Marcel Duchamp and invented the label "neo-Dada."[3] More recently, others have focused on the painterly aspects of Johns's representations of common objects, stressing their transitional — as opposed to strictly predictive — position between Abstract Expressionism and Pop. In fact, Johns's *Flag* continually defies classification by presenting viewers with compelling ambiguities.

One of the first ambiguities commentators grapple with when confronted with *Flag* is its confluence of image and support: "Is it a flag, or is it a painting?" asked Alan Solomon in 1964.[4] "There is a difference, of course," explained Fred Orton. "To make a painting of a flag is not the same as making one with paint. The former involves the artist in representation and illusion; the latter means dispensing with such things. . . . Johns blurred the distinction between 'making a painting of a flag' and 'painting a flag.' "[5] This distinction is further blurred by Johns's decision to construct Flag in three panels — one for the canton, one for the stripes to the right of the canton, and one for the stripes on the lower half of the canvas — following the same procedure used in assembling the standard canvas flag. As in a real flag, each of the forty-eight stars was cut out and applied individually.

Structural similarities aside, Johns's *Flag* is very much a painting. According to Johns: "The painting of a flag is always about a flag, but it is no more about a flag than it is about a brushstroke or about a color or about the physicality of paint, I think."[6] In contrast to the visual immediacy of *Flag*'s subject matter, the surface reveals the painstakingly slow process Johns used to build up the image. As recounted by the artist, *Flag* represents his first use of encaustic: "It's a very rotten painting — physically rotten — because I began it in house enamel paint, which you paint furniture with, and it wouldn't dry quickly enough. And then I had in my head this idea of something I had read or had heard about: wax encaustic. In the middle of the painting I changed to that, because encaustic just has to cool and then it's hard and you don't blur it again; with enamel you have to wait eight hours. If you do this, you have to wait eight hours before you do that. With encaustic you can just keep on."[7]

Unlike oil or enamel paint where each stroke dissolves

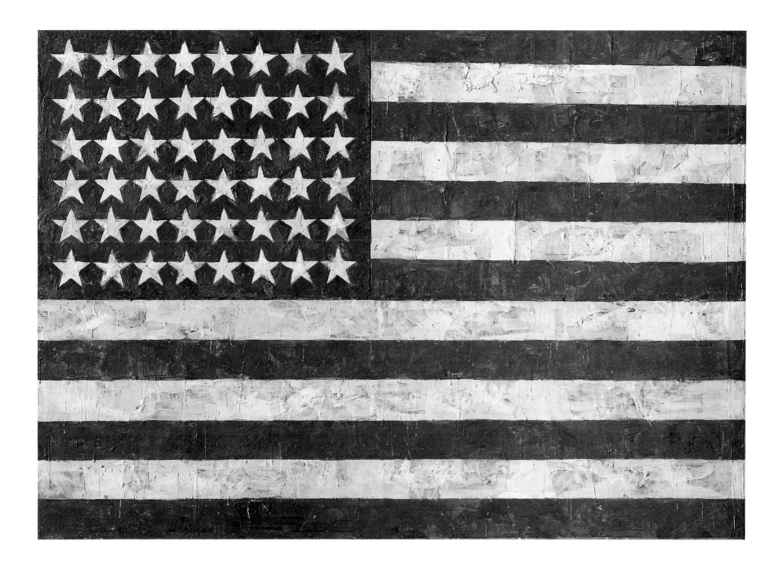

into every other and can be reworked continually, wax encaustic cools and is thus fixed, leaving a cumulative record of every blot, smear, and drip in the painting's development. Behind this thin membrane of wax, pieces of cut-and-torn newspaper are affixed in a seemingly haphazard manner, yet, like the varied marks in encaustic wax, they remain confined to their respective registers or stripes. Gesture within confines characterizes the painterly process of an artist who claims to have chosen predesigned objects like flags and targets — "things the mind already knows" — because they gave him "room to work on other levels."[8] This emphasis on painting in the moment and not toward an end result produces a painting surface treated with a general even-handedness. This repetitious, almost ritualistic engagement with process reveals, as Kirk Varnedoe has noted, "an affinity with Zen procedures, and Johns's close relationship with the composer John Cage's exposition of Eastern thought."[9]

Nonetheless, the instant one steps back, the methodical yet mesmerizing details re-cohere into one bold banner of national patriotism. Despite its ubiquitous presence in visual culture, the symbolic import of the American flag did not go unheeded in 1958 by The Museum of Modern Art's Director of the Museum Collections, Alfred H. Barr, Jr. Concerned that the Museum's Committee on the Museum Collections would find *Flag* "unpatriotic," Barr persuaded Philip Johnson to acquire it for donation to the Museum at a later date.

Johns's *Flag* was painted and presented during a politically sensitive period of national instability in the midst of the Cold War and in the wake of the Korean War and the Army-McCarthy hearings. In this context, any unconventional representation of the American flag — its surface "soiled" with viscous smears and paper scraps — may have been perceived as an affront to national identity and patriotism. Yet at the same moment, what for some spoke of potential blasphemy, for others suggested respect and admiration demonstrated in the "elegant craftsmanship" of the painting and "a sense of the artist having lavished care, patience, and love upon his work."[10] — L.J.

Edward Kienholz

(American, 1927–1994)

Edward Kienholz's *Friendly Grey Computer — Star Gauge
Model #54* provides yes-or-no answers to questions submitted
by viewers who follow the simple directions for operation:
"Print your problem on yellow index card provided in rack.
. . . Remove phone from rack and speak your problem into
the mouthpiece exactly as you have written it. . . . Replace
phone in rack and ding dinger once. . . . Flashing yellow
bulb indicates positive answer. Flashing blue bulb indicates
negative answer."[1]

Pre-dating the "user-friendly" computer, Kienholz's
crudely constructed prototype claims to interpret human
language but actually emits answers randomly. Complete
with ringing bells and flashing lights, *The Friendly Grey Com-
puter* functions more as a carnival game than a computer. By
making a toy of technology Kienholz wryly commented on
the blind faith invested in the power of machines to facili-
tate our daily lives. Since *The Friendly Grey Computer* can
only answer in the affirmative or negative, Kienholz also
pointed to the limits of the mechanized rationale. Nonethe-
less, he advised that we treat *The Friendly Grey Computer*
with the same respect we would a human helper: "Com-
puters sometimes get fatigued and have nervous breakdowns,
hence the chair for it to rest in. If you know your computer
well, you can tell when it's tired and sort of blue and in a
funky mood. If such a condition seems imminent, turn
rocker switch on for ten or twenty minutes. Your computer
will love it and work all the harder for you. Remember that
if you treat your computer well it will treat you well."[2]

As if to emphasize the computer's need for care and atten-
tion, Kienholz attached a pair of baby-doll legs to its front
side. The relationship between *The Friendly Grey Computer*
and its user is, however, clearly one of mutual dependence.
The coiled telephone/umbilical cord functions both literally
as the line of communication and symbolically as the line
of symbiotic exchange of care for information.

Burdened with such characteristically human traits as
fatigue and emotional variability, the *Friendly Grey Computer*
seems to be one of us. And physically, the two central dials,
phone, and doll's legs combine to create the semblance of a
face atop the "arms" and "legs" of the rocking-chair "body."
A robot of sorts, *The Friendly Grey Computer — Star Gauge*
Model #54 makes technology friendly by taking on anthro-
pomorphic form. Part-human, part-machine, it may also
allude to the ways technology and machinery have trans-
formed the body. We work and rest by the clock (i.e., when
the rocker switch is on) instead of following the body's
natural rhythms, for example.

Drooling down all sides of *The Friendly Grey Computer* is
a dirty crust of varnish. This characteristic Kienholz coating
— a process he described as "the painting gesture"[3] — not
only blurs the distinction between artificial and organic,
human and machine, but also mimics the patina of age.
By sealing *The Friendly Grey Computer* in this way Kienholz
at once preserved it in the moment and consigned it to
the past.

Once referred to as a "taxidermist of civilization,"[4]
Kienholz found his specimens in junk stores and flea markets
and reassembled them in provocative ways. "I really begin to
understand any society by going through its junk stores and
flea markets," Kienholz said. "It is a form of education and
historical orientation for me. I can see the results of ideas in
what is thrown away by a culture."[5] While Rauschenberg's
Combines are also composed of cultural detritus, Kienholz's
assemblages engage more directly in a cultural critique of
American society, creating what he called "three-dimensional
social cartoons."[6] *The Friendly Grey Computer* addresses not
only life in the age of machines, but, more generally, waste
in a disposable culture. "There is so much waste here,"
Kienholz remarked. "There is an enormous strata of junk
here that is usable. The stuff you find in Thrift Stores here is
usable, while in other places where there is extreme poverty,
you find that it will all be falling apart and in little pieces
when it's finally thrown away."[7]

Kienholz revitalized what society had relegated to junk
in a commentary on the wastefulness of American consumer
culture. The dented and grimy surface of *The Friendly Grey
Computer* suggests use and decay — distinct from the sterile
presentation of Warhol's Campbell's soup cans and Brillo
pads, for example. While Warhol presented the "new and
improved" items available today, Kienholz presented
tomorrow's trash, calling attention to "the latent putrefica-
tion of commodity culture."[8] — L.J.

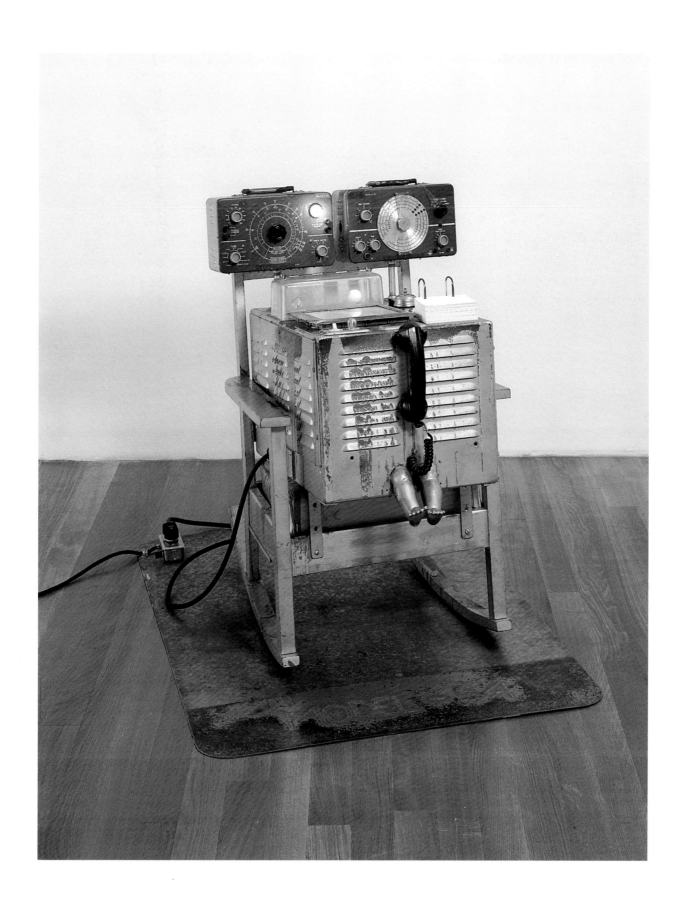

R^{oy} Lichtenstein

(American, 1923–1997)

Roy Lichtenstein.
Drowning Girl. 1963.
Oil and synthetic polymer paint on canvas,
67 ⅝ x 66 ¾" (171.6 x 169.5 cm).
Philip Johnson Fund and gift of Mr. and Mrs. Bagley Wright

In 1961–62, two artists — unknown to one another but soon to be forever allied as prime movers behind a radical new movement in American art called "Pop" — both painted a canvas of "Popeye." Despite this apparent shared affinity for the spinach-powered sailor and for comic strips in general, what Roy Lichtenstein and Andy Warhol really had in common was an awareness of the expressive potential of popular imagery. While Warhol soon abandoned celebrities of the cartoon variety for their more glamorous Hollywood counterparts, Lichtenstein continued to work from comic strips until 1965.

In discussing the subjects of his paintings, Lichtenstein explained: "The early ones were of animated cartoons, Donald Duck, Mickey Mouse, and Popeye, but then I shifted into the style of cartoon books with a more serious content such as 'Armed Forces at War' and 'Teen Romance.' "[1] *Drowning Girl*, for example, was derived from a 1962 D.C. Comics book titled *Secret Hearts*. The scene is one of the utmost melodrama; a cramp-stricken young girl, apparently dismayed with her lover, would prefer death by drowning to crying out for his help. By cropping the source image to include only the girl's face and editing the text so it is more succinct, Lichtenstein condensed both composition and narrative, zeroing in on the comic book's stereotypical representation of woman as helpless and irrational. Such stereotypes abounded in this genre of popular imagery, which was targeted specifically toward adolescent girls. *Drowning Girl* belongs to a group of paintings from 1963–65, all of which depict girls in the throes of passion, despair, or fear brought on, one assumes, by encounters with men. In contrast to the brave and assertive fighter pilots and submarine commandos — examples of Lichtenstein's male characters derived from war comics aimed at teenage boys — the "girls" appear meek, their words irres-

Run for Love!, in *Secret Hearts*, 83 (November 1962). Copyright © by D.C. Comics

olute. Depicted as lacking a coherent and confident means of expression, women in the romance paintings allow the words and deeds of some authoritative male presence to provoke and govern their actions.

Emotionally charged in terms of content, *Drowning Girl* is, nonetheless, quite "cool" in execution. According to Lichtenstein: "I was very excited about, and interested in, the highly emotional content yet detached, impersonal handling of love, hate, war, etc. in these cartoon images."[2] To emulate the "impersonal" process of commercial printing, Lichtenstein transferred an initial sketch onto canvas with a projector, drew in bold black outlines and filled them with primary colors applied in flat areas or with benday dots through a screen. Much of the detail, like shading, is lost while the benday dots become pronounced. The result is an unnaturalistic image that calls attention not only to the process of its construction, but also to the construction of female stereotypes as disseminated through pop culture.

A mechanical approach to painting has precedents in the work of artists like Piet Mondrian and Fernand Léger, for example, but Lichtenstein's insistence on making his work look, in his words, "programmed" was more directly a response to the painterly and emotive painting style of Abstract Expressionism. The airborne arabesques of Jackson Pollock, for example, are hardened and stylized in a Lichtenstein composition in a manner reminiscent of the curvilinear patterns of Art Nouveau. In translating from source image to canvas, Lichtenstein adjusted certain details to enhance the fluidity of the composition. The curve of the *Drowning Girl*'s shoulder, for example, is made to parallel the slope of the swell's underside, creating a downward visual momentum that is picked up by the upward reach of her hand, then echoed in the crest of the wave, to finally descend in a cascade leading to the stylish flip of her hair. This circular momentum suggests the churning of the sea while the series of connecting curves combines to create a two-dimensional pattern that "fixes" distinct elements to the surface of the canvas.

"In the *Drowning Girl*," Lichtenstein remarked, "the water is not only Art Nouveau, but it can also be seen as Hokusai," referring to the famous nineteenth-century Japanese printmaker. "I saw it and then pushed it a little further until it was a reference that most people will get. I don't think it is terribly significant, but it is a way of crystallizing the style by

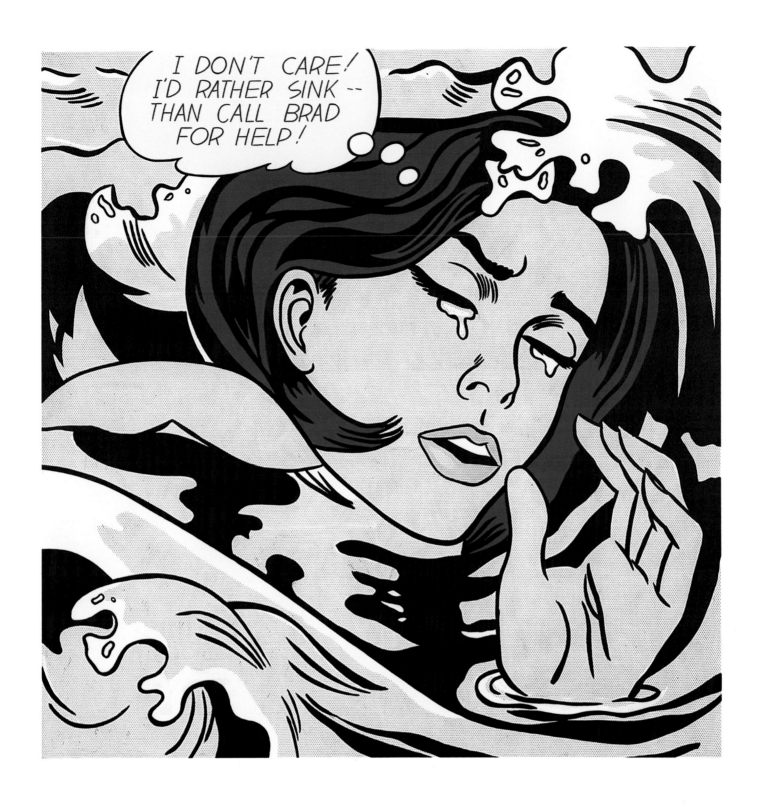

exaggeration."[3] Through this process of "crystallization" or consolidation, Lichtenstein's images function like visual shorthand; their initial effect is immediate and simplistic, like a cliché. Similarly, when composing balloon texts for his characters, Lichtenstein edits that of the source image to include only the bare minimum. (In *Drowning Girl*, for example, he deleted "I have a cramp" and changed "Mal" to "Brad.") According to Lawrence Alloway: "The fact that words, directional in syntax and specific in reference, denote events in one way, and visual images, immediately present and spatially simultaneous, do it in another way was continually on Lichtenstein's mind."[4] By editing the balloon text, Lichtenstein accelerated linguistic expression; by abstracting the image, he multiplied pictorial connotations, thereby "binding the words and image closer as a unified display."[5]
— L.J.

While critical attention in the early 1960s often focused on his use of "vulgar" popular imagery from comic strips to newspaper advertisements, Lichtenstein was equally engaged with the subject of high art. The austere grids of Piet Mondrian and Pablo Picasso's bodily distortions provided subjects for Lichtenstein's initial explorations into key figures of twentieth-century modernism. Presenting them through his cartoon style, Lichtenstein not only popularized these canonical modern artists but also addressed the very notion of what constitutes style in art.

In discussing the development of his Brushstrokes series, Lichtenstein said: "I was very interested in characterizing or caricaturing a brushstroke. The very nature of a brushstroke is anathema to outlining and filling in as used in cartoons. So I developed a form for it . . . a standardized thing."[1] The initial brushstroke in the series was, in fact, derived from a cartoon, but the others were created by Lichtenstein through a complicated process described by John Coplans: "The images were arrived at by applying loaded brushstrokes of black Magna color upon acetate, allowing the paint to shrink on the repellent surface and to dry, and then overlapping the sheets to find a suitable image, which was finally projected onto a canvas and redrawn."[2]

Roy Lichtenstein. *Brushstroke*. 1965. Screenprint, printed in color, 22 ¹⁵⁄₁₆ x 28 ¹⁵⁄₁₆" (58.4 x 73.6 cm). The Museum of Modern Art, New York. John B. Turner Fund

Brushstrokes represents one of several stylized patterns that Lichtenstein created in 1966–68 in a variety of mediums; it also exists as a painting, as a print, and as a poster for his 1967 exhibition at the Pasadena Art Museum. Cropped as if a detail, the drawing suggests dynamic movement characterized by sweeping strokes and by paint splatters trailing a quick downward motion. In another of the Brushstrokes series, *Brushstroke* (1965), shown here, gradual drips rather than splatters distinguish the slow, rhythmic movement of a single stroke. Placed centrally in the composition, this stroke takes on an iconic presence, giving eminence to the intrinsic fluidity of paint. If the single stroke can be said to function as a symbolic representation of paint, *Brushstrokes* may then represent "painting" — a manner of painting, or style.

The suggestion of bold gestural strokes is clearly evocative of Lichtenstein's Abstract Expressionist precursors and more specifically, perhaps, the slashlike marks of Franz Kline or Willem de Kooning. According to Lichtenstein: "I got the idea very early because of the Mondrian and Picasso paintings, which inevitably led to the idea of a de Kooning. The brushstrokes obviously refer to Abstract Expressionism."[3] Through Lichtenstein's methodical process, however, the spontaneous strokes and chance drips associated with Abstract Expressionism have been rendered mechanically, the hard-pressed graphite creating a metallic, industrial sheen. Surrounded by a field of benday dots, the painting *Brushstrokes* is as predictable and processed as its printed counterparts. By the 1960s, the work of second-generation Abstract Expressionists was more or less formulaic and, in this context, Lichtenstein's programmatic brushstrokes seem to satirize the formal preoccupations of his contemporaries.

While the "printerly" quality of Lichtenstein's painting style is characteristic, his cross-medium explorations are further complicated in this work — a drawing of a brushstroke as a print. Three distinct mediums are engaged as process, subject, and style. Combined, they question assumptions about the intrinsic qualities of each: the substance and fluidity of paint is flattened and fixed; the regularized uniformity of a print surface is belied by the trace of the artist's hand; and pencil, associated with the subtlety and finesse of fine drawing, is employed as a mechanical tool. — L.J.

Marisol (Marisol Escobar)

(Venezuelan, born Paris, 1930. To U.S.A. 1950)

Marisol.
The Family. 1962.
Painted wood and other materials in three sections,
overall 6' 10 ⅝" x 65 ½" x 15 ½" (209.8 x 166.3 x 39.3 cm).
Advisory Committee Fund

Framed by two narrow, white hinged door panels covered with curving, somewhat menacing, black linear forms, the matriarch of Marisol's sculpture *The Family* sits stoically, positioned directly in the center of her architectural backdrop. Her strict frontality along with the overall composition's geometric rigor combine to create a hieratic image of a secular madonna in real sneakers. Flanked on either side by two children symmetrically arrayed around her right knee, she possesses a strange majesty, despite her unfashionable attire and dumpy proportions. Projecting an image of stability, this maternal figure could not be more removed from Lichtenstein's stereotypes of women as helpless and irrational, Wesselmann's eroticized female nudes, or even Warhol's glamorized "girls." The biases of these images of women are far more prevalent in mainstream Pop. While often relegated to the periphery of Pop, works such as *The Family* perform an important function, drawing critical attention to the ways women are represented and understood.

For viewers of the 1960s confronted with this sculpture, however, the key issue was not that of feminine identity but of social class. Describing *The Family* in *Art News*, one critic commented: "The latest lowest Jukes sit for their family portrait as they might appear in a psychology text."[1] So too, the critic continued, "do J.F.K., Jackie and the children," referring to Marisol's sculpture *The Kennedys* (1960), which was included, along with *The Family* and other works, in what is widely acknowledged as her "breakthrough" exhibition held at the Stable Gallery in New York City in May 1962. Patrician, politician, and mass-media celebrity, Kennedy, along with his wife and children, contrasted sharply with the anonymous types portrayed in many of Marisol's other sculptures, which interjected a note of social consciousness into the domain of Pop. Engaged less with mass media than with the masses, *The Family* proposed that Pop art's ongoing dialectic between high and low culture could involve not only objects but people, including distinctions and divisions between the upper and lower classes.

Photograph used for Marisol's *The Family*. 1920s–30s (Collection Files, Department of Painting and Sculpture, The Museum of Modern Art, New York).

Like Warhol, Marisol usually based her portraits on photographs, preferring to work at a remove from her subjects rather than directly from life. *The Family*'s source is not a contemporaneous Photomat snapshot, but an old black-and-white photograph, shown here, probably dating from the 1920s or 1930s, that Marisol found among discarded papers outside her studio. A comparison of this image with Marisol's sculpture suggests that the latter's posed, planar, frontal presentation owes much to the conventions of portrait photography.

Various critics have compared *The Family* to Walker Evans's Farm Security Administration photographs of the mid-1930s, many of which featured impoverished rural families living in the southeastern states. Unlike Evans's images, however, Marisol's found family portrait is clearly an amateur production. Thematically, emotionally, and stylistically, her "family" stands apart from canonical Pop's seemingly cool, distanced mechanical approach. The poignancy implicit in the very notion of a family photograph once treasured and then discarded underlies the sense of nostalgia evoked by *The Family*.

Marisol's photographic source can, of course, be described as a "found" or "scavenged" image, a piece of urban detritus. "All my early work came from the street," Marisol has stated. "It was magical for me to find things."[2] The use of materials found by chance would become a central feature of her creative process. Even more distinctive, however, was the way she disjunctively combined painting, drawing, casting (of body parts), and carving, with ready-made objects (such as sneakers and hinged doors). Marisol's use of cast body parts (restricted, in the case of *The Family*, to the mother's hands) and of objects plucked from the everyday environment have frequently been compared to the work of Johns and Rauschenberg. The way she integrated these elements into sculptural tableaux, however, juxtaposing ready-mades with, among other things, beautifully wrought passages of figurative drawing, was uniquely her own and added a new dimension to the tradition of assemblage. So, too, did her focus on families, both anonymous and famous, as a recurrent theme. — A.U.

Marisol.
Love. 1962.
Plaster and glass (Coca-Cola bottle),
6 ¼ x 4 ⅛ x 8 ⅛" (15.8 x 10.5 x 20.6 cm).
Gift of Claire and Tom Wesselmann

A real, liquid-filled bottle of Coca-Cola is displayed upended on a plaster base depicting part of a human face, literally rammed down someone's throat. The classic consumer product and the anonymous consumer are violently, and inextricably, brought together, providing an apt visual metaphor for advertising's hard sell. "Try it, you'll like it!" "Just do it!" "It's the real thing!" are familiar marketing slogans that, when applied to Marisol's sculpture *Love*, assume a hectoring, slightly sinister, and overtly sexual tone. For all that Marisol isolates and elevates her Coca-Cola bottle, it is far from idealized. Its pedestal is all too recognizably human, its glass form too rigid, and the force of gravity too strong for it to strike anything other than a decidedly nasty note. To compare *Love* with the artist's relatively innocuous but iconographically similar *Paris Review* poster, shown here, highlights the sculpture's aggressive character.

Among brand name soft drinks, Coca-Cola was the one most frequently represented by artists in the 1950s and 1960s. It is by now widely recognized as a classic icon of Pop. *Love* positions Marisol's work in relation to Pop to a greater degree than any of her other 1960s sculptures. It was purchased by the artist Tom Wesselmann from a group exhibition held at the artist-run Tanager Gallery in New York City in 1962. Among the mainstream Pop artists, Wesselmann's work, along with that of Claes Oldenburg

Marisol. *Paris Review*. 1967. Silkscreen, 26 x 32 ½" (66 x 85.2 cm).
The Museum of Modern Art, New York. Gift of Page, Arbitrio, & Resen

and Mel Ramos, most explicitly addressed the advertising industry's conflation of selling with sex. While the parallels between *Love* and selected works of these other artists are, on the one hand, obvious, involving phallic forms provocatively positioned in relation to flesh, the "flesh" represented in Marisol's sculpture is sexually ambiguous. It is, in other words, impossible, based on visual appearance alone, to determine its gender. Through the effective substitution of a part (a face) for the whole, Marisol sets forth *some* body, as opposed to a *woman's* body, for scrutiny.

This said, however, the plaster mask that supports *Love's* Coca-Cola bottle has been specifically identified. Like the other body parts Marisol often attached to her sculptures, it was cast from herself. The face that confronts us then is a woman's, and not just any woman's: it is the artist's. Her initial idea of using casts of human faces has been attributed, among other influences, to the strong impression made upon her by Johns's *Target with Four Faces* (1955). This work includes four truncated, eyeless, cast faces, which, as in *Love*, initially read as genderless but were, in fact, cast from a woman's face. Marisol has explained that she used herself as a ready-made for several reasons, some practical ("I began to make self-portraits because working at night I had no other model."),[1] some philosophical ("Whatever the artist makes, it is always a kind of representation of self.").[2] The latter suggests that *Love* must be read, at least on one level, as a "self-portrait" of the artist, later described by Warhol as "Marisol! The first girl artist with glamour,"[3] and as the only woman associated with Pop who "survived."[4]

The knowledge that Marisol chose to, literally, "cast" herself in the role of sex object contributes to the barbed, provocative quality of this work. When asked in 1964 by the feminist writer Gloria Steinem if she objected to those critics who labeled her "Pop," Marisol said that no, on the contrary, "It's nice, it gets you into group shows."[5] Pursuing the implications of Marisol's statement and the work's title, should *Love* be seen as a self-representation, a blatant image of the artist/object engaged in the act of fellatio, ironically pleasuring a product of Pop? Or are we confronted with a case of force-feeding, a depiction of America's favorite soft-drink shoved down her throat? These are, of course, questions without definitive answers, posed rhetorically to underscore the discomfort provoked by Marisol's work.

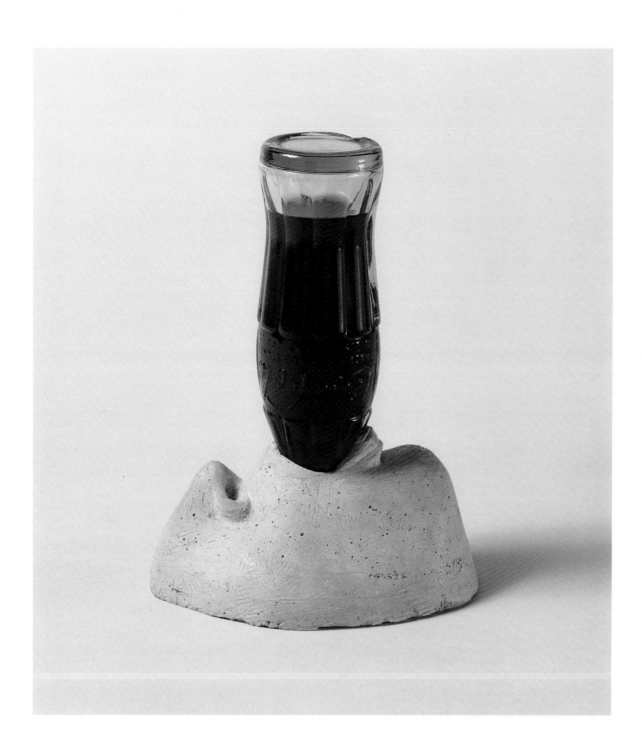

Feminists in the 1970s, for instance, criticized the artist for her willingness to play stereotypically feminine roles. As demonstrated in *Love*, however, Marisol controlled the ways she chose to represent women. In *Love* she not only starred but directed and produced a prickly, disturbing, yet iconically Pop picture of the relationship between the commercial product, the consumer, and the artist herself.

—A.U.

In 1966 the art historian Lucy Lippard published one of the first books to attempt a retrospective survey of Pop. Although Marisol was mentioned, Lippard wrote that her work had "little to do with Pop Art, aside from its deadpan approach and touches of humour. Marisol rarely, if ever, uses commercial motifs, although her *John Wayne* and *The Kennedy Family* would fall within Pop iconography."[1] Had Lippard's book appeared one year later, Marisol's 1967 full-length portrait of Lyndon B. Johnson could easily have been added to Lippard's list of works that, iconographically speaking at least, could be described as Pop. While she is perhaps better known for her self-portraits and portraits of anonymous figures, famous personalities constituted a central theme for Marisol; her work in this genre has been compared with that of Warhol, despite their very different stylistic approaches. During the 1960s and afterwards, she often portrayed figures known through the mass media, drawn from the worlds of art, entertainment, and politics.

LBJ is one of six sculptures Marisol completed in 1967, commonly referred to as her Heads of State series. At the suggestion of London's *Daily Telegraph Magazine*, Marisol created sculptural portraits of Britain's Prime Minister Harold Wilson and the British royal family, and then added China's Chairman Mao Tse-Tung, French President Charles de Gaulle, Spain's Generalissimo Francisco Franco, and United States President Lyndon B. Johnson to the group. Portrayed striding forward, somberly suited and with furrowed brow, Marisol's *LBJ* overlays simplified, geometric blocklike forms with elements of humor, satire, and caricature. Details such as Johnson's elephantine ears and bulbous nose, along with the three tiny birds bearing the faces of Lady Bird, Lynda Bird, and Luci Baines Johnson (the president's wife and two daughters), introduce humorous and humanizing notes into the traditionally august realm of heroic monuments. Cradled protectively in the palm of his left hand, Johnson's three "birds," despite their diminutive scale, establish that this too is a form of family portrait.

Johnson's painted and drawn body covers the surface of two joined and angled blocks of wood, whose shape has been compared by one critic to "Egyptian mummy cases"[2] and by another to a "coffin."[3] Whether or not such analogies were intended by the artist, their funereal connotations serve, in this instance, as reminders that 1967 was a year of escalating anti-Vietnam War sentiment. The chant, "Hey, hey, LBJ, how many kids did you kill today?" would have been familiar to anyone who participated in, or witnessed, that period's increasingly frequent antiwar protests and demonstrations. Sworn in as president immediately after John F. Kennedy was assassinated on November 22, 1963, Johnson was returned to office by election in 1964. Although he is best remembered today for his civil-rights legislation, in 1967 the sad circumstances that surrounded his presidency were clearly on Marisol's mind. In an interview on her Heads of State series, published in a November 1967 issue of *Look* magazine, she remarked: "The atmosphere is more businesslike since the change of Presidents. The world is not a happy place anymore."[4] Her words color perceptions of her *LBJ* sculpture, drawing attention to its solemn emotional tenor and subdued palette, qualities only partially mitigated by comical details. — A.U.

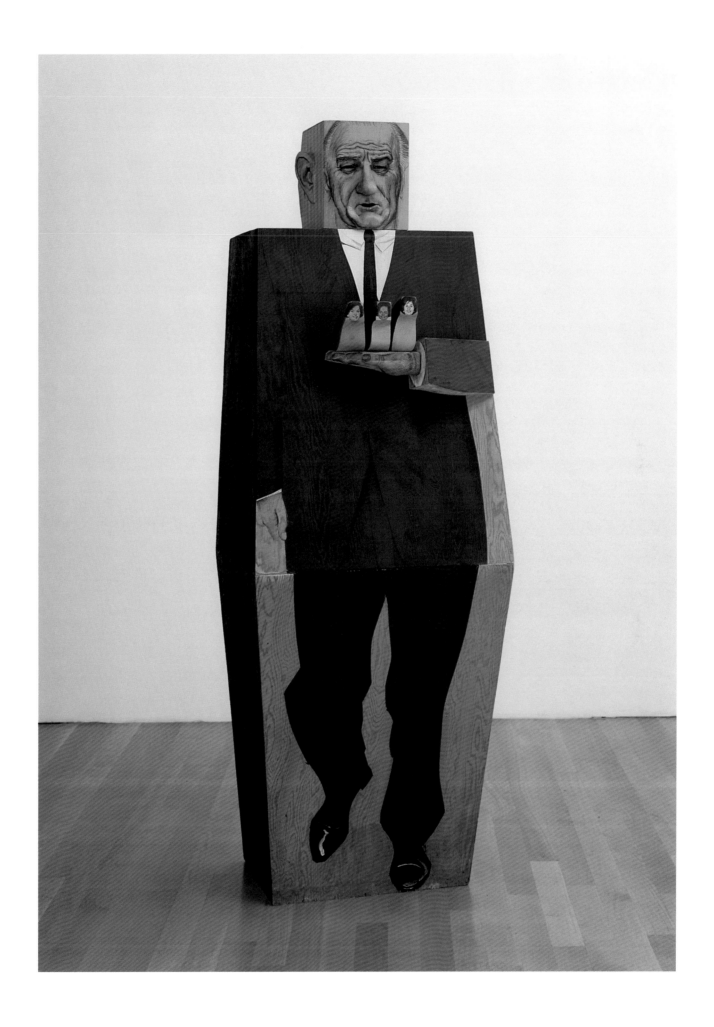

Claes Oldenburg

(American, born Sweden, 1929)

Claes Oldenburg.
Empire Sign — With M and I Deleted. 1960.
Ink and spray paint on cut-and-pasted corrugated cardboard,
54 ¾ x 23 ⅞" (139.1 x 60.7 cm) (irregular).
Gift of Agnes Gund

Claes Oldenburg arrived in the United States from his native Sweden with his parents at the age of seven. He grew up in Chicago, and, after graduating from Yale University in 1952, he flirted with the idea of the theater but decided to be an artist. In 1956 he moved to New York City, where he met Allan Kaprow and a group of artists who were experimenting with a hybrid art form that mixed theater with sculpture to create what would become known as Happenings. Kaprow, the leading proponent of this art form, called for artists to "become preoccupied with and even dazzled by the space and objects of our everyday life, either our bodies, clothes, rooms, or, if need be, the vastness of Forty-Second Street. . . . Not only will these bold creators show us, as if for the first time, the world we have always had about us but ignored, . . . but they will disclose entirely

Snapshots from the City, performance at the exhibition *The Street*, Judson Gallery, Judson Memorial Church, New York, February and March 1960.

unheard of happenings and events, found in garbage cans, police files, hotel lobbies, seen in store windows and on the streets."[1]

"The 'Happening,'" Oldenburg wrote, "is bearing fruit as a new physical theater, bringing to the dry puritan forms of the US stage the possibilities of a tremendous enveloping force."[2] Inspired by Kaprow and the work of a circle of younger artists who were experimenting with performance, including Jim Dine, Red Grooms, and Robert Whitman, Oldenburg staged his own series of Happenings in March 1960 as part of a two-person exhibition (with Dine) at the Judson Gallery in the Judson Memorial Church on New York's Washington Square. Oldenburg called both the exhibition and the Happenings *The Street*, a name that he later used to refer to a series of sculptures, drawings, collages, and performances that he created between 1960 and late 1961. Developed from sketches of the Lower East Side where he was living, all the works produced under this rubric had the worn, dirty look of urban detritus and were meant, in the artist's words, to capture the "textures of the city," the "asphalt, concrete, tar, paper, metal, . . . etc."[3] Oldenburg's imagery was drawn from urban street life — "newspapers, comics, scrawls of all sorts."[4] Many of the objects included in the Judson exhibition were made of newspaper soaked in wheat paste and draped over a wire armature, a method taken from a children's art manual. For his collages, drawings, and monoprints Oldenburg used newsprint or found sheets of brown cardboard and blackened their ragged edges to make them look charred.

Empire Sign — With M and I Deleted takes as its subject the flashy and shabby neon marquees that grace urban theaters, dance halls, and diners. Made of corrugated cardboard with uneven, blackened edges and executed in a rough, purposely awkward manner, it is altogether different from the signs on which it was ostensibly modeled. This work is among the first examples of Oldenburg's practice of transforming a mass-produced object into something clearly handmade. This urge to humanize inanimate, particularly machine, objects would be a recurring theme in the artist's work throughout the 1960s and for his entire career, as would the desire to make an art "that . . . is . . . sweet and stupid as life itself."[5] Of his signs, in particular, the artist wrote that they "naively contain a functional contemporary

magic. . . . I try to carry these even further through my own naiveté. . . . I do not try to make 'art' of them."[6]

Because the Judson show was less an exhibition of individual works than a display of a single environment, the sculptures and drawings were placed on the floor, tacked to a wall, or suspended from the ceiling, imitating the way in which they would have appeared on a busy urban street. Although it was most probably suspended

from the ceiling at a 90-degree angle from the wall like a neon sign, the vertical rectangular shape of *Empire Sign* also resembles that of a Manhattan skyscraper. Indeed, the odd, earlike extrusions that cap the work might relate to a vision of "erect rabbit ears" that Oldenburg recalled having seen nestled amid the tall buildings while driving down a Manhattan street in 1958. — L.H.

"I have got love all mixed up with art," wrote Oldenburg in 1961. "I have got my sentiments for the world all mixed up with art. . . . I can't leave the world alone."[1] This deep commitment to both art and quotidian experience led the artist to conclude that he needed a place "like a store"[2] to fabricate and display his work. In June 1961 in a storefront at 107 East Second Street he created a space that was neither a shop, nor a studio, nor an environmental art exhibition, but a hybrid of all three. The Store was filled with painted plaster sculptures of objects that one would expect to find in a down-market emporium; the back part of The Store functioned as Oldenburg's studio where he manufactured works to replenish The Store's stock. In the courtyard behind the building, Oldenburg produced performances every two weeks on Saturdays at 10:00 p.m. The performances featured the same people who had participated in Oldenburg's Happenings, including Metropolitan Museum

View toward the street from the front window of The Store, 107 East Second Street, New York, 1961–62.

of Art curator Henry Geldzahler, the musician Billy Klüver, the artists Jean-Jacques Lebel and Lucas Samaras, and Oldenburg's wife Pat. The theater, as well as The Store itself, were the productions of the Ray Gun Manufacturing Co., an entity created by Oldenburg for all Store enterprises. This reinvention of an exhibition space as a neighborhood gallery, an artist's working environment, and a theater was an early model for what would come to be known in the late 1960s as alternative spaces — artist-run galleries that offered studio space and exhibited experimental work.

During the following year, Oldenburg re-created versions of The Store at the Dallas Museum of Art and at the Green Gallery in New York. In each case, he modified the objects in the exhibition to fit the nature of the space and his evolving interest in new sculptural materials.

The worn, handmade look of *Store Poster, Torn Out Letters, Newspaper, Pie, Cup Cakes, and Hot Dog*, with its awkwardly cut letters and addition of a torn, smudged scrap of newspaper, has a clear relationship to collages created for his 1960–61 series of exhibitions and Happenings, called The Street, and particularly to earlier works that used a sign motif, such as *Empire Sign*. "The Store is like the Street," wrote Oldenburg, "an environmental (as well as thematic) form. In a way they are the same thing because some streets or squares (like TSq) are just large open stores (windows, signs etc.). In The Store the concentration upon objects is more intense."[3]

Featuring a rather cartoonish cutout of a hot dog, fanciful cupcakes, and errant letters that perhaps could have fallen from the *Empire Sign*, this work is one of a number on paper produced in conjunction with The Store project, including monoprints, drawings, and paper assemblages. A collage, whose bulbous elements give it a relieflike quality, despite its name, *Store Poster* is not a poster at all, as it was never reproduced for use as an advertisement. — L.H.

Describing The Store as "a combination of neighborhood free enterprise and Sears and Roebuck," Sidney Tillim noted "Oldenburg's very real infatuation with the tawdriness of specifically American *kitsch*."[1] Responding to such critical commentary in a famous untitled series of declarations published in 1961, Oldenburg joyfully and defiantly asserted: "I am for an art that embroils itself with the everyday crap & still comes out on top. . . . I am for an art . . . which is eaten, like a piece of pie."[2]

The group of nine painted plaster sculptures in *Pastry Case, I* includes cookies, a cake, a tart, ice-cream sundaes, a candied apple, and a piece of blueberry pie. Each object was made by dipping burlap or muslin in plaster and laying the saturated fabric over a wire frame. After the cloth dried, another coat of plaster was applied and Oldenburg then painted the whole with store-bought enamel paint straight from the can. Products though they were, these plaster objects could never be mistaken for mass-manufactured items. Lumpish and messy, their shiny enamel paint was applied almost expressionistically. Their handmade quality was a key element of their humanity, at once establishing their distance from a ready-made reproduction and tying them firmly to the artist who made them.

According to Oldenburg, all the items in The Store were chosen because they seemed to him to be "fixed in time,"[3] and indeed, all the objects in *Pastry Case, I* have a peculiar, old-fashioned air. The desserts — the apple, the piece of pie, the banana split — are specific to the tastes of mid-century America, but the temptation they arouse is tempered by an equal measure of repulsion. All the sculptures have the familiar, flyblown look of food too long on display. Not only do these works look old, but they also look artificial, resembling actual sweets less than the wax or plastic replicas often seen in pastry-display cases in diners and coffee shops throughout America.

Pastry Case, I can be seen as part of a long art-historical tradition of the depiction of opulent still lifes painted as allegories of human excess and frailty. Luridly colored and awkwardly shaped, the items in *Pastry Case, I* are both grotesque and seductive, abject and humorous. (Asked about the humor in his work Oldenburg replied, "Yes, my work is humorous, but you get over that.")[4] It has often been noted that there is a poignancy in much of Oldenburg's work,

even the most boisterous. Sidney Tillim wrote of an "aura of faint melancholy" that surrounded all the items in The Store, and pronounced the ostensibly merry cakes and pies of *Pastry Case, I* "hopelessly nostalgic."[5] In *Pastry Case, I,* as in a seventeenth-century Dutch still life, along with temptation and delight there is a sense of the price paid for indulgence. Oldenburg, however, was quick to deflate such grandiose interpretations. "The food," he wrote of the work, "of course, can't really be eaten so that it's an imaginary activity which emphasizes the fact that it is, after all, not real — that it's art, whatever that strange thing is of doing something only for itself rather than for function."[6]

Pastry Case, I was included in the 1962 re-creation of The Store at the Green Gallery in New York. In a price list from the show, this item was offered for sale for $324.98. The New York art dealer Sidney Janis purchased the work out of that exhibition, and included it in the *New Realists*, his own Pop art exhibition, which opened at his gallery on November 1, 1962. This show, which grouped together American Pop artists such as Oldenburg, Warhol, and Lichtenstein with European artists Yves Klein, Arman, and Niki de Saint-Phalle, is considered among the most important exhibitions to have introduced the new international trend toward figuration and subject matter taken from popular culture. The transparency of *Pastry Case, I* on all four sides has allowed it to be displayed in many creative ways. In the Janis exhibition, for example, it was angled at 90 degrees from the wall to mimic the look of a counter. — L.H.

Installation view, *New Realists*, Sidney Janis Gallery, New York, November–December 1962

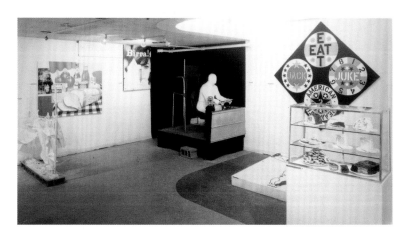

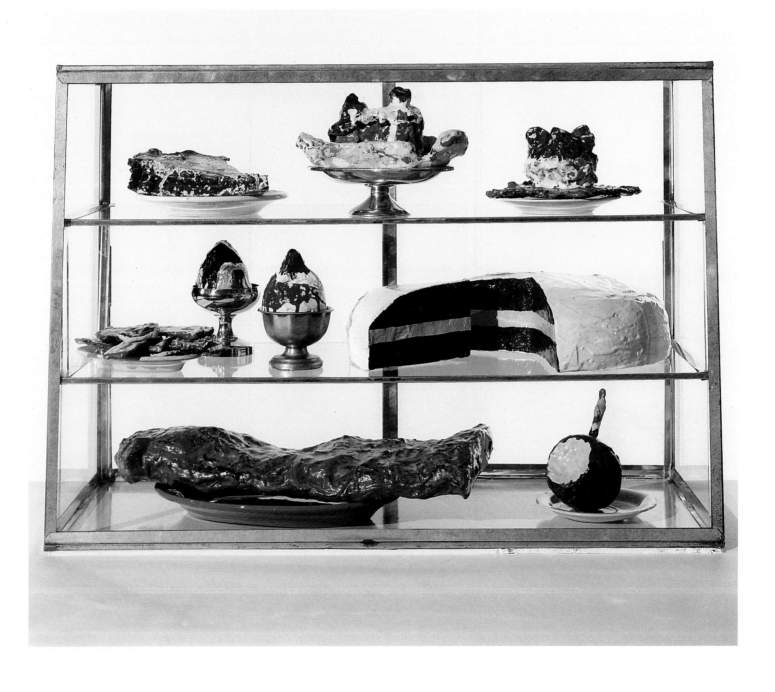

If the visual and aural emblems of America are the Stars and Stripes and the National Anthem, respectively, surely the hamburger is its comestible emblem, rivaled only by the hot dog for the title of national sandwich. Oldenburg's *Two Cheeseburgers with Everything (Dual Hamburgers)* is one of several sculptures, drawings, and prints of this subject, most of which were created in 1962 during the artist's series of exhibitions known as The Store. *Two Cheeseburgers* exemplifies Oldenburg's — and Pop art's — ambivalence toward its prime inspiration — popular American culture; although this sculpture confronts the viewer with the straightforward seduction of an advertisement, the artist has said of it: "If it is . . . thought of as a satirical image, I won't deny it."[1]

Oldenburg remembered fabricating *Two Cheeseburgers* in the East Second Street storefront that housed the first incarnation of The Store. During the few months that Oldenburg inhabited it, the space doubled as a studio and an exhibition space. *Two Cheeseburgers* resembles painted plaster Store objects created during the same year. Painted in bright primary colors with a globular application of paint that connotes slatherings of ketchup, mustard, and mayonnaise, *Two Cheeseburgers* is among the most sensuous and opulent of his small plaster sculptures, and was first exhibited at the second incarnation of The Store at the Green Gallery on Fifty-seventh Street in 1962. It was also in this

exhibition that the artist introduced his first large soft sculptures — *Floor Cone, Floor Cake*, and *Floor Burger*, all of 1962.

The artist has recalled that the inspiration for *Two Cheeseburgers* came from a Rheingold beer advertisement that he spied in the window of a small grocery next to the first Store. The ad depicted two cheeseburgers with everything sunning themselves on a rock at an ocean beach. The image, which gave life and subjectivity to inanimate objects, clearly appealed to Oldenburg, who used this conceit to humorous effect in his sculpture. With their slabs of tomato uncannily resembling tongues, combined with the snarling upturn of their buns, Oldenburg's *Two Cheeseburgers* look like mouths open wide in anticipation of speech or perhaps food. Painted in two shades of green, as is camouflage, the lettuce that forms the lower layer pokes out from under the other layers like nascent legs. So lively, bumptious, and human are these twin sandwiches, that they seem to have been detained in the act of a garrulous stroll.

A drawing in lithographic crayon titled *Hamburger* (1962), also in the Museum's collection, is related to the *Two Cheeseburgers* but was made after the sculpture had been installed at the Green Gallery. As Oldenburg made clear some years after the work was made, the drawing was not a preparatory study for a work in three dimensions but was decidedly "an independent drawing of the hamburger subject."[2]

Drawing played an important role in the conception of all of Oldenburg's works, and he produced a few distinct types related to his sculptural efforts, including more finished drawings in pencil, ink, crayon, and watercolor of motifs that he would later tackle in three dimensions. Throughout the 1960s the artist also habitually made sketches of his ideas for sculptures and monuments, which he kept in spiral notebooks. These loose sketches were often preparatory for more detailed plans for the fabrication of a particular work. As he explained to an interviewer: "After a subject has been realized by an impressionistic drawing, it is necessary to make a technical study of it, leading to the construction of a model."[3] — L.H.

Claes Oldenburg. *Hamburger*. 1962. Lithographic crayon on paper, 14 x 17" (35.3 x 43 cm). The Museum of Modern Art, New York. Philip Johnson Fund

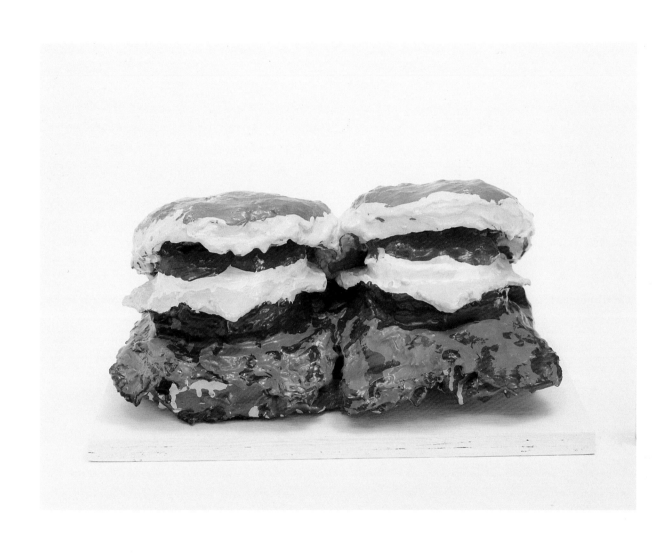

The opening of The Store in June 1961 was the beginning of a period in Oldenburg's oeuvre in which sculptural objects, while still tied to environments, no longer existed primarily as props, but became autonomous sculptural presences. In the spring and early summer of 1962 the artist worked at The Store on East Second Street, creating small plaster sculptures. Asked by Richard Bellamy to create a new version of The Store for his Green Gallery, Oldenburg began to develop ideas for a different kind of sculpture. The Green Gallery had a reputation as the epicenter of the burgeoning Pop art movement, and by 1962 Bellamy had already organized two group exhibitions that brought together work by Warhol, Rosenquist, Oldenburg, and other artists whose careers would subsequently be inextricably linked with Pop art.

The subject matter of Oldenburg's new works remained everyday objects — particularly food — but greatly enlarged. In addition, they were soft. Made of sewn and painted canvas, these sculptures were stuffed with kapok (a synthetic substitute for lamb's wool often used in the toes of ballet slippers), foam rubber, and cardboard. *Floor Cake* and *Floor Cone* (page 71) were exhibited in September 1962 at the Green Gallery along with *Floor Burger* (a soft hamburger form, measuring 52 inches in diameter, now in the collection of the Art Gallery of Ontario), *Pastry Case, I* , and *Two Cheeseburgers with Everything (Dual Cheeseburgers)*.

These two deceptively simple devices — a radical shift in scale and the use of soft materials — are responsible for what the art historian Barbara Rose has asserted is Oldenburg's premier contribution to the history of form. "What Oldenburg proposes," she wrote, "is a low, vulgar, representational art of formal significance."[1] Works like *Floor Cake* make us reconsider our preconceptions about the meaning and function of monumental sculpture in the contemporary world. Imposing in scale and sitting directly on the floor without the benefit of a base, *Floor Cake* has many of the attributes of a monument, but its softness undercuts its disproportionate size. Canvas and foam rubber are the opposite of marble and bronze — the materials we expect for sculpture. Monumental sculpture, furthermore, is meant to be relatively permanent and unmovable. In contrast, *Floor Cake*'s malleability allows for the element of chance to become a significant part of its composition. Pulled by gravity or squeezed by its surroundings, it can change its shape and aspect depending on the conditions of its installation.

Oldenburg's innovative idea to produce large-scale soft sculpture was the result of a confluence of many disparate elements, among them other artists working with soft sculpture at the time and his wife Pat, who collaborated with him by sewing his sculptures together. The impetus to work large also might have been inspired by the larger

Claes Oldenburg. *Cake Wedge*. 1962. Crayon on paper, 25 x 32 ⅜" (63.5 x 83.8 cm). Whereabouts unknown

Claes Oldenburg making his first giant "soft" sculptures, Green Gallery, New York, Summer 1962.

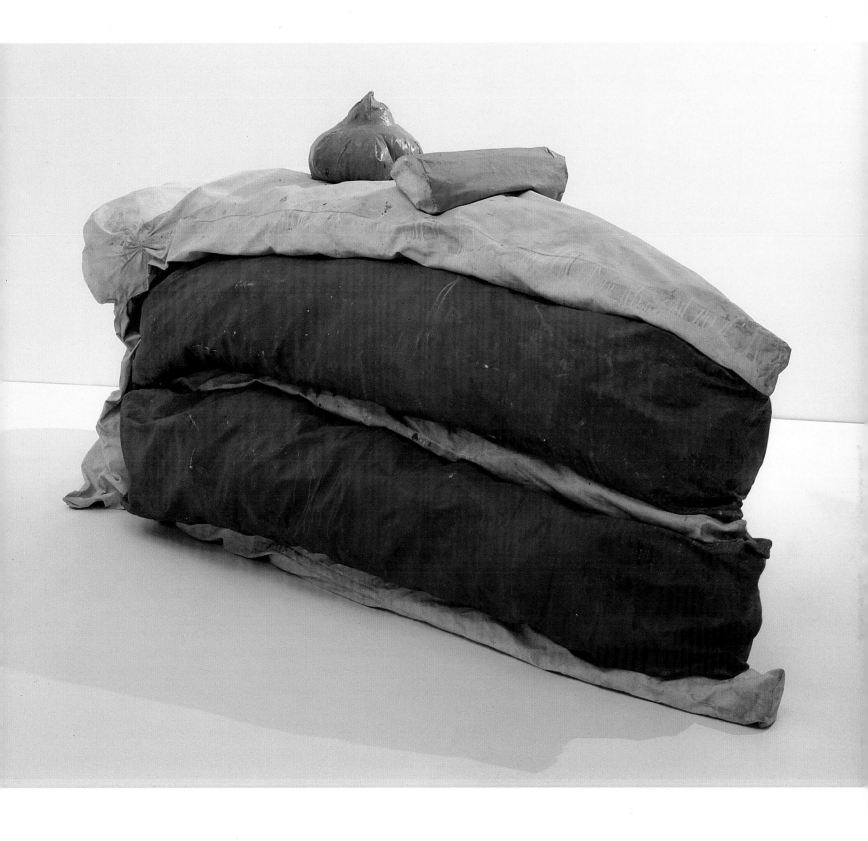

dimensions of the space offered for his upcoming show. As William Rubin recalled, when Oldenburg was asked to restage The Store in the Green Gallery, the artist used the opportunity to modify the exhibition to fit the site.

Abandoning the model of the small, crowded downtown variety store, Oldenburg chose instead the example of the spacious auto showroom. According to Rubin, he enlarged his sculptures accordingly. — L.H.

Claes Oldenburg.

Floor Cone (Giant Ice-Cream Cone). 1962.
Synthetic polymer paint on canvas filled
with foam rubber and cardboard boxes,
53 ¾" x 11' 4" x 56" (136.5 x 345.4 x 142 cm).
Gift of Philip Johnson

"Things have come to a pretty pass when an art critic has to miss lunch to go and size up a bacon, lettuce and tomato sandwich three feet across and deliciously executed in vinyl, wood, kapok and cloth," wrote *New York Times* art critic John Canaday in an enthusiastic review of Oldenburg's large-scale sculpture.[1] *Floor Cone (Giant Ice-Cream Cone)* is one of three "colossal" soft sculptures that Oldenburg fabricated in the waning summer months of 1962 for his Store exhibition at the Green Gallery in September. *Floor Cone* is made from the same materials used for *Floor Cake* and *Floor Burger*. Its canvas skin has been covered with two colors of acrylic paint applied in a slapdash manner, with paint from the ball of "ice cream" dribbling over the "cone" in a manner that recalls melting ice cream. Lumpishly stuffed with foam rubber and cardboard boxes, as are *Floor Cake* and *Floor Burger*, *Floor Cone* happens to have been filled with containers that were once used for ice cream.

In the same review in which he rhapsodized about lunch writ large, Canaday compared a person-sized half-squeezed tube of toothpaste (the 1964 *Giant Toothpaste Tube*), which lay on the floor, to "Garbo dying in the final scenes of 'Camille.' "[2] All of Oldenburg's large soft sculptures have a pronounced anthropomorphic quality. In a notebook entry of 1962 Oldenburg admitted the connection between his objects and human form, describing the relationship as a kind of empathy between the animate and the inanimate, and between the artist and the objects that he makes.

When he looked at his colossal sculptures, Oldenburg wrote, "What I see is not the thing itself but — myself — in its form."[3]

This bold association between the form of a familiar consumable object and our own bodies, seems to cast *Floor Cone* as a commentary on commodity culture. Writing in 1966, fellow Swedish artist Öyvind Fahlström called Oldenburg's colossal sculptures "monuments erected to the Unknown Consumer,"[4] fetish objects emblematic of our voracious appetite for things. However critical of consumerism Oldenburg's colossal sculptures might be, they are also concerned with mending the rift between people and the things that surround them. While it is clearly humorous in its pathos, it is difficult to view the benign, pillowy form of *Floor Cone* as a negative commentary on the state of modern humanity.

The resemblance to human form is only "one imitation" of any number of "parallel representations"[5] inherent in the abstract forms of the cone and the sphere. Depending upon how it is installed, *Floor Cone* can resemble many similar objects in the world, including an oil derrick, a steeple, and a phallus. During the next few years, particularly in his drawings, Oldenburg concentrated more and more on visual puns between wildly disjunctive images. This obsession with morphological translations became the basis for his later designs for monumental sculptures. — L.H.

Installation view, *Claes Oldenburg*, Green Gallery, New York, September–October 1962.

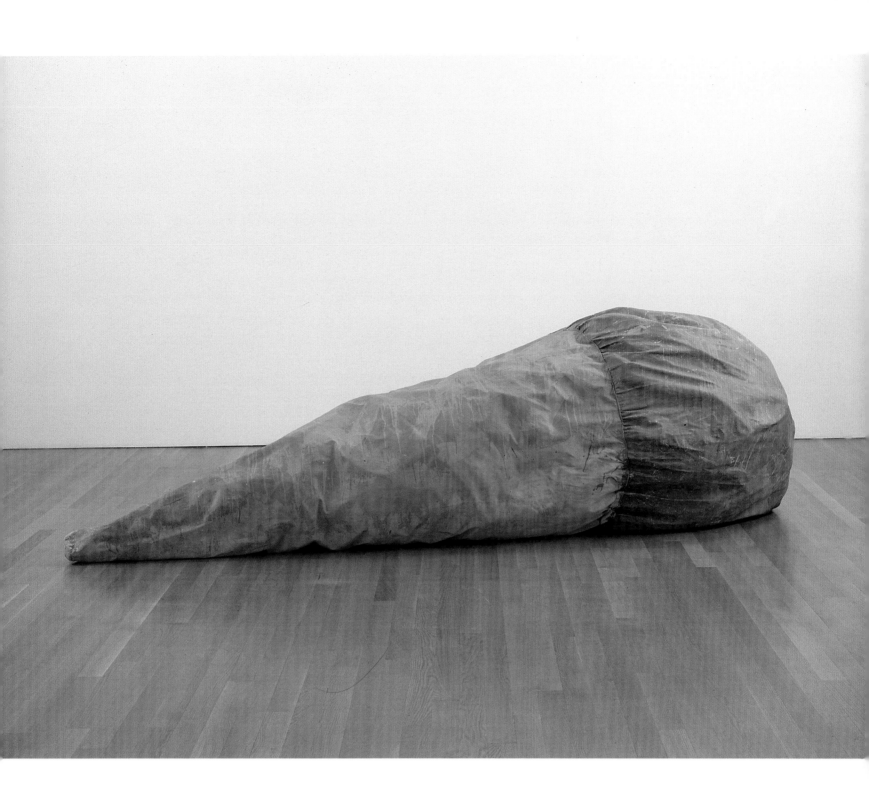

Claes Oldenburg.
Giant Soft Fan. 1966–67.
Construction of vinyl filled with foam rubber, wood, metal,
and plastic tubing, 10' x 58 ⅞" x 61 ⅞" (305 x 149.5 x
157.1 cm) (variable); cord and plug, 24' 3 ¼" (739.6 cm) long.
The Sidney and Harriet Janis Collection

At ten feet high, *Giant Soft Fan* marks Oldenburg's first attempt at a soft sculpture of truly monumental proportions. Commissioned for the American Pavilion of the Canadian Universal and International Exhibition, Montreal, 1967, better known as Expo '67, *Giant Soft Fan* was hung from the top of a twenty-story-high geodesic dome designed by the visionary American architect R. Buckminster Fuller.

The theme of the United States Pavilion was "Creative America," with the 141,000 square feet of the dome's exhibition space devoted to "exhibits of American creativity in the arts, sciences and technology."[1] Since their inception in the nineteenth century and particularly during the Cold War, international exhibitions like Expo '67 served as arenas in which political and national rivalries were played out through architectural and technological one-upmanship. Fuller's dome, the largest of its kind built at that time, was an exercise in technical virtuosity with a decidedly futuristic aesthetic, and was meant to fill "foreign spectators with awe."[2] Its choice for the American Pavilion was considered somewhat controversial. Oldenburg's *Giant Soft Fan* was only one of a number of artworks and other objects that hung from the dome; among them were James Rosenquist's mural of two huge dangling legs titled *Firepole*, life-sized models of three NASA spacecrafts, and a series of patterned Styrofoam segments that together formed an enormous American flag.

As Oldenburg explained, *Giant Soft Fan* was meant to work in opposition to the dome's glittering hardness. Indeed, pulled by gravity, the antiheroic droop of the sculpture's elements must have served as a critical foil for the triumphant engineering of the dome and, by extension, for the entire spectacle of technological wonders of Expo '67.

Amid the numerous emblems of national pride, *Giant Soft Fan* can be seen as a commentary, specifically, on the triumph of American technology.

Installation view, *American Painting Now*,
United States Pavilion, Expo '67,
Montreal, April–October 1967

With blades wilting like plant leaves under the summer sun, its aspect is far more organic than mechanical. It might represent a machine, but, in its flaccid, unplugged state, it is one that radiates qualities that are diametrically opposed to the vigor and efficiency commonly associated with automation.

Oldenburg originally proposed this work for the American pavilion because it had a particular political significance for him as well. In a drawing of 1967 titled *Proposed Colossal Monument — Fan in Place of the Statue of Liberty, Bedloes Island* Oldenburg depicted a giant whirring fan as a replacement for the Statue of Liberty, the base of the statue mimicking the pedestal of a desk fan and its pointed crown represented by fan blades in motion. In notes published in conjunction with an exhibition at the Sidney Janis Gallery in the same year, Oldenburg was even more explicit, stating that he saw the fan as a kind of "substitute image of America."[3]

Giant Soft Fan is part of a larger series of sculptures of appliances and domestic objects that Oldenburg created, beginning in 1963, and dubbed The Home. Other sculptures from the period include, among others, *Soft Juicer* (1965) and the *Bedroom Ensemble*, a three-dimensional, multi-object environment of 1969. Oldenburg first experimented with soft-fan forms in 1965, and *Giant Soft Fan* is one of two versions of the sculpture of approximately the same dimensions. The other, *Giant Soft Fan — Ghost Version* (1967), in the Museum of Fine Arts in Houston, differs from The Museum of Modern Art's version in that its primary material is white canvas, not black vinyl. Just as Oldenburg reworked the theme of the hamburger in drawings as well as sculptures, he also often altered the aspect of sculptures of the same motif by fabricating them in different materials. A number of works from The Home series come in "soft" and "ghost" versions, a juxtaposition that Oldenburg adopted as much for its metaphorical resonance as for its formal reference to light and shadow. Noting that the black and (ghost) white versions of *Giant Soft Fan* were together "a working of the theme of opposites in the context of superstition," Oldenburg said that they reminded him primarily of "two angels . . . that walk beside you."[4] — L.H.

In 1965 Oldenburg became interested in the design of colossal, civic public sculpture, monuments for contemporary society to replace more outdated ones. Using everyday, "antiheroic"[1] subject matter of the kind he had explored in his earlier work, he began to envision objects like cigarette butts blown up to enormous proportions, as awesome as any classic memorial in bronze or stone. "Colossal" is Oldenburg's word, and it connotes not just the enormous but the freakishly large. If there had been a question concerning the satirical intent of Oldenburg's earlier sculptures of hamburgers and ice-cream cones, with the advent of the colossal monuments, Oldenburg's keen, politically edged irony became more pronounced. Drawings such as *Colossal Fagend, Dream State* are meant to be both "aggressive and critical,"[2] as well as humorous and explicitly erotic.

The term "fag end" is British slang for cigarette butt and also might refer to the West End neighborhood in which Oldenburg stayed on a visit to London in the winter of 1966. Housed in a studio furnished by the print publisher Editions Alecto, he was inspired to draw a series of imaginary monuments particularly for the city. These designs were featured on a program for BBC television. In 1968 some of the same motifs reappeared in a series of prints created for Gemini G.E.L. in Los Angeles. Rendered in a realistic style that makes virtuoso use of the cross-hatching and delicate

shading of Renaissance drawing, *Colossal Fagend* also shows the range and mastery of Oldenburg's draftsmanship.

According to art critic Gene Baro, during Oldenburg's time in London he collected cigarette butts because their varied sizes and twisted shapes fascinated him. In the series of drawings executed in 1966 and 1967 in pencil, crayon, and watercolor (of which *Colossal Fagend, Dream State* is one) the cigarette butts are enlarged to monumental proportions and installed in public parks in London. "Scattered like columns of ancient temples"[3] the fag ends are accompanied by female figures who present the sculptures in the way that models present appliances at a trade show. In this drawing, a model-like figure in a hat in the center is juxtaposed with a kneeling nude model suggestively posed with a soft fag end. A third female figure is splayed out at the foot of the "monument," lolling in ecstasy.

Oldenburg's interest in erotic art emerged simultaneously with his interest in public sculpture, the phallic nature of the prototypical public monument acting as a goad. "More than food, the universal element in Oldenburg's monuments is usually sex," wrote the artist Dan Graham in an article about the colossal sculptures.[4] *Colossal Fagend* is an explicit expression of Oldenburg's desire to make a sculpture that could give "a physical sensation when you looked at it."[5] As *Dream State* suggests, there is a strong element of fantasy in this work, pertaining both to the idea of a cigarette-butt monument itself and to the women who seem in one way or another to be mastered by its spectacle.

Most of the drawings of monuments of this period depict a kind of visionary architecture that does not necessarily have to be built. "A monument," Oldenburg wrote, "is a matter of peopling or externalizing the mass consciousness."[6] When asked about the probability of a work like *Colossal Fagend* coming to realization, Oldenburg replied gleefully that his monuments existed as drawings, "which may be beautiful even if the ideas are unsound."[7]

In 1967, the same year that *Colossal Fagend* was drawn, Oldenburg did in fact execute a large soft sculpture on a similar theme; *Giant Fagends* is now in the collection of the Whitney Museum of American Art. — L.H.

Claes Oldenburg. *Giant Fagends*. 1967. Canvas, urethane foam, wire, and wood; 13 parts, overall 54" x 8' x 8' (132.1 x 243.8 x 243.8 cm). Whitney Museum of American Art, New York. Purchase with funds from the Friends of the Whitney Museum of American Art

1.

2.

3.

4.

5.

6.

Claes Oldenburg.
Notes. 1968.
Twelve lithographs and photolithographs, printed in color
(four with embossing and/or varnish additions),
each 22 ¾ x 15 ¾" (57.8 x 40 cm).
John B. Turner Fund

The twelve color lithographs and thirteen text pages that comprise Oldenburg's *Notes* depict ideas for colossal monuments to be situated in various cities in the United States and in Europe. They were created while Oldenburg was in residence at the print workshop Gemini G.E.L. in Los Angeles from January through September 1968.

Oldenburg had habitually collected his daily scribbles and scraps of text and photographs in binders, referring to them as source material for drawings and sculpture. Seeing the print medium as a way of permanently preserving the feeling of one of these working notebooks, the idea behind *Notes* was to use techniques like photolithography and embossing to create almost trompe-l'oeil simulations of

them. True to the unruly chronology of an artist's notebook, images that share the same plate do not necessarily refer to one another but, rather, have been combined primarily for visual coherence and effect. Together, the plate and text pages of *Notes* comprise a record in the print medium of the ideas that Oldenburg was working on during his nine months in California.

Oldenburg has called the *Notes* "a suite of 'monuments' which . . . may be defined as objects or parts of the body increased to colossal scale and set in a landscape."[1] Many images in *Notes* are of body parts enlarged to the scale of buildings, and most were created with a specific site in mind. "My concern on first coming to a place is always with its geography, the shape or the smell of it,"[2] wrote Oldenburg in 1967. Plates seven and nine feature plans for buildings shaped like a woman's lower torso, thighs, and legs, with particular emphasis on the knees. "Of all the parts of the body," Oldenburg claimed, knees were "the most significantly architectural."[3]

Although the *Notes* also include ideas for public sculp-

7.

8.

9.

10.

11.

12.

ture in Chicago, Kassel, and Aspen, monuments for Los Angeles dominate. Plate nine includes a sketch for a monumental nose nestled up against a Pasadena hill. In plate one, a noselike punching bag appears in a similar position, this time, according to Oldenburg, asleep against the Santa Monica mountains. Plate two features a suggested design for the Pasadena Art Museum in the shape of a pipe-tobacco tin abutting an open cigarette pack that spills its contents. Finally, in plates six and ten, Oldenburg refashioned the Los Angeles skyline into a jumble of capital letters, a quintessential vision for a city that is home to the famous Hollywood sign, as well as to out-sized marquees and billboards that line its boulevards.

In plate six Oldenburg introduced the Geometric Mouse, a motif that would become something of a logo for the artist and his many enterprises. An architectural facade with two ear-shaped crenellations, windows for eyes, and an oblong snoutlike protrusion, its shape at once recalls that of a comic-strip mouse as well as an old-fashioned exterior-reel film projector.

The idea that the shape of an architectural structure should literally reflect its use has its origins in the history of late eighteenth-century French visionary architecture. As Calvin Tomkins reported in a 1977 profile of Oldenburg, when the artist first came to New York he was "fascinated by reproductions of the drawings of the eighteenth century French visionary architects Boullée, Ledoux, and Lequeu. . . . He particularly liked Lequeu's design for a cow barn in the shape of a cow."[4] Like a growing number of architects in the 1960s, Oldenburg was also doubtlessly inspired by American commercial vernacular architecture as well. In cities such as Los Angeles, in particular, Oldenburg had ample opportunity to study contemporary symbolic architectural forms: hot-dog-shaped hot-dog stands, ice-cream shacks in the form of ice-cream cones, and the like.

Notes is one of two projects that Oldenburg completed at Gemini G.E.L. in 1968 and 1969. The second, titled *Airflow*, was a series of seven multiples based on the automobile of the same name manufactured by Chrysler in the 1930s. — L.H.

Richard **Pettibone**

(American, born 1938)

Richard Pettibone.

Andy-Warhol — Marilyn Monroe. 1968.
Silkscreen ink on canvas, 5 ¼ x 5 ¼" (13.3 x 13.3 cm).
Frances Keech Bequest

Andy-Warhol — Marilyn Monroe. 1968.
Silkscreen ink on canvas, 5 ¼ x 5 ¼" (13.3 x 13.3 cm).
Frances Keech Bequest

Jackie. 1968.
Silkscreen ink on canvas, 2 ¾ x 2 ¼" (7 x 5.8 cm).
Frances Keech Bequest

In 1964 Richard Pettibone came to New York City carrying a cardboard box with eighty-five variations of Warhol's Soup Cans. "I figured I'd better show them to him from courtesy if nothing else," said Pettibone, "and what do you know, he liked them."[1] Warhol suggested to Pettibone that he show the work to art dealer Leo Castelli, which led to his first show at the Leo Castelli Gallery in 1969, something of a miniature "Warhol retrospective." "Andy opened the door," Pettibone recalled. "I saw his first show in L.A. in 1962. Duchamp's retrospective was in Pasadena in 1963, with his *Museum in a Suitcase*, which reproduces in miniature his own work. They both said it's okay to copy."[2]

Since the early 1960s Pettibone has made a career of copying. He re-created works by contemporaries of note such as Warhol, Lichtenstein, and Frank Stella, among others, raising issues concerning authorship and artistic originality. However, Pettibone's "Warhols," for example, are remarkably smaller than the 1964 "originals." Lilliputian in scale and executed with absolute precision to the point of mounting the mini-canvas onto tiny stretcher bars, Pettibone's "craft"

may be compared to that of a miniaturist. The diminutive scale, relative to the Warhol "originals," drastically alters our experience and conception of the images themselves.

Warhol's image of Marilyn — enlarged from a cropped publicity still for the 1953 film *Niagara* — assumes monumental proportions equivalent to the subject's celebrity. However, Pettibone transformed Marilyn's image from billboard to precious object by reducing it to miniature scale. By cropping the image still further, Pettibone placed Marilyn's face tightly into the frame, like a gem into its setting — her brilliant platinum-blonde hair playing off the silver and pale sapphire-blue of the backgrounds. Both Warhol's and Pettibone's Marilyns function as memorials to the actress, who died in 1962. From this point of view, the rich colors and small scale of Pettibone's versions suggest portable icons or reliquaries appropriate to American culture's devotion to celebrity idols.

Literally pocket-size, Pettibone's *Jackie* approximates the dimensions of a wallet photo. Like a memento or souvenir, *Jackie* evokes happier times before the 1963 assassination of

Installation view, *Richard Pettibone*, Leo Castelli Gallery, New York, February 1969.

Andy Warhol. *Jacqueline Kennedy III (Jackie III)* from the portfolio *11 Pop Artists*. Volume III (1966). Screenprint, printed in color, 39 ¹⁵⁄₁₆ x 29 ¹⁵⁄₁₆" (101.5 x 76.1 cm). The Museum of Modern Art, New York. Gift of Original Editions

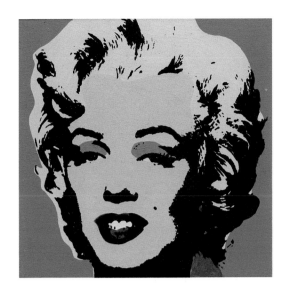
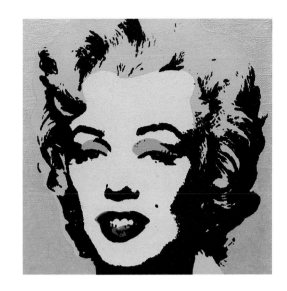

President Kennedy, whose presence in the original magazine photograph has been trimmed to include only the corners of his mouth and eye and the part in his hair. While Warhol often juxtaposed joyful images with more somber ones from the Kennedy funeral, Pettibone focused on a smiling Jackie, although the muted blue-gray portends the sadness of the event to come.

Decreased in scale and often modified through cropping and color choice, Pettibone's paintings are not copies — just as Warhol's enlarged and colored silkscreens are not copies of the photographs found in tabloids and fan magazines. In a sense, Pettibone returned Warhol's images to their portable dimensions. He did so, however, not through a process of reduction, as is most commonly assumed, but rather by tracing directly from printed reproductions found in art magazines. Each painting, identical in size to its source, thus contrasts the experience and conception of art with those of the mass-produced object. At the same time, Pettibone obligingly offered a small-scale, practical alternative to the grandiose proportions that made so many of the works of the Abstract Expressionists and the practitioners of Pop and Minimalism suitable only to the large spaces of museums, corporate lobbies, and the homes of wealthy collectors. Pettibone's petite paintings were not only more practical, they were more affordable. In a marketing strategy worthy of Warhol himself, Pettibone commodified "brand Warhol," eventually expanding his inventory to include "brand Stella" and "brand Picasso" among others. Switching from style to style, Pettibone not only demonstrated a wide range of technical skill, but also brought up the issue of artistic originality that was to become an animating aesthetic concern in the 1980s. — L.J.

Mel Ramos

(American, born 1935)

Mel Ramos.
Chic from the portfolio **11 Pop Artists**.
Volume I (published 1966).
Screenprint, printed in color, 23 ¹⁵⁄₁₆ x 19 ⅞" (60.8 x 50.5 cm).
Gift of Original Editions

Miss Comfort Creme from the portfolio **11 Pop Artists**.
Volume III (published 1966).
Screenprint, printed in color, 39 ¹⁵⁄₁₆ x 30" (101.4 x 76.2 cm).
Gift of Original Editions

In 1968 the artist and critic Douglas Davis identified what he perceived as an increase in the sexual content of art as the "New Eroticism." "We are witnessing," he wrote, "a use of erotic materials unique to the arts of our time. . . . This mood is slowly effecting (and reflecting) a major change in our attitude toward sex and its use in art."[1] The new eroticism, Davis claimed, asserted the return of Eros and sensuality following years of seemingly hermetic, abstract art. From this point of view, Mel Ramos's *Miss Comfort Creme* and *Chic* are more than mere pinups — they embody the artistic avant-garde on the eve of the sexual revolution. However, as in the work of the nineteenth-century realist Gustave Courbet, or the Surrealists Man Ray and Salvador Dali, the equation of social and artistic liberation with erotic content is manifested almost exclusively in the nude *female* body. The history of sexism in art aside, what distinguishes Ramos's brand of eroticism from that of his artistic precursors and from many of his contemporaries is its blatant "artlessness," which persistently wallows in vulgarity. While Wesselmann's nudes, for instance, may suggest an alliance with Henri Matisse, Ramos follows in the tradition of the photographic "pinup."

In a quintessentially Pop gesture, Ramos dismissed distinctions between high and low art, stating: "The whole point about my work is that art grows out of art. That is central, no matter whether it is high art, low art, popular art or what. Comic books, girlie magazines, magazine ads, billboards are all art to me."[2] At the same time Roy Lichtenstein was painting images of Popeye and Donald Duck in New York, Ramos was painting Superman and Batman in California. By the mid-1960s both artists had forsaken well-known cartoon characters for more anonymous subjects: Lichtenstein's *Drowning Girl* (page 51) and Ramos's *Miss Comfort Creme*, for example. Derived from mass culture, both represent stereotypes of women — helpless victims and sex objects — intended for distinct audiences. Where Lichtenstein featured images of women as presented to adolescent girls in *Teen Romance* comics, Ramos exposed the stereotypical female pervasive in girlie magazines aimed at heterosexual men.

The "girlie nude" first appeared in Ramos's work in 1964 and, until 1971, was the central figure in all his paintings and prints. Like their air-brushed prototypes, Ramos's nudes have hair-free poreless skin that takes on the quality of plastic, along with often grossly inflated breasts. Ramos also exploits the pinup poses typical of the genre: from woman as passive object to woman as aggressive seductress. In *Chic*, for example, having caught the voyeur in the act, the model shields herself yet remains defenseless to the gaze which is only diverted to the nipple peeking out from the crook of her right arm. Her exhibitionist sister, *Miss Comfort Creme*, in contrast, elevates her arms to maximize the display of her right breast in a seeming parody of the commercial come-on. Although working from photographic images either drawn from magazines or taken himself, Ramos never re-created his nudes in naturalistic colors. As if to emphasize their non-art origins, the neon pinks, oranges, and yellows, and artificial "perma-tan" flesh tones of *Chic* and *Miss Comfort Creme* are based on "circus colour, scientific colour, anything but the colour of French painting."[3]

Miss Comfort Creme belongs to a series of "consumer odalisques" that epitomize the advertising industry's selling of products with sex.[4] The eroticized female body, captured in suggestive embrace with a phallic tube of Comfort Creme, becomes an object for (heterosexual male) consumption. By exaggerating the equation between consumer products and the female body, Ramos's representation revels in the sexism inherent in a male-dominated consumer society.

Chic relates to what have been referred to as Ramos's "wolf call paintings"[5] in which nude women, seen from the shoulder or waist up, are depicted posed against vividly colored backdrops inscribed in bold lettering spelling out sexist remarks a woman might hear while walking down the street. (*Hubba-Hubba*, *Yum-Yum*, and *Spicey* are other examples.) In *Chic* the model recoils physically yet stares at the viewer. Interpretations of her gesture may, of course, vary depending largely on the viewer-turned-wolf-caller's own experiences related to gender and sexuality. While for some her modesty may suggest playfulness, or the passive ideal in an aggressive's erotic fantasy, for others she may embody the feelings of helplessness of women, in general, when verbally harassed.

Pinups, typically, "were attached to the walls of barracks, machine shops, bars, barbershops, in the cabs of trucks . . . in other words they appeared where men gather without

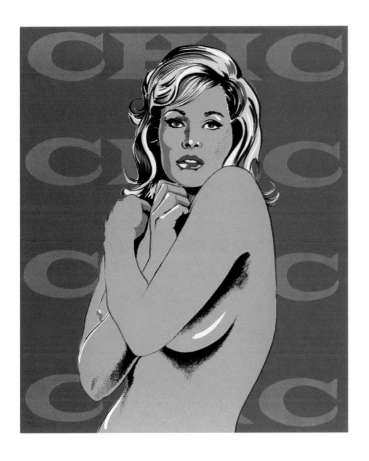

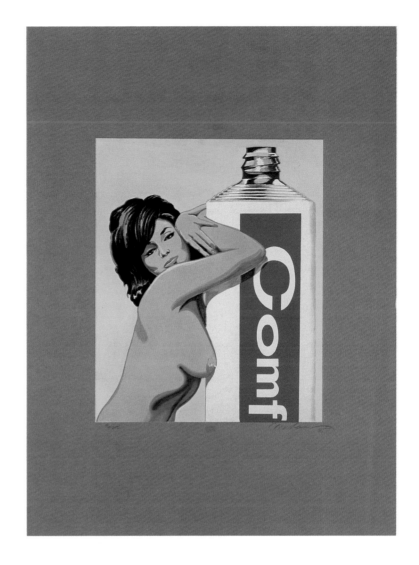

women."[6] By removing the pinup from its exclusively male context and introducing it into the space of a museum or art gallery Ramos not only questioned the nature of high art but also granted a form of legitimacy to low art and its titillating powers. In fact, the eroticism of his provocative nudes may be heightened within what many during the 1960s perceived as sacrosanct spaces, thus evoking a kind of guilty pleasure among certain viewers. — L.J.

Robert **Rauschenberg**

(American, born 1925)

Robert Rauschenberg.
First Landing Jump. 1961.
"Combine painting": cloth, metal, leather, electric fixture, cable, and oil paint on composition board, overall, including automobile tire and wood plank on floor, 7' 5 ⅛" x 6' x 8 ⅞" (226.3 x 182.8 x 22.5 cm). Gift of Philip Johnson

In 1959 Robert Rauschenberg proclaimed: "Painting relates to both art and life. Neither can be made. (I try to act in that gap between the two.)"[1] Working within that gap, he collected mundane objects from everyday life and affixed them to a wood or canvas support. Part painting and part sculpture, part art and part life, Rauschenberg's Combines, begun in the mid-1950s, included everything from the extremely personal, like worn shirts and slept-on pillows, to tires and lumber scavenged from the streets and construction sites of New York City. "I felt very rich being able to pick up Con Edison lumber from the street for combines and stretchers, taking advantage of whatever the day would lay out for me to use in my work."[2] Rauschenberg's preference for the banal as opposed to the sublime of Abstract Expressionism led to his early classification as a neo-Dadaist; later, in the early 1960s commentators were quick to name him, with Johns, a prophet of Pop.

Rauschenberg's openness to chance encounters with the urban environment relates his endeavors to those of the Surrealists and resulted in nonhierarchical allover compositions, described as evidence of his "vernacular glance."[3] In *First Landing Jump*, exhibited in his 1961 one-person show at the Leo Castelli Gallery, Rauschenberg's glance seems to be momentarily fixed on the road. Predominant elements include a tire, black-and-white striped street barrier, white-enamel light reflector from the street, and a rusted license plate mounted on composition board covered with black tarpaulin, a white drop cloth, and a paint-stained khaki shirt. The work is lit by a small blue lightbulb inserted in a tin can. According to one reviewer: "The tires in Rauschenberg's shantied cenotaphs have rolled straight off Whitman's open road to come to a great big rubbery stop against Castelli's wall. In fact there is a tarry ozone of U.S. traffic here altogether, with its Bogart roadblocks and crushed oilcans like the cuffs of bums' trousers."[4]

Literally stalled not only by the barrier that has punctured and impaled the tire to the floor, but also by the electric cord that ties the Combine to its power source, Rauschenberg's view of highway culture is distinctly curbed in contrast to the expansive interpretations of such later Pop artists as Allan D'Arcangelo and Ed Ruscha. Rather than accelerating along the open road, capturing glimpses of bold-colored logos and streamlined gas stations, Rauschenberg confined his explorations to the junkyard of journeys past. The colors of *First Landing Jump* are sober and faded, its objects rusted and battered, and its canvas scarred with suture stitches — traces of their pre-artistic histories. It requires time to fully understand Rauschenberg's rich and layered surfaces. While the work of Johns, for example, functions in part by being instantly recognizable, Rauschenberg's Combines evoke prolonged experiences such as "memory, reflection, [and] narration."[5]

Visual contemplation (as opposed to immediacy) is characteristic of the collage aesthetic, which juxtaposes multiple and often diverse elements that solicit the viewer to "read" its associative potential. Often compared to works by Pablo Picasso and Kurt Schwitters, Rauschenberg's Combines further expanded the collage vocabulary and literally broke through the boundaries of the two-dimensional picture plane to engage floor and space as sculpture does or, as suggested by the artist, to create an environment.

Duchamp's *Bicycle Wheel*, Rauschenberg said, "has always struck me as one of the most beautiful pieces of sculpture I've ever seen."[6] Mounted upside down on a wood stool, Duchamp's wheel, like Rauschenberg's tire, is deprived of its function but remains a signifier of rotary motion. Similarly, in *First Landing Jump* latent propelling motion (like a "jump") is manifest in the taut coils of the large spring attached to a loose flap of the black tarpaulin by a leather strap. Paired with a second taut strap, the suspended canvas suggests the parachute imagery alluded to in the title. The alternative to a cushioned impact, suggested by the tire, is implicit in the shirt pressed flat to the surface in the lower left. Having landed (or rolled into) the art gallery or museum, Rauschenberg's Combine offers a second life to objects that, although functionless, have become rich with meaning. "There is no reason," Rauschenberg once said, "not to consider the world as one gigantic painting."[7] — L.J.

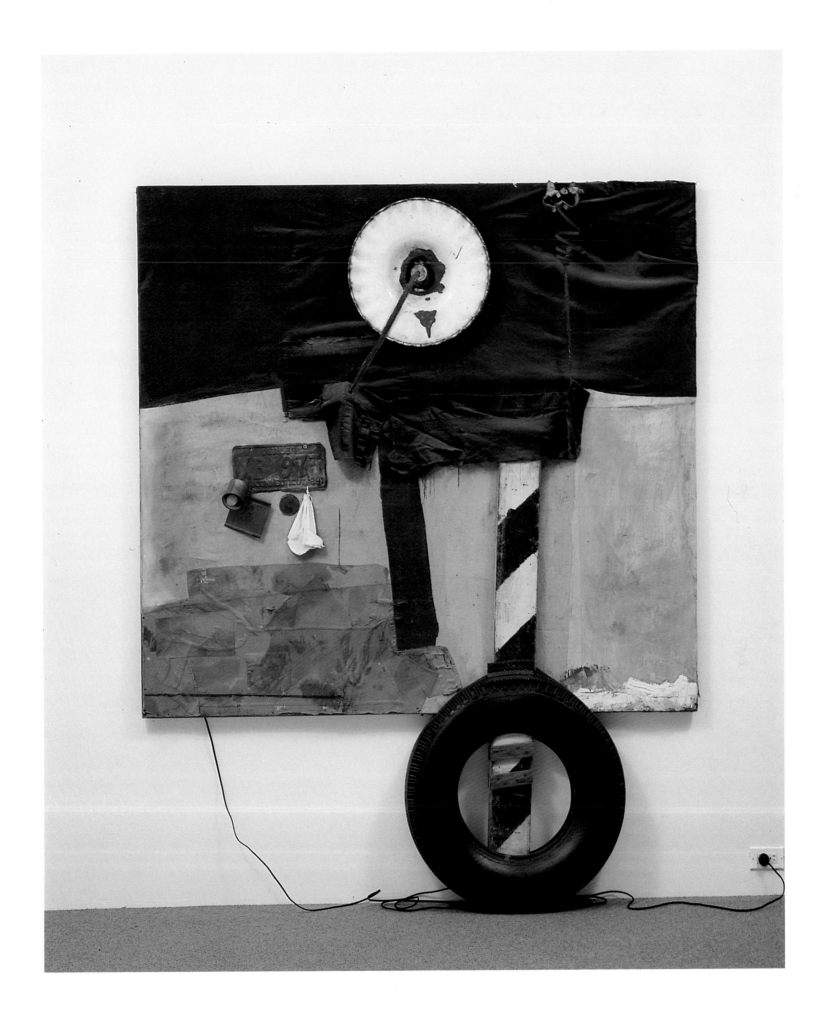

Larry **Rivers**

(American, born 1923)

Larry Rivers.
The Last Civil War Veteran. 1959.
Oil and charcoal on canvas, 6' 10 ½" x 64 ⅛" (209.6 x 162.9 cm).
Blanchette Rockefeller Fund

On December 19, 1959, Walter Williams, the last Civil War veteran, died at the age of 117. A few months earlier *Life* magazine featured Williams in a full-page photograph resting "among mementos that he can no longer see." [1] Clearly based on the photograph, Larry Rivers's *Last Civil War Veteran* was painted shortly after the magazine feature appeared and represents one of several works by Rivers on this and related themes. "I did many versions of it, small and large. The poor old man died a few months later." [2] Earlier in 1959 Rivers had painted *The Next-To-Last Confederate Soldier* based on a photograph that accompanied John B. Salling's obituary. According to Rivers, "Once this 'next-to-last' confederate soldier died, there was this one guy left from the Civil War. Now he was a media thing immediately: the *last* Civil War veteran. So I began getting interested in him and I did paintings." [3]

Rivers's attraction to such a "media thing," and especially one so blatantly American, anticipated later Pop artists' interest in American mass culture. His variations on a theme also looked forward to Warhol's use of serial imagery. And, like his peers, Rivers was exploring alternatives to the rhetoric of Abstract Expressionism. As early as 1947–48 when he was studying art with Hans Hofmann and painting "peculiar rectangles [Rivers] became frantic to draw the figure." [4]

In an avant-garde about-face, *The Last Civil War Veteran* was radical in part by virtue of its extreme conservatism.

"The Last Survivor of the Civil War," *Life* (May 11, 1959).

The Last Civil War Veteran, for example, evokes heroic deathbed scenes from religious Lamentations to such scenes as Jacques-Louis David's *The Death of Socrates* and may even be described as a sort of contemporary history painting. Nonetheless, *The Last Civil War Veteran* calls attention to the patriotic sentimentality exploited by the media in their representation of this pathetic hero; moreover, given the context of the Cold War, this depiction of the frail old soldier is less about celebrating the heroism of one individual than about American society's need to revive national heroes and patriotism in general. The body and facial features of Williams, for example, have been blurred beyond recognition through a sum of gestural strokes, erasures, and charcoal sketchmarks. His presence is ghostly against the bold reds and blues of the flags that are joined together visually by the veteran's dress uniform.

Rivers's tailoring of this painting becomes evident in comparison with the source photograph. He adjusted the uniform's right shoulder to align with the cross bar of the Confederate flag and dropped out the brocade on the left so that the sleeve fuses seamlessly with the Union flag's blue canton. Below the suspended uniform, Rivers appears to have sutured together the two flags with charcoal "stitches," evoking the union of North and South. He has also chosen to edit out the headboard, so that there is no spatial distinction between the surface of the flag and that of the pillow supporting the veteran's head and upper body. Flags, Rivers noted, provided a perfect excuse for an exercise in flat painting. Nonetheless, in collapsing space and fusing the body and uniform of the veteran with the flags, not to mention the erasure of features, *The Last Civil War Veteran* also suggests the absorption of the individual by the state.

Against the flat painting of the flags, Rivers performed a varied gestural display of bold strokes, lost and found contours, and whimsical outlines that have led to comparisons with the expressionistic brushwork of precursors Willem de Kooning and Arshile Gorky. The figure of the veteran fluctuates between the figurative and the abstract, evading absolute identification, but identifiable nonetheless by the symbolic arrangement of patriotic props. Painterly yet Pop, Rivers's *Last Civil War Veteran* presents a rich composition that addresses popular and political issues. — L.J.

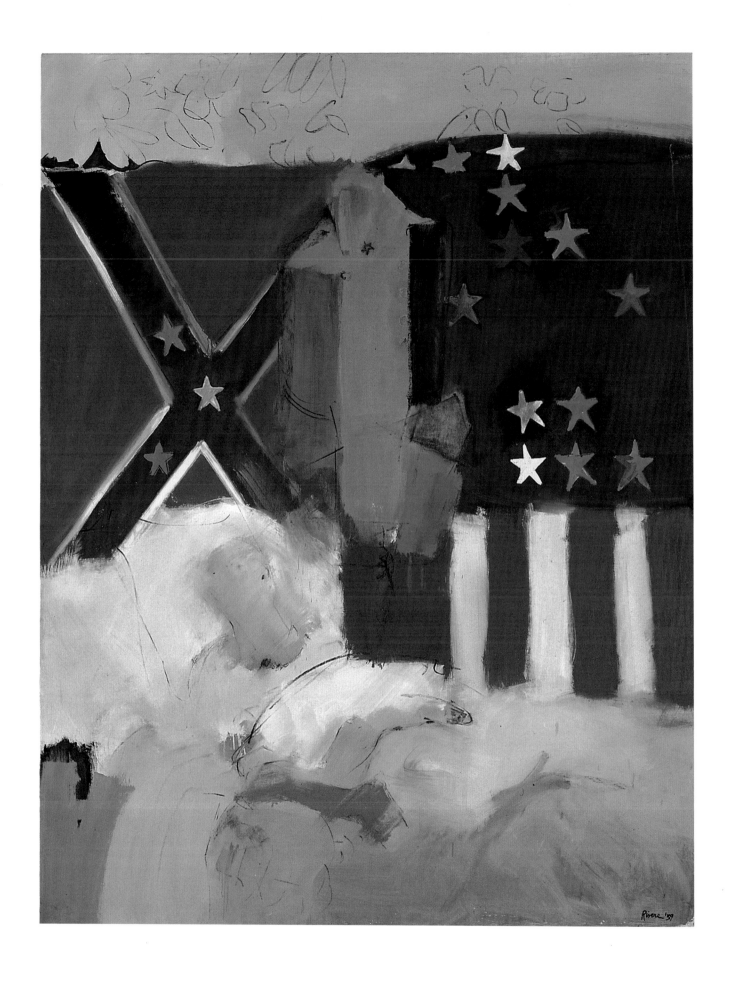

In the early 1960s, after nearly eighteen years of working primarily as a painter, Larry Rivers began to introduce diverse materials into his work. The results were rough-hewn constructions that have been described as "inspired, if makeshift, carpentry."[1] *Jim Dine Storm Window*, for example, is a portrait of Rivers's friend and fellow artist built up from the glass, screen, and aluminum of its storm-window support with additional layers of wood paneling, graph paper, and painted cardboard cutouts for the face, forearm, and hand. Sketchy lines in paint and pencil connect the diverse elements, defining the figure across the various surfaces.

Jim Dine Storm Window in position 2.

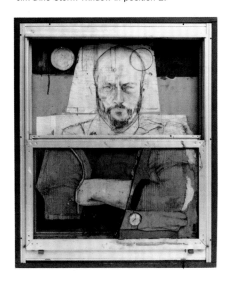

Jim Dine Storm Window in position 3.

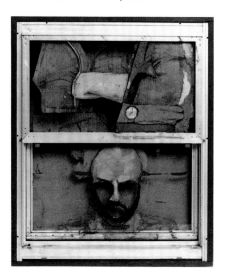

Rivers painted a number of storm-window portraits, but *Jim Dine Storm Window* was the first and, according to the artist, the only work he ever made based on a dream. In the dream, according to Rivers: "I am staying in the home of Virginia Dwan in Malibu. I open the door to my bedroom and look out the window, a storm window, at the Pacific lapping the rocky beach. When I turn to the other window, which faces the tennis court, there is no tennis court. The bust of Jim Dine, fitting perfectly into the frame of the window, blocks the view. His bald head, which I love, and his folded hairy arms, which I also love, and the grim stare of his eyes cause me to walk over to him. When I get to the window his bust is flat, as in a painting. It is only an image of Jim."[2]

Arms folded, shoulders squared, and head erect, the figure of Jim Dine faces the viewer with a mien apparently as rigid and unyielding as the storm window that frames him. From below his prominent brow and bulbous bald head, and behind the dark and somewhat demonic beard, emerge two eyes and a mouth finely sketched in pencil. Upon closer observation one finds a naturalistic rendering of the entire face hiding below the cardboard cutout "mask" pasted to the surface of the window pane.

The storm-window support allows for multiple positions, or views, of its subject. With the upper pane lowered, for example, Dine's "mask" disappears, revealing the somewhat less threatening drawing in its entirety as well as the stenciled letters H, I, and O that, combined with the circular cutout in the upper left-hand corner, spell "OHIO," Dine's home state. In the upper right-hand corner is a vague pencil sketch of Rembrandt's *Syndics of the Draper's Guild* (1662), a group portrait that was the basis for the Dutch Masters cigar-box label and was then appropriated by Rivers for his Dutch Masters series of paintings. While the incorporation of commercial imagery is a quintessentially Pop gesture, the fact that the image was originally that of Rembrandt also suggests Rivers's regard for art of the past, a regard shared by Dine. Both Dine and Rivers respected such traditional artistic skills as draftsmanship, which were generally dismissed as conservative by Pop artists fixated on the new, the now, and the mechanical. Thus, in *Jim Dine Storm Window* the contrast between the crude cutout "mask" and detailed naturalistic drawing not only reflects an exploration of

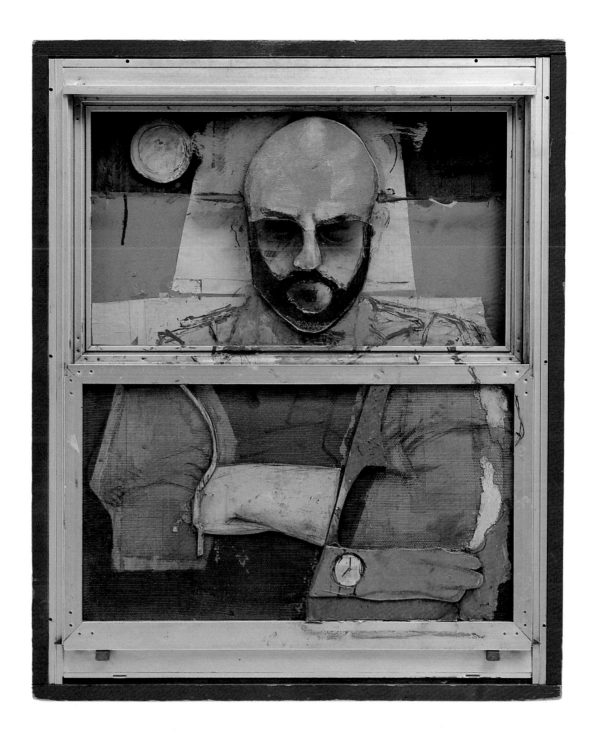

diverse materials, but also, perhaps, the interest Rivers shared with Dine in combining new pictorial strategies with traditional ones.

Viewed in this second position, does the unmasked image suggest a representation of the "real" Jim Dine? Or does it simply reveal one of multiple identities that constitute the Jim Dine "self?" Although concerned primarily with physical appearance, conventional portraiture (especially since Romanticism) also sought to capture the interior, or psychological, self, often through facial expression or body language. However, in speaking of his treatment of the face in general, Rivers has said: "One is a victim of its look. I can't express pity, hatred, joy, anxiety; I have to work on it until the expression or the look is something you cannot give a name to."[3] Dine appears as cool as

the bust Rivers thought he saw in his dream. In addition, while Rivers's storm-window portraits appear to offer a formal solution to the limits of the single surface in portraying the many layers of the complex human subject, they also call attention to those very limits.

In the third view, the conventional portrait format is literally severed in two. Dine's image is decapitated and inverted as the "mask" drops to the lower position and his folded arms move into the top position. His bald crown and bearded mouth emerge from behind the screen, creating the uncanny illusion of Dine grasping his own head. This surreal portrayal, in addition to the other two, presents a (literally) multifaceted portrait of Dine, while, at the same time, makes visible multiple ways of viewing a subject. — L.J.

James Rosenquist

(American, born 1933)

James Rosenquist.
Doorstop. 1963.
Oil on canvas with seven electric lightbulbs,
60 ⅛" x 6' 11 ⅞" x 16 ¾" (152.6 x 213 x 42.5 cm).
Mrs. Armand P. Bartos Fund (by exchange) and gift of Agnes Gund

Doorstop plays with our perceptions of domestic space. The work relies on preexisting and found objects — specifically, a floor plan of a house and seven electric lightbulbs. The floor plan represents a domestic ideal schematically laid out in black and white. It diagrams a house with three bedrooms, a dining room, a living room, a kitchen, a dinette, and space for two cars outside, most likely intended for upper-middle-class residents. The hand-painted quality of the floor plan is evident in the slight imperfections in the lines, but the artist has retained the architectural schema's impersonality, lack of painterly nuance, and flatness. In this sense, *Doorstop* relates stylistically to many other Pop works.

Rosenquist literally, and perhaps symbolically, inverts the domestic ideal by suspending his painted floor plan from the ceiling, right side down. In this position, the painting's active lightbulbs transform the work into a sculptural and utilitarian object that provides illumination, which led the artist to consider this type of painting a "chandelier."[1] In

James Rosenquist. *Circles of Confusion I*. 1965–66.
Lithograph, printed in color, 38 ⅜ x 28" (97.5 x 71.2 cm).
The Museum of Modern Art, New York. Gift of the Celeste
and Armand Bartos Foundation

1965, the collector Ethel Scull, who owned *Doorstop* at the time, confirmed the ease with which the painting was transformed into a ceiling decoration and one that reasserted aesthetic pleasure, even in the generic architectural rendering: "Some people have a Tiepolo on the ceiling — we have a Rosenquist."[2] Unlike Tiepolo's vast, softly luminous, eighteenth-century frescoes, however, *Doorstop* is a relatively cold, abstract image that provides an incongruous contrast with notions of warmth conventionally associated with the home. Likewise, its lightbulbs, while glowing, are blatantly artificial and puncture the painting's surface (the space of the home) and block some of the doorways depicted on the plan.

The title, *Doorstop*, has both positive and negative connotations. While a "doorstop" usually serves to keep a door open, thus associating the painting with ideas of accessibility, the words "door" and "stop" suggest the opposite — no entry. According to the artist, *Doorstop* was inspired by a less-than-comforting domestic image: a former coworker's awkward behavior in his own home. Wally (the coworker) and Rosenquist had painted gas tanks and refinery equipment in Wisconsin and grain elevators in North Dakota during the artist's 1953 summer break from the University of Minnesota. According to Rosenquist: "Wally, the man I worked with was an ex-convict. I didn't know he was an ex-convict until I visited his home. He was a free man, yet all the shades were drawn on his house, and he moved around his home rapidly like a mouse in a maze. I was amazed by this seemingly randomness [sic] movement, going from room to room, turning the lights on and off as he went around the house. He was a careless individual bumping into furniture as he went. I decided to try to make a randomness machine like a pinball machine that would light the lights on and off from this floor plan. It didn't work and I didn't want to revert to electronics, and apparently there's no such thing as a 'randomness' machine. I hung the *Doorstop* painting on the ceiling to reflect the mental space between ceiling and floor. The work was intended to hang in a normal home or apartment."[3]

With its untraditional installation strategy and its use of functioning lights, *Doorstop* is very much about looking and vision. Suspended from the ceiling, the painting questions the standards of observation normally associated with the

museum experience, in which paintings usually hang on walls. The experience of surprise at discovering the work on the ceiling as well as the physical discomfort in looking at it for even a short period of time recall an experience Rosenquist had in his early days as a billboard painter, in which the act of looking not only had unpleasant results but also involved lightbulbs: while the artist was watching a nude girl sunbathe on another building, three men dropped about 200 lightbulbs on his head. The lightbulbs used in *Doorstop* also anticipate the Circles of Confusion series. (Circles of confusion are the images that occur in the eye after looking at a lightbulb or the balls of light that occur when the lens of a camera is focused on the sun.)

Doorstop remains, however, a work primarily about perceptions of domesticity and confirms Rosenquist's ability to manifest the underlying complexities of otherwise familiar or common images. At the same time, its reliance on the home aligns it with that aspect of Pop art that used domestic subject matter and its symbols of consumerism, such as the lightbulbs and the house here, which the artist presented as standardized consumer products. — B.H.

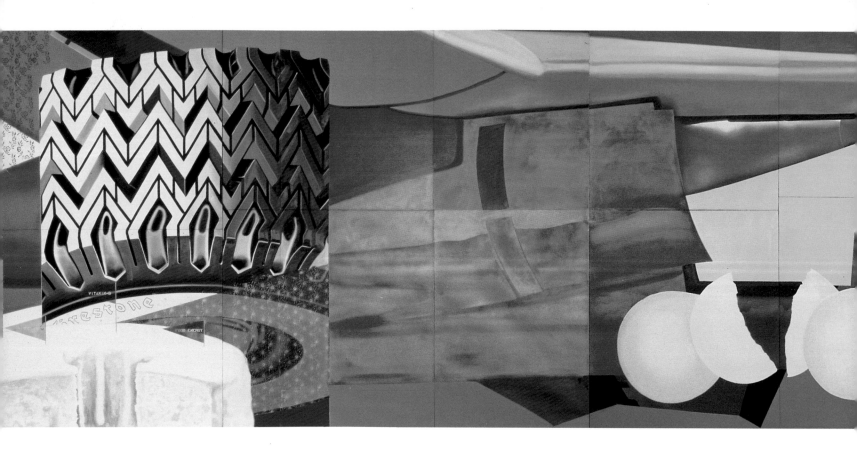

Rosenquist had painted billboards while a student at the University of Minnesota, but his experience in New York was decisive. The pictorial devices of billboard painting — commercial imagery rendered in a highly nuanced yet strictly controlled and impersonal style — began to inform his own painting in 1960, the year he quit his job as a billboard painter. For source material, the artist looked to advertisements from magazines, and, for the F-111, he found photographs and plans. This strategy was similar to the one he employed in painting billboards, in which Rosenquist was given a variety of images and materials upon which the billboard would be based. In his paintings, the artist manipulated source materials in a collagelike fashion and often maintained discrepancies in scale among them.

Rosenquist claimed he was not "glorifying popular imagery"[5] by using the subjects and style of mass media. Instead, he sought to turn the logic of advertising into the logic of painting. He wanted to create what he called "another kind of value"[6] that explored line, form, color, texture, and scale. *F-111* displays Rosenquist's love of paint, with its washes of color, imperfect edges of forms, and sometimes-visible brushstrokes. The artist preferred "anonymous images of recent history"[7] that would not compete with his "abstract attitude toward [his] painting."[8] Yet, he described

F-111, somewhat contradictorily, as his "personal reaction as an individual to the heavy ideas of mass media and communication . . . an antidote. . . . The idea of this picture was to do an extravagance, something that wouldn't simply be offered as a relief."[9] Rosenquist also looked to art history for inspiration, specifically to Mexican muralists of the 1930s and the heroic scale in Jackson Pollock's work.

The painting "parallels the war economy" by combining symbols of technological prowess and destruction with commercial products indicative of the economic stability generated by the war industry. According to Rosenquist: "People are planning their lives through work on this bomber, in Texas or Long Island. A man has a contract from the company making the bomber, and he plans his third automobile and his fifth child because he is a technician and has work for the next couple of years. Then the original idea is expanded, another thing is invented; and the plane already seems obsolete. The prime force of this thing has been to keep people working, an economic tool; but behind it, this is a war machine. . . . [The maker of the F-111] is just misguided. Masses of people are being snagged into a life and then continue that life, being enticed a little bit more and a little bit more in the wrong direction."[10] Consequently, for the artist, tools of warfare and consumer products were

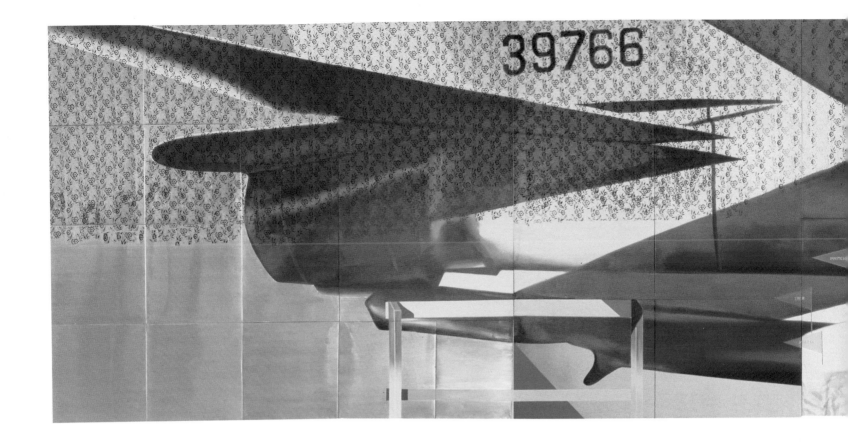

James Rosenquist.
F-111. 1964–65.
Oil on canvas with aluminum, 10 x 86' (304.8 x 2621.3 cm) overall.
Gift of Mr. and Mrs. Alex L. Hillman (by exchange) and Lillie P. Bliss
Bequest (by exchange)

F-111 was called the "world's largest pop painting"[1] when the Leo Castelli Gallery first exhibited it in April–May 1965. Consisting of approximately fifty-one interlocking sections, the eighty-six-foot-long work is reminiscent of a billboard in size, in the scale of its images, and in its commercial technique. The painting covered four walls in the Castelli gallery and created an enclosed room that surrounded the viewer in a "visual boomerang."[2] The painting's central horizontal element is an F-111 fighter-bomber, above and below which the artist has deployed a panoply of motifs. These include, reading from left to right, a wallpaperlike floral pattern, a hurdle, an angel food cake with flags bearing the names of nutrients, a Firestone tire, lightbulbs, a fork stuck in spaghetti, a girl under a missile-like hairdryer in front of an artificially green lawn, and a beach umbrella superimposed on an atomic blast, the latter anticipating the air bubble rising from what the artist has described as an "underwater swimmer."[3] Beginning with the umbrella, these elements rest upon a clothlike form and an expanse of spaghetti. The painting combines the visual rhetoric of military tools of destruction with commodities and consumption. *F-111* may be read, then, as a commentary on the relationship between militarism and consumer capitalism. The year in which it was completed, 1965, was marked by intensified U.S. military action in Vietnam and by antiwar protests at home. The artist saw the painting as "a huge extravagance that would parallel the war economy in our country."[4]

In 1957, two years after Rosenquist had arrived in New York City from Minneapolis with a scholarship to the Art Students League, he began to work as a billboard painter in Times Square and in Brooklyn in order to support himself.

Installation view of Rosenquist's *F-111* in the Leo Castelli Gallery, New York, April–May 1965.

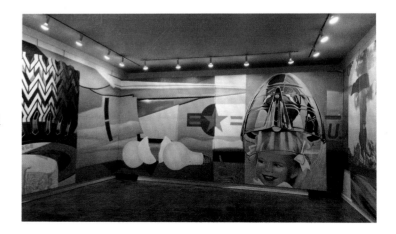

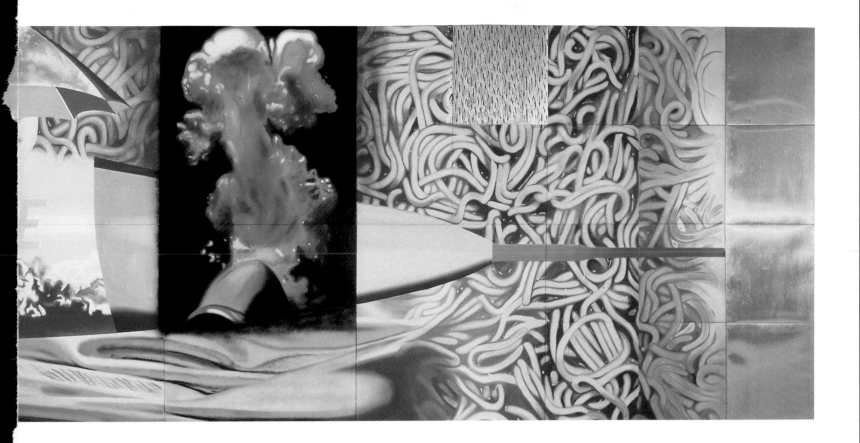

changes in the colors, which are blatantly artificial (such as "Franco-American spaghetti orange").[15] The horizontal movement of the airplane conflicts with the more vertical arrangement of the other imagery, despite their friezelike organization. Furthermore, the impossibility of viewing the painting all at once underscores the artist's interest in peripheral vision, which he also saw as an experience conditioned by the mass media. (He later stated that this was more important than the antiwar theme.) Rosenquist particularly liked the way in which the "enclosure" created by the painting caused "the senses . . . [to be] filled from the side."[16] The aluminum panels exaggerated the effects of indirect vision by reflecting other panels. And, Rosenquist controlled the "stops and rests for the person's eye," offering the break in the painting as a "relief."[17]

The painting's fragmentation, however, may have eclipsed its ability to function as a cohesive social and historical critique. For example, on the occasion of the inclusion of the work in the 1968 exhibition *History Painting — Various Aspects* at The Metropolitan Museum of Art, New York, critics hotly debated *F-111*'s success as political commentary. Henry Geldzahler (then a curator at the Metropolitan) deemed *F-111* "the symbol of the industrial-military complex of our time,"[18] and Max Kozloff called it "a picture that

whether consciously or not, replies to . . . [Picasso's] 'Guernica' across the years, and . . . which maximizes the political implications of Pop art."[19] Another critic, however, felt that the work's use of "a variant of synthetic Cubism" automatically precluded the possibility of a "meaningful narrative" and "the expression of sentiment."[20] Still another critic, writing in 1965, believed it was the work's "simple story . . . [that] subordinated formal inventiveness."[21]

For Lawrence Alloway, however, writing in 1972, form and content were extraordinarily in tune. In an evaluation that seems to summarize Rosenquist's intentions in *F-111*, he noted that the artist's "environmental paintings propose an epic treatment of American subjects and, at the same time . . . a postponed closure of the relationships and a derealization of the objects themselves. . . . Rosenquist . . . depicts the world in terms of those episodes in which we lose our grip on it . . . celebrating America and alienation from it."[22] *F-111*'s indulgence in the visual landscape of capitalism and militarism is simultaneously one of attraction and criticism, and, as such, the work offers us the contradictory pleasures that only a "huge extravagance" could. — B.H.

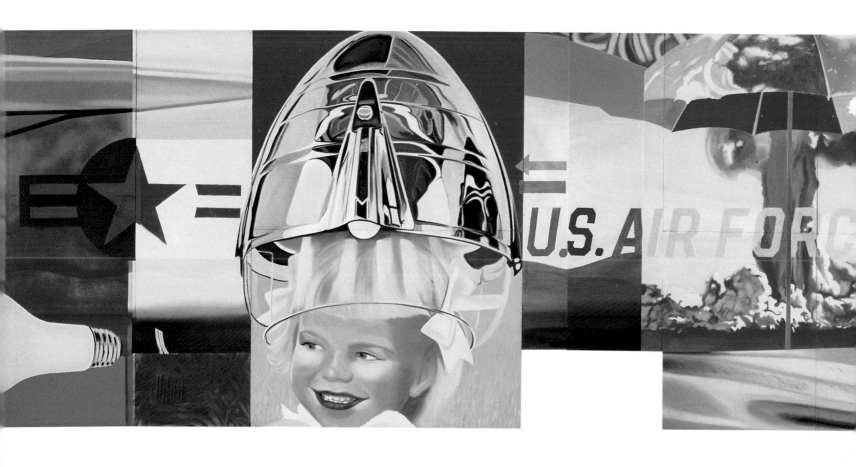

interchangeable. Rosenquist saw the angel food cake as a "metaphor for a missile silo," the wallpaper pattern, which he painted with a roller, as "a solid atmosphere filled with radioactivity," and the lightbulbs as falling "from the bombbay doors."[11]

Along with the iconographic commentary, the artist hoped that the painting's physical structure would "parallel the war economy." Although Rosenquist made the painting in separate pieces because his studio was too small to accommodate the entire work (which is longer than the actual F-111), the separate panels were more importantly a commentary on the tax structure underlying the production of military weapons: "One piece of this painting would have been a fragment of a machine the collector was already mixed up with, involved in whether he knew it or not. The person has already bought these airplanes by paying income taxes or being part of the community and the economy. The present men participate in the world whether it's good or not and they may physically have brought parts of what this image represents many times. Then anyone interested in buying a blank part of this, knowingly or unknowingly — that's the joke — he would think he is buying art and, after all, he would just be buying a thing that paralleled part of the life he lives."[12]

Rosenquist, like other Pop artists, thus acknowledged that the painting is a commodity like the commodities it represents. Fortunately, Castelli stipulated that the sale of the individual panels was subject to cancellation if someone wanted to purchase the entire work, which Robert Scull did for a reported $60,000 in a sale that received coverage in *The New York Times*. Through iconographic and structural tactics, *F-111* addressed what Kirk Varnedoe has called "the interrelation between private consumer amusements and massive societal malfeasance."[13]

In proposing the sale of the individual panels, Rosenquist wanted people to collect "fragments of vision"[14] in a way that would resemble the visual experience created by the mass media, in which a bombardment of imagery often resulted in the abstraction of that imagery. The panels of *F-111*, taken individually, assume an abstract quality that undermines their function as part of the whole painting (much like the pieces of a puzzle), but their commercial style still evokes the language of advertising. Fragmentation occurs in the painting formally, too, as a certain pictorial violence. Rosenquist cropped, juxtaposed, and superimposed elements. The seams between the panels and the corners connecting them intensify the segmentation. He employed unrealistic disparities in scale, and unexpected and shrewd

Edward Ruscha

(American, born 1937)

Edward Ruscha.
OOF. 1962–63.
Oil on canvas, 71 ½ x 67" (181.5 x 170.2 cm).
Gift of Agnes Gund, the Louis and Bessie Adler Foundation, Inc., Robert and Meryl Meltzer, Jerry I. Speyer, Robert F. and Anna Marie Shapiro, Emily and Jerry Spiegel, an anonymous donor, and purchase

Oof! Like a punch line without a joke, or an effect searching for a cause, the bright yellow letters that spell out the word "oof" are centered and isolated within the boundaries of Ruscha's canvas. They lack even a punctuating exclamation mark. Belonging to that class of words known as interjections, "oof," despite its deadpan presentation, is onomatopoeic, it imitates a sound from the audible world. An "oof" is often prompted by an action like a punch in the stomach or sinking down, exhausted, into a chair. Involving an abrupt, sometimes violent, expulsion of breath, it is typically human. Like other words that appear in Ruscha's paintings of this period, among them *Honk* and *Smash*, it often functions as an interruption, just as, visually speaking, it interrupts the deep blue of the painting's ground.

In its written form, "oof" has definite pop-culture associations, in particular those of comic-strip or cartoon language. Unlike the short phrases or words included in Lichtenstein's comic-book paintings, however, it has no graphic sound bubble or any sort of explanatory surround. As a result, it imbues Ruscha's spare, abstract painting with an uncanny, anthropomorphic presence. At the same time, it emphasizes the gap that exists between the noise of human speech and the silence of the written (or painted) word. Emblazoned across the flat opaque surface of Ruscha's canvas, "oof" appears in a state of suspended animation.

Spread from *Print*, February–March 1957, with reproductions of Jasper Johns's *Target with Four Faces* (1955) and Marvin Israel's poster *Ballet Russe de Monte Carlo*.

Noise is presented visually, muted, and severed from literal sound just as the word is severed from clues to its meaning.

Frustrating all but the most rudimentary attempts at reading, *OOF* insists that it is there to be looked at, forcing us to distinguish, as the critic Peter Schjeldahl has noted, between the word as sign and the word as sight. Appearance, sound, and spelling — the "non-discursive aspects of language"[1] — are highlighted and brought, literally, to the foreground. To look at *OOF*, is, first of all, to acknowledge its abstract simplicity, its hard-edged geometric forms, restricted palette, and uninflected ground. At the same time, its two yellow "O"s appear to ogle or gaze at us, doubling as glow-in-the-dark, cartoonlike "eyes." The plain, sans-serif style of *OOF*'s letters contributes to the work's cartoonlike punch and graphic effect.

When Ruscha arrived in Los Angeles in 1956 from Oklahoma City it was with the intention of studying to become a commercial artist. Enrolling in the Chouinard Art Institute, best known at the time as a school for Walt Disney illustrators (yet counting among its faculty members artists such as Robert Irwin and Billy Al Bengston), Ruscha worked for a time as a printer and for an advertising agency doing layout and graphics. Like a number of other Pop artists, therefore, he came to painting with a strong background in commercial art, typography, and design.

Ruscha has frequently credited his decision to become a fine (as opposed to commercial) artist with his discovery, in 1957, of a reproduction of Johns's *Target with Four Faces* in *Print* magazine. A look at the original layout, shown here, reveals that Ruscha saw not just one target but two. The work was illustrated twice, open and closed. Presenting a visual pair of concentric circles, Johns's targets, like Ruscha's painted letters, function as mimetic representations and abstract signs. Although Johns's use of "impersonal-looking letters" (in works other than *Target with Four Faces*) has been compared with Ruscha's painting,[2] the *Print* magazine spread, when scrutinized with an eye not only to Johns's images but to its overall layout, strangely foreshadows *OOF*'s basic elements: two circles paired with a series of straight vertical and horizontal lines.

OOF was begun in 1962, a key year for Ruscha and for Pop. The artist has described *OOF* as "one of my best works of this period."[3] — A.U.

In paintings like *OOF*, Ruscha placed words where we might expect to find images. In books like *Twentysix Gasoline Stations* he reversed the process, reproducing pictures where we might expect to find texts. Words are hardly absent from Ruscha's books, however. Rather, they appear as found elements within roadside landscapes, recorded by the artist's camera instead of being printed in conventional, linear fashion across the surface of each page. Whereas Ruscha's paintings of the early 1960s display single words in isolation, *Twentysix Gasoline Stations* sets them back out in the world.

The idea for *Twentysix Gasoline Stations*, according to the artist, "came out of a play with words." Specifically, he liked the quality of the number "twenty-six" and the word "gasoline."[1] This said, however, the book's subject matter remains difficult to ignore. It contains, as promised by its title, photographs of twenty-six different filling stations taken by Ruscha in California, Arizona, New Mexico, Texas, and Oklahoma. Brief captions accompany these images, pinpointing each station's location along Route 66.

Ruscha used to drive back and forth between Los Angeles and Oklahoma City at least five to six times a year. Although the book is far from a personal travel narrative, an autobiographical dimension nonetheless underlies the interest it manifests in highway culture, car travel, and the proliferation of signs, all subjects that are indisputably Pop. Ruscha was not the only Pop artist making road trips in the early 1960s. Andy Warhol, for instance, drove by car across the country in 1963, traveling from New York City to Hollywood. He later recalled: "The farther west we drove, the more Pop everything looked on the highways. Suddenly we all felt like insiders because even though Pop was everywhere — that was the thing about it, most people still took it for granted, whereas we were dazzled by it — to us, it was the new Art. Once you 'got' Pop, you could never see a sign the same way again. And once you thought Pop, you could never see America the same way again."[2]

Ruscha's photographs of gas stations were intentionally deadpan, but the paintings and the print he subsequently made based on one of the two Standard station photographs featured in *Twentysix Gasoline Stations* were anything

but. To compare his 1966 screenprint *Standard Station* with its photographic counterpart is to witness a transformation from nitty-gritty black-and-white particulars to a "standard" station, a station that sets standards, a model station, an ideal.[3] Flopping the photograph so that the word "standard" leads into the composition from the upper left, Ruscha extended the image's proportions, evoking those of a billboard or wide movie screen. Moving in close to his subject, adopting a raking angle of vision, Ruscha presents us with a gas station that we can, literally, look up to. Its gleaming white planes and sharp angles contrast vividly with the print's lurid background.

Ruscha's stylized paintings of gas stations quickly led critics to identify him as one of the West Coast's key Pop artists, and his books, of which *Twentysix Gasoline Stations* was the first, remain among his most well-known contributions. "The purpose behind the books and my paintings is entirely different," the artist has stated, and one of the purposes of the books "has to do with making a mass-produced object."[4] This interest in mass production can also, of course, be connected to Pop aesthetics, shifting attention from issues of subject matter to those of style, structure, and distribution form. Striving, in his photographs, for an anonymous amateur quality, Ruscha conceived of his books as collections of inartistic "facts."[5]

Ruscha's use of repetition, replication, and grouping by type in *Twentysix Gasoline Stations* presents certain parallels with Warhol's series of thirty-two *Campbell's Soup Cans* (page 109), first shown at the Ferus Gallery in Los Angeles during the summer of 1962. Warhol, however, "manufactured" thirty-two basically similar, yet subtly varied, soup cans (each represents a different flavor); Ruscha produced, in his own words, "400 exactly identical books."[6] And while Warhol used paint on canvas to introduce mechanically reproduced imagery into his work, Ruscha — alone among the major Pop artists — used straight photography rather than represent consumer culture at a stylized remove. Because of their "systematic deployment" of photography, among other reasons, his books came to provide important touchstones for late 1960s and 1970s Conceptual art.[7] — A.U.

STANDARD, AMARILLO, TEXAS

MOBIL, WILLIAMS, ARIZONA *STANDARD,* WILLIAMS, ARIZONA

Ruscha's best-known book, *Every Building on the Sunset Strip*, takes Pop art's leveling impulse to a conceptual extreme. Mounting a motorized camera onto a pickup truck, Ruscha set out to record every building, billboard, sign, and vacant lot falling within the boundaries of the mile-long stretch of Sunset Boulevard known as the Sunset Strip. For *Twentysix Gasoline Stations* the artist had photographed nearly fifty gas stations and then made a selection from them corresponding to the number set by the book's title. In producing *Every Building on the Sunset Strip*, however, he sought to avoid the aesthetic choices involved in editing by recording a continuum. Issues of selectivity and subjectivity entered in only with regard to his initial decision to restrict his field of activity to the Strip.

When closed, *Every Building on the Sunset Strip*, like many of Ruscha's other books, measures a compact 7¾ inches high by 5¼ inches wide. Once opened, however, its panoramic contents unfold to twenty-seven feet. The small black street numbers ranging from 8024 to 9176 Sunset, the names of cross streets that run along one edge, and the similar names and numbers extending from 9171 to the Strip's intersection with Laurel Canyon running along the other provide the only caption information found in the book. Photographed in black-and-white, the two sides of the street are divided by an expanse of white. The book's format as a whole presents, as David Bourdon has remarked, "the literal but humorous idea of rendering the Strip in strip form."[1]

The two extended photographic images displayed in *Every Building on the Sunset Strip* are far from seamless. Cutoff cars, along with shifts in light and perspective, reveal the montage process used in constructing this continually discontinuous picture of a street. Montage is, perhaps, particularly suited for rendering the Strip, which has been described as "a montage of fantasies similarly cut or distorted."[2] Ruscha's art, and in particular his books, are not only appropriate to but inseparable from the context of his adopted city, Los Angeles. Speaking of *Every Building on the Sunset Strip*, Ruscha noted: "All I was after was that storefront plane. It's like a Western town in a way. A store-front plane of a Western town is just paper, and everything behind it is just nothing."[3] Simultaneously evoking Los Angeles's proliferation of signs and its connection to film culture, Hollywood, and the artificially constructed reality of movie

sets, Ruscha's words highlight the reciprocity between the visual language of the city and that of *Every Building on the Sunset Strip*.

If, as Los Angeles art critic Christopher Knight has stated, "Los Angeles . . . represents the first authentic mass culture environment in world history,"[4] a place "where even the architecture seems to be only an excuse to prop up enormous signs,"[5] *Every Building on the Sunset Strip* emphasizes precisely those qualities of the city. In this sense, it presents certain parallels with the type of urban consciousness and architectural thinking represented in Robert Venturi's and Denise Scott Brown's book of the early 1970s, *Learning from Las Vegas*. Focusing on the architecture and signs particular to car culture and to the evolving model of the urban/suburban roadside strip, both Ruscha's book and that of Venturi and Scott Brown suggest an openness to and tolerance for the unplanned, even tawdry, aspects of their respective "strips."

From a late 1990s perspective, it is perhaps difficult to recapture a sense of the profound excitement generated by Ruscha's "bookworks" during the decade in which they first appeared. While it is perfectly accurate to discuss both *Twentysix Gasoline Stations* and *Every Building on the Sunset Strip* in terms of Pop art, given their shared concerns with mechanically reproduced imagery, words and signs in the landscape, vehicular motion, and highway culture, these books proved influential in other ways as well. Ruscha once remarked: "My other work is definitely tied to a tradition . . . I've never followed tradition in my books."[6] Instead, his books established an entirely new model for artists' books, one that depended on unlimited editions, non-narrative structures, the use of photography, and banal subject matter.

Every Building on the Sunset Strip was reproduced by artist Sol LeWitt in his important article, "Paragraphs on Conceptual Art," published in *Artforum* in 1967. LeWitt stated that the avoidance of subjectivity was Conceptual art's primary goal. In its antihierarchical organization, its relatively random selection of imagery, its quantifying captions, and its deadpan documentary style, *Every Building on the Sunset Strip* represents a systematically constructed image of pop culture's visual vernacular key to definitions of both Pop and Conceptual art. — A.U.

8806 8810 8814 8816 8818 8820 8822 8824 8826 8828 8844 La

Horn 8801 8831 8833 Larrabee

Edward Ruscha.
1984. 1967.
Gunpowder and fixative on paper, 14 ½ x 22 ⅞" (36.8 x 58.4 cm).
The Joan and Lester Avnet Collection

Wax. 1967.
Gunpowder and fixative on paper, 14 ½ x 23" (36.8 x 58.5 cm).
The Joan and Lester Avnet Collection

Speaking a few years after his gunpowder drawings were first exhibited at the Alexander Iolas Gallery in New York, Ruscha remarked: "If I could do it all over again, I would not tell anybody [they were] made of gunpowder, because people expected some kind of stunt."[1] In his review of Ruscha's show, Hilton Kramer had written: " 'Gunpowder Drawings' . . . sounds rather alarming. One expects something violent even if one does not know quite what it is that one expects."[2] Although Kramer went on to qualify his comments, noting that the exhibition's title reflected only the work's unusual medium rather than its "emotional tenor," an undeniable, even delectable, sense of frisson still clings to Ruscha's drawings, provoked by the intimate proximity, or rather, transformation, of a potentially explosive substance to art.

As with *OOF* (page 93), short isolated words (or, in the case of *1984*, numbers) are the subjects of Ruscha's gunpowder drawings. Whereas the painting features a guttural, practically preverbal, utterance, Ruscha's exquisitely shaded, modulated velvety drawings literally portray words of substance (like *Wax*) or words with literary overtones (it is impossible, for instance, to separate *1984* from George Orwell's eponymous book). *OOF*'s lettering is flat, but the gunpowder drawings' letters are illusionistically rendered in cursive script, both letters and numbers having a three-dimensional presence. Although visualized without the aid of a still-life model, they are depicted as though constructed from strips of paper or ribbon and shown in perspective as if seen from above or below. Continuing to explore language's visual or optical potential, Ruscha transformed words into pictorial images of sculptural objects possessed of an indeterminate (and indeterminable) scale.

Ruscha announced that he liked gunpowder "better than charcoal,"[3] finding within it the means to achieve an extraordinary range of tonalities and subtle modulations of light. His discovery of this new medium heralded the introduction of an incredible variety of mineral and organic substances into his work. At the same time, it led several commentators to compare the gunpowder drawings to the softly contoured, conté crayon drawings of the French painter Georges Seurat. Although less than accurate, this comparison serves to suggest one of many reasons why, when Ruscha's drawings were first shown in New York, few commentators thought to connect them — or the artist — with the bright, bold brash imagery of Pop. Although Ruscha's early work of the decade had been featured in key Pop art shows in California and he had previously been included in group shows in New York, the gunpowder drawings constituted his first one-person exhibition in the city, coming at a time when not only the mood of his work but the political, social, and cultural climate had changed. This said, however, Ruscha stands as one of the key Pop artists of the 1960s, even as his multifaceted body of work pushes at and challenges the boundaries of the term. The somber, silvery photographic tones of his gunpowder drawings hint at the darker side of what is often taken simply as a celebratory movement. At the same time, these works reinterpret and reinvigorate what might, by the end of the 1960s, have been seen as a banal gesture, transforming humble stuff (materially speaking), or the commonplace, into a work of art. — A.U.

George Segal

(American, born 1924)

George Segal.
The Bus Driver. 1962.
Figure of plaster over cheesecloth; bus parts including coin box, steering wheel, driver's seat, railing, dashboard, etc., figure 53 ½ x 26 ⅞ x 45" (136 x 68.2 x 114 cm), overall 7' 5" x 51 ⅝" x 6' 4 ¾" (226 x 131 x 195 cm).
Philip Johnson Fund

George Segal first "met" *The Bus Driver* on his regular commute between the Port Authority Bus Terminal in New York City and New Jersey, where he lived and worked in a studio that was once a chicken coop. Struck by the driver's sullen, arrogant manner, Segal "really wanted to order the air around him and give him the dignity of helplessness — a massive, strong man, surrounded by machinery, and yet basically a very unheroic man trapped by forces larger than himself that he couldn't control and least of all understand."[1] At a Newark scrap yard he found a junked city bus lying on its side along with cold-chiseled parts that would become the permanent platform for his plaster figure of *The Bus Driver*.

The Bus Driver was one of Segal's earliest works in plaster. After ten years as a painter he became frustrated with the spatial limits of the two-dimensional and, in the late 1950s, began exploring sculpture. "The decision to enter literal space was determined by strong urges for total experience," the artist stated.[2] Mannequins were the models for his first plaster figures, which were constructed of armatures and wire mesh and covered with burlap dipped in plaster. Then in 1961 one of Segal's students, responding to an assignment to use unusual materials, brought him a sample of Johnson & Johnson bandages ordinarily used for the setting of bones. "Immediately, I knew what I wanted to do," Segal proclaimed. "I was my own first model. I wrapped myself in the bandages and my wife put on the plaster. I had a hell of a time getting the pieces off and reassembled. But it eventually became *Man at the Table*. I had found my medium."[3]

Segal used friends and relatives as his models; his brother-in-law posed for *The Bus Driver*. Casting was done in sections and required the model to hold poses for up to forty minutes until the plaster hardened. Reassembled by Segal, the final plaster was not used as a mold (the standard process for making a bronze) but existed as the final object, encasing all surface details (like pores) inside. According to Segal: "I choose to use the exterior because, in a sense, it's my own version of drawing and painting. I have to define what I want and I can blur what I don't want. It bears the mark of my hand; but it bears not the work of my hand so much as the mark of my decisions in emphasis."[4] Segal's interest in tracing his process recalls the indexical gestures of the Abstract Expressionists, while his embrace of figurative subject matter derived from the everyday shows a clear rejection of the abstract and its often subjective aims. "Casting left me free to compose and to present content," Segal stated. "I could report on my model and not on me; it was a rejection of the psychological distance of the canvas painter."[5]

This rejection of the psychological combined with subjects tied to quotidian experience led many to categorize Segal as a Pop artist, and *The Bus Driver* and *The Dinner Table* (1962) were included in the landmark show *New Realists* of 1962, one of the first Pop-art exhibitions in the United States. But Segal's anonymous and often solitary figures are closer in mood to the images of isolation painted by Edward Hopper than to the visually immediate, commercially inspired and often celebrity oriented images of such champions of Pop as Warhol or Lichtenstein. With cinder blocks for wheels and lacking an engine as well as passengers, Segal's *Bus Driver* remains helpless and alone — his isolation emphasized by his "taped-up" mouth and closed eyes, an unavoidable result of the casting process, yet symbolically expressive in this driver — apparently on the road to nowhere. His despondent expression and hunched posture are further emphasized by the sagging of his plaster-saturated cheesecloth coating. Of Segal's works Allan Kaprow noted that despite "their closeness to the actual, they are also removed, cut off from life, with a sad and sometimes terrifying ominousness,"[6] like "vital mummies."[7] Identified only by his occupation, *The Bus Driver* is not a portrait of a specific individual, but of a type; like Segal's other figures of gas-station attendants, a diner customer or farm worker, for example, *The Bus Driver* is a representation of the common man. In general, Segal engaged more with the "masses" than with mass culture, presenting an often dispirited cast of characters with an air of matter-of-fact directness. Described as "humanitarian" and as "proletarian" from a political point of view, Segal's figures, in both instances, present an alternative to mainstream Pop's more celebratory view of life in American society. — L.J.

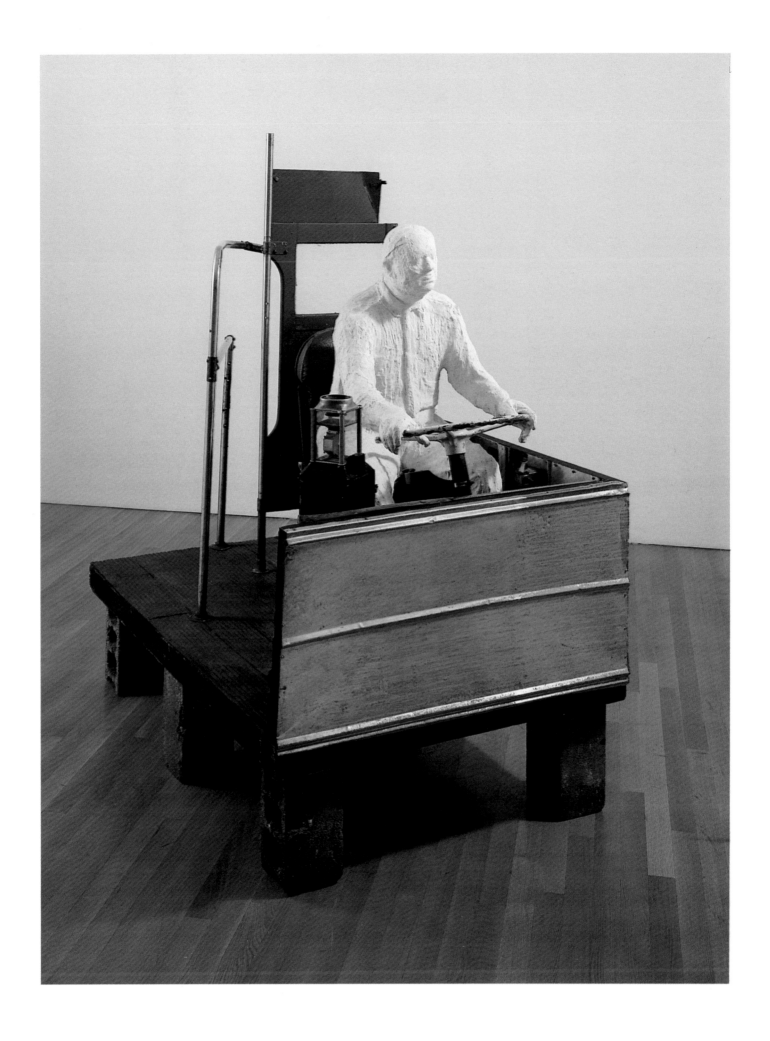

Cast from life, Segal's plaster figures seem the ideal format for portraiture. But Segal actually preferred not to do casts identified as specific persons, favoring instead generalized depictions or types. When asked to do a portrait of his dealer, Segal was surprised: "Here was Sidney Janis, whom I had always relied upon to shield me from commissions, himself wanting to be portrayed!"[1] Accepting his dealer-turned-patron's wish to be represented in the company of his favorite Mondrian painting, Segal then suggested it be exhibited on an easel. Without a moment's hesitation, Janis offered his favorite English display easel. *Portrait of Sidney Janis with Mondrian Painting* presents the dealer in a relaxed pose with his left hand placed gently on the frame of *Composition* (1933), the first of eight Mondrians to enter his collection. In discussing the poses of his models in general, Segal has said: "The human being is capable of an infinity of gestures and attitudes. My biggest job is to select and freeze the gestures that are most telling so that if I'm successful . . . I hope for a revelation, a perception."[2] Janis's outward reach suggests not only proprietorship but also affection for the painting that Janis selected one year before it was completed from among works he saw in Mondrian's studio in 1932. "The thing that touches me," Janis said, "is that it's a Mondrian to which I feel very close, having lived with it since 1933."[3]

Mondrian's abstract vision of the world distilled to a grid and primary colors provides an arresting contrast to Segal's

figure of Janis created from the dealer's body. While Mondrian resisted reference to material reality, Segal was dependent on it for the making of his art. In addition, the graphic precision of Mondrian's lines and planes can evoke the machine-made, while the crusty and palpated plaster "skin" records the artist's touch. The process of casting from life necessitates a certain amount of physical intimacy between artist and sitter. This may explain not only Segal's reliance on friends and family as models but also his desire to capture a physical likeness that is more than superficial. As Segal has remarked: "To hold a pose for forty minutes, you can't be in a social or artificial posture. Then the body reveals certain truths about itself."[4]

Dealer to other Pop artists such as Dine, Marisol, Oldenburg, and Wesselmann, and organizer of the *New Realists* exhibition, Janis played a key role in promoting Pop. He began collecting works "by the more challenging 20th century artists" in 1926 and twenty years later became a dealer committed to selling, as well as continuing to acquire, works of the contemporary avant-garde. Alfred H. Barr, Jr., once described Janis as "the most brilliant new dealer, in terms of business acumen, to have appeared in New York since the war."[5] In Segal's *Portrait of Sidney Janis*, the relationship between Janis and the Mondrian painting attests not only to its owner's taste in art, but also to his artistic foresight. By the 1960s Mondrian's contribution to the history of art was unquestionable and his influence had permeated the more popular arts like commercial design. Mondrian's painting functions as a sort of celebrity endorsement for Janis's professional skills. The selling of Janis the dealer, and of art in general, is addressed more directly by Marisol in her 1967–68 *Sidney Janis Selling a Portrait of Sidney Janis by Marisol, by Marisol*, shown here. With his head and leg forward, hand resting on his knee, in a casual yet assertive stance, the "real" Janis is portrayed by Marisol as consummate salesman. Segal's Janis, by contrast, addresses the canvas (not the viewer/buyer) and is apparently absorbed in some private contemplation, a faint smile on his lips. Janis the connoisseur and Janis the dealer met Janis the art world celebrity, as portrayed by Warhol, when the three portraits were exhibited together in the 1968 exhibition *The Sidney and Harriet Janis Collection: A Gift to The Museum of Modern Art*. — L.J.

Portraits of Sidney Janis, from left to right, by Marisol, Warhol, and Segal. Installation view, *The Sidney and Harriet Janis Collection: A Gift to The Museum of Modern Art*, January–March 1968.

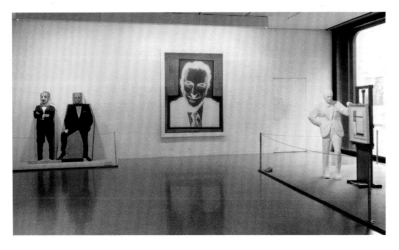

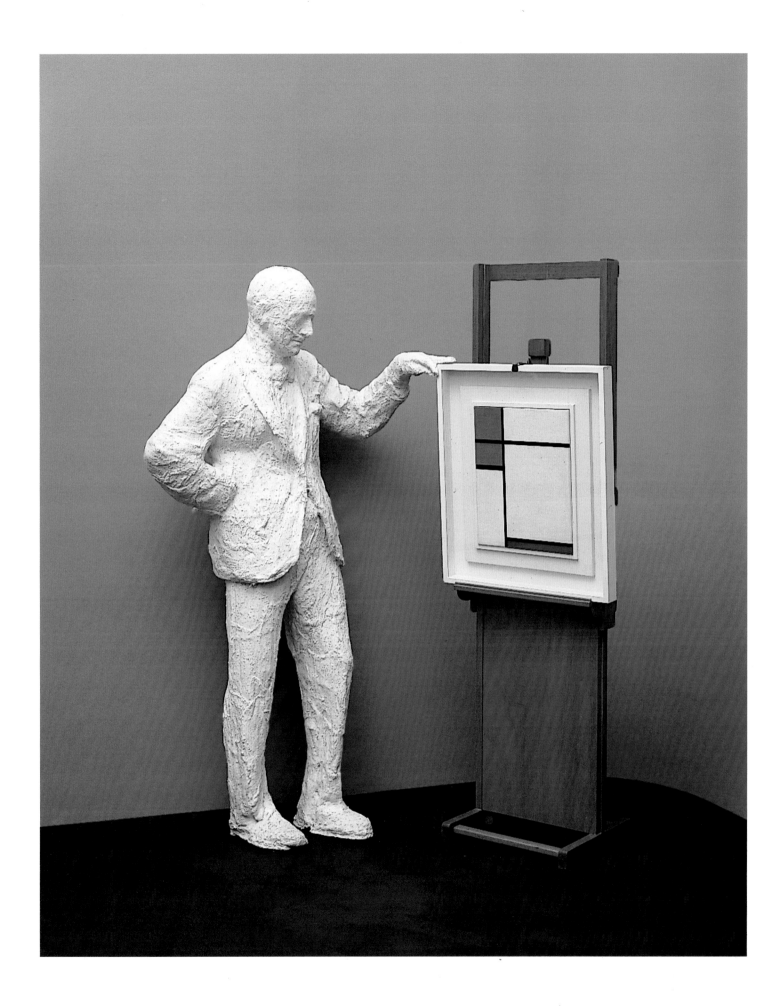

Andy Warhol

(American, 1928–1987)

Andy Warhol.
Water Heater. 1960.
Synthetic polymer paint on canvas, 44 ¾ x 40" (113.6 x 101.5 cm).
Gift of Roy Lichtenstein

In 1960 Andy Warhol decided to become a painter. Since 1949, when he arrived in New York City after having completed an art degree at the Carnegie Institute of Technology in his native Pittsburgh, Warhol had pursued a career as a commercial artist. By 1960 he was tremendously successful, designing everything from stationery to store windows for such elite establishments as Bonwit Teller, I. Miller, and Tiffany's. It was not uncommon for fine artists to seek out commercial work. Both Jasper Johns and Robert Rauschenberg (who designed together as "Matson Jones"), for example, started out in New York City designing store windows. But they considered their commercial production a temporary endeavor based on financial necessity and thus distinct from their real art; Warhol did not. Rather, commercial imagery, albeit of a very different sort from that on which his reputation as an advertising artist was based, became the primary source for his artistic production.

Andy Warhol. *Cooking Pot* (1962) from *International Anthology of Contemporary Engraving: The International Avant-Garde.* Volume 5: *America Discovered.* 1964. Relief halftone, printed in black, plate 6 ³⁄₁₆ x 4 ⅝" (15.7 x 11.7 cm), sheet 10 ¹⁄₁₆ x 7 ⁹⁄₁₆" (25.6 x 19.3 cm). The Museum of Modern Art, New York. Gift of Peter Deitsch Gallery

Water Heater was one of the first paintings Warhol based on printed images from the advertising section of the daily newspaper. In addition to water heaters, Warhol's subjects included television sets, storm windows, iceboxes, cooking pots, and corn plasters — all relatively mundane in contrast to the luxury items (designer clothes, shoes, and jewelry) that were the focus of his commercial production. Considered together, the subjects of these early paintings "appear to inventory the old working-class notion of the American Dream,"[1] which aspired to such items (now commonplace) of personal and domestic comfort. That such comforts come at a price is emphasized by Warhol's choice to represent not simply a water heater, but an ad for a water heater. In fact, the advertising copy that details its marketable qualities — capacity, warranty, and price — is of equal importance to the water heater's pictorial rendering.

Warhol's transition from commercial art to fine art, from design of high-end advertising to painting of commonplace merchandise also brought about a drastic stylistic change. As described by Bradford Collins: "Warhol's commercial trademark in the 1950s was a simple, graceless blotted line, which, in conjunction with his preference for cheerful subjects, gave his work a sweet, childlike appeal."[2] The paintings, in contrast, appear relatively cool and industrial and this, combined with the basic black-and-white palette, evokes the mechanical process of printing that created the originals on which they were based. Like newspaper print, Warhol's paint or ink tends to run and smudge, sullying the white ground. The degraded quality of cheap, daily advertising suggested in *Water Heater* distinguishes this and other early paintings not only from the refined elegance characteristic of his Bonwit Teller ads, for example, but also from the clean lines and bold colors of later works.

Although evocative of printing, *Water Heater* was painted by hand, clearly evidenced by the traces of dripping paint, the off-register tilt of the heater's "frame" and the loose brushwork and exposed canvas at the picture's edges. The painterly qualities become even more pronounced when compared with one of Warhol's own printed images, such as *Cooking Pot* from the print portfolio *America Discovered* (1964), shown here, which, unlike *Water Heater*, was not only mechanically produced but also closer to "true" scale. In the translation from print to paint, small to large, the

image became crudely distorted. Notice, for example, how one of the water heater's legs rests slightly askew, as does the black knob that crowns the tank. Warhol also cropped words and omitted letters, thus engaging the viewer in a sort of visual wordplay that at once suggests the Cubist antics of Picasso and Braque and plays off the abbreviated language characteristic of advertising. Imitating erasure, the cropped word fragments "Ea" and "pri" would be meaningless removed from their advertising context. They also affirm the hand of Warhol, who chose to paint out certain details just as he chose to let paint drip. These formal alterations animate a painting that is not simply a mimetic representation of a newspaper ad but one that plays with the language and images of consumer culture. — L.J.

A version of *Before and After* was first publicly exhibited as a part of a backdrop that was made up of a number of Warhol's paintings in a 1961 Bonwit Teller window display of women's spring fashions. This display, which also included *Superman*, *Saturday's Popeye*, and *The Little King*, may be considered one of the earliest Pop art shows in the United States. At the time Warhol was, in fact, attempting to break into the "art scene" after eleven years as a successful commercial artist. The mass-culture references to comic strips and tabloid ads in his new paintings stood in marked contrast to the high fashion that was the focus of his commercial career.

Before and After was based on a newspaper ad which ran regularly in *The National Enquirer*, a tabloid, and thus considered the most banal realm of advertising. Painted by hand, the patterning of dots at left, right, and across the top (probably painted through a small rectangular screen) are clear references to the benday printing process that was commonly used in newspapers and comic books. Areas of off-register dots smear the eyebrow of the profile to the left and the cheek and forehead of that to the right, suggesting the inked imperfections found in actual ads. Warhol's interest in these mechanical processes anticipated the silkscreening that would become his standard practice beginning in 1962.

Pulled from the visual cacophony of the daily's back pages, this isolated image calls attention not only to American society's superficial concerns with physical appearance, but to its specific notion of ideal beauty. While the recontoured nose is the most obvious alteration, it is worth noting changes in other features as well. For example, on the right Warhol lowers the bump of the left brow, completes the line of the eyebrow, and shifts the flesh of the upper lip forward so it protrudes just slightly. The treatment of the eyes is also distinct. The eyelashes after the alteration are full and turn up with a gentle curl echoing the shape of the lock of hair that falls from the top of the picture frame. "Before" the eyelashes and strand of hair are relatively thin and straight by comparison, while the hair is notably more kinky. And from the deeply set eye on the left (emphasized by the black underline) drops a black tear. Or is it a mole? In either case, this imperfection, like the others, has been erased in the creation of "After." The ideal female beauty in the original ad conforms to the features characteristic of the white Anglo-Saxon facial type.

The image that inspired *Before and After* may also have had a personal significance for Warhol, who himself had a nose job in 1957. In a "preparatory sketch" (a manipulated photograph) from the 1950s, Warhol reduced the width of his nose and filled out his hair in pencil. Illness in his childhood resulted in a loss of pigmentation and the bulbous inflammation of his nose, which made Warhol extremely sensitive about his physical appearance and an expressed advocate of plastic surgery. "I believe in low lights and trick mirrors. I believe in plastic surgery," he once said.[1] It could be said that Warhol was himself a plastic surgeon of sorts in some of his portrait paintings — nipping a bit here, filling out a bit there to create an image with starlike appeal. — L.J.

Installation of Andy Warhol's early paintings in window display of Bonwit Teller, New York, April 1961. The window display was designed by Gene Moore.

Two passport photographs of Warhol, one altered by Warhol to show him with a smaller nose and fuller hair. The Archives of the Andy Warhol Museum, Pittsburgh.

"Beef Noodle," "Chicken Gumbo," "Scotch Broth," and "Tomato" were just four of the thirty-two flavors available to the soup consumer in a typical grocery store in 1962 and, thanks to Andy Warhol, also available to consumers of art when exhibited for the first time at the Ferus Gallery in Los Angeles. There, as if displayed at the supermarket, Warhol's soup cans were aligned neatly on a single continuous shelf. Each soup can was rendered with painstaking precision in a combined process of silkscreen, hand-painting, and stamping to most closely approximate the "original" label. But this is where the similarities ended; Warhol's "soup cans" were framed and sold for $100 each. The equation of the art market and the supermarket suggested in this and other works by Warhol brought hostile responses from opponents who insisted on maintaining a separation between art and consumer society. At a disapproving neighboring gallery, for example, "the real thing" was displayed in the window and could be purchased for the standard market price of 29 cents a can.

But, as Marcel Duchamp pointed out: "If you take a Campbell's Soup can and repeat it fifty times, you are not interested in the retinal image. What interests you is the concept that wants to put fifty Campbell's Soup cans on canvas."[1] Warhol, like Duchamp, found the content for his art in the commonplace — a practice that challenged

Installation view, *Andy Warhol*, Ferus Gallery, Los Angeles, July–August 1962.

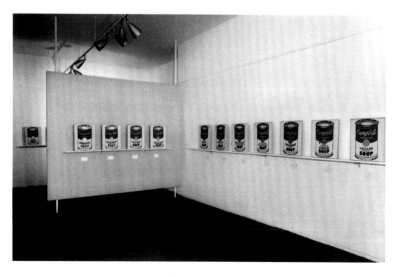

assumptions as to the value and meaning of art. Yet, as Arthur Danto has observed, while Duchamp's objects (bottle racks and urinals, for example) "were often arcane and chosen for their aesthetic blandness, Warhol's were chosen for their absolute familiarity and semiotic potency."[2] The original idea for his soup cans came from art dealer Muriel Latow, who suggested "that he paint something so familiar that nobody even noticed it anymore, 'something like a can of Campbell's soup.' "[3] Campbell's soup, as well as Coca-Cola and Del Monte, had been a part of American consumer culture since the nineteenth century; the "experience" of Campbell's is one shared by many people and its representation invites individual, as well as cultural, memories. Warhol claimed to have eaten "Campbell's Tomato Soup" for lunch every day for twenty years: "I used to drink it. I used to have the same lunch everyday, for 20 years, I guess, the same thing over and over again."[4]

In invoking his past, Warhol revealed another dimension to the social "meaning" of Campbell's soup. Warhol was from a lower-middle-class immigrant family in industrial Pittsburgh, and the kitchen pantry, like that of other low-income homes, likely stocked many of the same products he chose to represent (Campbell's soup, Coca-Cola, Kellogg's, Del Monte, and Brillo), which now stock art galleries and collectors' homes. As Kenneth Silver has remarked: "It was a 'blue-collar' woman's world that Warhol offered New York's sophisticated art consumers. In a Duchampian transference, women *and* men who never did their own shopping or cleaning were sent to the Stable Gallery and Leo Castelli's to buy Campbell's and Brillo."[5]

At the same time that Warhol's "products" may seem to address the class structure of American society, the extensive variety of available "flavors" inventoried in the thirty-two soup cans, for example, suggests the choice and abundance available in capitalist consumer society — a notion emphasized formally by the serial format, which suggests mass production and infinite reproducibility. "What's great about this country," Warhol stated later, "is that America started the tradition where the richest consumers buy essentially the same things as the poorest. You can be watching TV and see Coca-Cola, and you can know that the President drinks

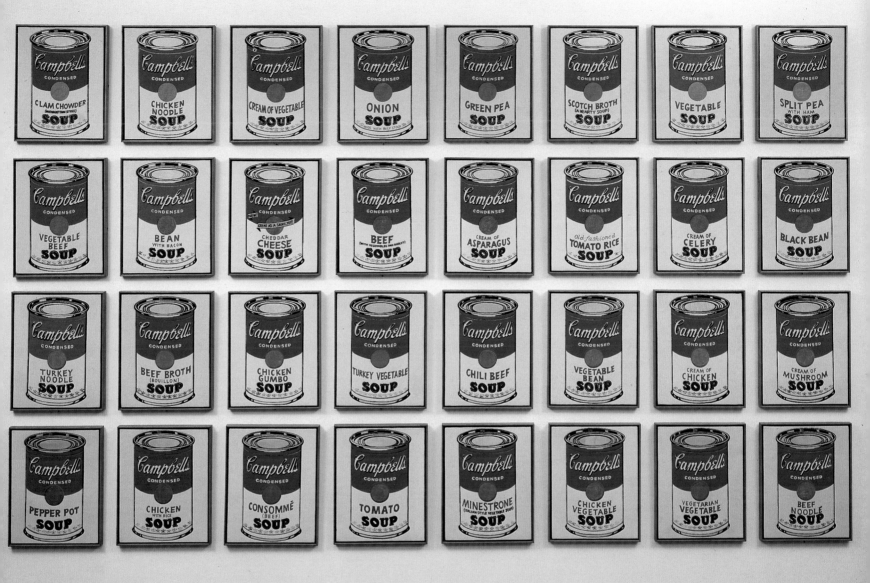

Coke, Liz Taylor drinks Coke, and just think, you can drink Coke, too. A Coke is a Coke and no amount of money can get you a better Coke,"[6] or bowl of Campbell's soup.

Arranged one after another in monotonous succession, the thirty-two paintings appear to have just rolled off the assembly line. *Campbell's Soup Cans* marks a decisive shift to Warhol's use of serial imagery, which would become a characteristic format and anticipate the use of successive, repeated forms by Minimalist artists. Reproduced here

thirty-two times and subsequently reproduced singly and in countless variations in silkscreened paintings and prints (often with the help of assistants), the repeated image of the Campbell's soup can questions the traditional notion of an artwork as a unique expression of the individual artist. Nonetheless, in an ironic twist, there is perhaps no single image more recognizable as an Andy Warhol than the painted, silkscreened, or printed Campbell's soup can.
— L.J.

In 1962, Andy Warhol was desperate for ideas and called upon his friends for suggestions. "One evening," Calvin Tomkins recalled, Muriel Latow told Andy she had an idea but it would cost him money to hear it. Muriel ran an art gallery that was going broke. "How much?" Andy asked her. Muriel said, "Fifty dollars." Andy went straight to the desk and wrote out a check.

"All right," Muriel said. "Now, tell me, Andy, what do you love more than anything else?"

"I don't know," Andy said. "What?"

"Money," Muriel said. "Why don't you paint money?"[1]

Roll of Bills is one variation on the subject of money that Warhol would explore in drawings, paintings, and prints over the next year. Larger-than-life, this thick and tightly rolled wad of bills stands firmly erect like a monument to the all-American pursuit of prosperity. The equation of monetary wealth with happiness was one made by Warhol himself when he stated: "Cash. I just am not happy when I don't have it. The minute I have it I have to spend it. And I just buy STUPID THINGS."[2] Openly and gleefully expressing his love of money and the joy it can bring, Warhol firmly rejected the traditional stereotype of the artist as poor and suffering. Similarly, Warhol's money has nothing in common with the symbolic connotations of greed and avarice attached to it at least since the development of Christian iconography. (Scenes of Judas betraying Christ for a bag of coins or Jesus expelling the money

changers from the temple equated money with sin.) In *Roll of Bills*, the monumental scale and isolated presentation acknowledge money's iconic status as an object of worship. The pictorial vitality of *Roll of Bills* derives from a lively line that vacillates between the tenuous and the vigorous. Made just prior to his "discovery" of the silkscreen process, Warhol's money drawings illustrate a certain awkward grace of hand that characterized his earlier commercial designs as well. Together the edges of the bills fan out to resemble a series of pleats, the five-dollar note creased back carelessly to reveal just a bit of green on the front side. Loosely secured with a jaunty red string tied in a bow, *Roll of Bills* not only takes on a certain frivolous personality, but alludes to an owner who is quite casual with cash.

Commonplace, distinctly American, and mass-produced, dollars were a quintessential Pop art subject for Warhol and others. In the hands of artists Peter Saul and Öyvind Fahlström, however, the potent symbolism of the American dollar was exploited in the critique, rather than the exaltation, of the capitalist pursuit of material wealth. In Saul's drawing Untitled, shown here, for example, a five-dollar bill functions as the pivot point of a rough-and-tumble fight scene. Limbs flail, figures turn on their heads, a car flips in a whirl of commotion that recalls a comic-strip scramble. Unlike characters in the "funnies," however, Saul's figures tote guns and wield blood-stained axes. And they don't just brush themselves off and walk away; there are victims,

Peter Saul. Untitled. 1961. Color crayon, cut-and-pasted paper, and turpentine on paper, 26 ⅜ x 27 ⅛" (67 x 68.9 cm). The Museum of Modern Art, New York. Gift of Allan Frumkin

Öyvind Fahlström. *$108 Bill*. 1972. Lithograph, printed in color, sheet 26 x 19" (66 x 48.3 cm). The Museum of Modern Art, New York. Gift of Experiments in Art and Technology

like the eviscerated dog whose last wish was "dog food." Scrawled in brightly-colored crayon, Untitled also evokes the playtime activity of children. But Saul wiped the surface of his crayon drawings with turpentine, causing the colors to bleed and smudge, evoking blood, viscera, excrement — stains of violence and filth associated with money.

In *$108 Bill* (1972) Fahlström addressed the issue of inflation and its relation to American expansionist politics. According to Fahlström, the carving of the world for economic gain began in 1961, illustrated to the left under the auspices of a portly bourgeois pig. By 1971 a mean and lean boar oversaw the world now charted as a block of militarized zones. The inflation of the dollar, Fahlström suggested, does not reflect overall economic prosperity, but the selfish pursuits of the few who, on the back of the bill, recline in easy chairs upon the bowed backs of the masses.

While Warhol's *Roll of Bills* is far from an explicit critique of capitalist materialism, its exaggerated scale may, nonetheless, be perceived as a parody of the inflated importance of money in American society. In a revealing statement, Warhol directly addressed the pretensions associated with art and money: "I like money on the wall. Say you were going to buy a $200,000 painting. I think you should take that money, tie it up, and hang it on the wall. Then when someone visited you the first thing they would see is the money on the wall."[3] — L.J.

The daily newspaper provided never-ending inspiration for Warhol. In 1962 he began collecting UPI photographs of tragic car accidents to create his own "front-page" sensationalism. In *Orange Car Crash Fourteen Times* the left panel functions as a screen onto which Warhol projected a photograph of a car crash over and over again — fourteen times. Against the orange glow of the right panel, the blackness of the "ink" on the left pulls the viewer in for a closer look at the gruesome details; a pried-open door allows a view of the victim, twisted like the car that is wrapped around a tree.

Orange Car Crash Fourteen Times belongs to a series of paintings by Andy Warhol titled Death and Disasters. In addition to car crashes, the series includes scenes of suicides and assassinations, portraits of celebrity victims of such disasters (the Marilyns and Jackies, for example), and "portraits" of the electric chair and the atomic bomb — modern "tools" of death. Warhol began the series in 1962 upon the suggestion of his close friend, Metropolitan Museum of Art curator Henry Geldzahler, who said: "It's enough affirmation of soup and Coke bottles. Maybe everything isn't always so fabulous in America. It's time for some death."[1] Warhol's first treatment of the subject of a car crash actually dates from his years as a commercial artist with the 1955 drawing *Dead Stop*, shown here. It is, however, morbid humor — emphasized by the sketchy cartoon drawing style — and not tragic reflection that dominates the mood of the earlier piece. In the interim, Warhol had abandoned freehand drawing for the

practice of silkscreening onto canvas images culled from the mass media. The scenes of car crashes and other disasters focus on the gruesome facts, recalling the sensational journalistic photography featured in print and television tabloids then and now. As a visual document taken "on the scene," the photograph heightens the image's emotional impact but, typically, Warhol presents not a clearly focused picture but

one that has been degraded in the translation from original to silkscreen and finally to canvas. He often, for example, "inked" his screens too heavily or too sparingly making the images difficult to read. This loss of detail emphasizes the retrograde, low-rent nature of Warhol's printing process. His "debt" to the newspaper industry is also suggested by the field of repeated images evocative of the pre-cut sheets that roll off the printing press. Yet Warhol's four registers are not aligned, some of the images run to the edge, others skid to a stop, leaving a mark and an orange gap.

By printing the image repeatedly in the form of a loose grid, Warhol alludes not only to the processes of mass reproduction but also to the experience of being bombarded by mass-media imagery. Front-page disaster photos are as much a part of our daily visual experience as are advertisements for soup, Coca-Cola, and Brillo pads. Have we, as a result, become anesthetized to gore and human tragedy? According to Warhol: "When you see a gruesome picture over and over again, it doesn't really have any effect."[2]

From this point of view, the car crash may be described as the most "democratic" of Warhol's death series subjects. While equally fascinating in their "gruesomeness," the depictions of suicides and electric chairs, for example, do not summon personal experiences for many viewers. The number of car owners in the United States had greatly increased in the postwar years, and the car had come to symbolize the American dream of leisure and wealth. The car crash turned dream to nightmare and was a roadside specter for more people than ever before.

Opposite this grid of morbid imagery extends a vast expanse of orange, a sort of visual release from the "density" of the image panel. The diptych format sets up an opposition of material (and human) destruction and absolute immateriality (or "blank" as Warhol referred to it) — the latter evoking the transcendental and quasireligious aspirations of monochrome painters Newman and Reinhardt, for example. Yet, in a typically nonreverential manner, Warhol explained: "You see, for every large painting I do, I paint a blank canvas, the same background color. The two are designed to hang together however the owner wants. He can hang it right beside the painting or across the room or above or below it. . . . It just makes them bigger and mainly makes them cost more."[3] — L.J.

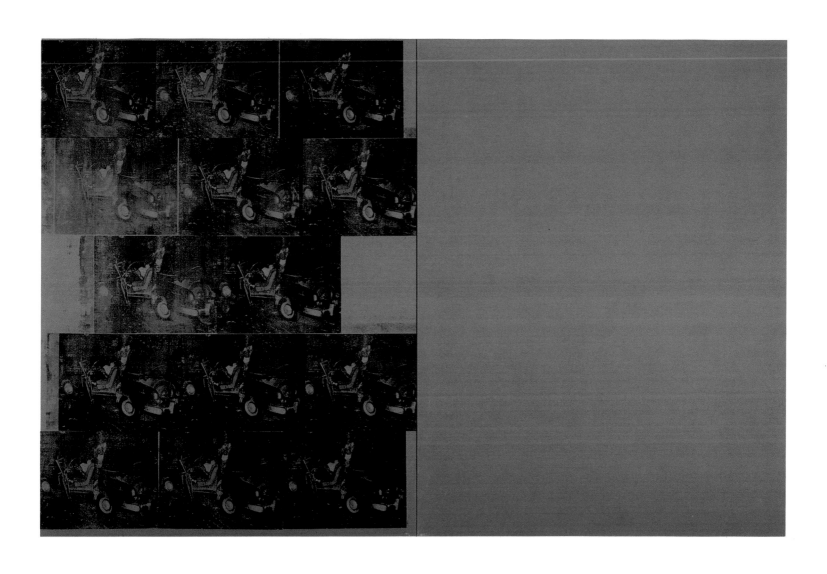

Andy Warhol.
Brillo Box (Soap Pads). 1964.
Synthetic polymer paint and silkscreen on wood,
17 ⅛ x 17 x 14" (43.5 x 43.2 x 36.5 cm).
Gift of Donald and Doris Fisher

Brillo Box (Soap Pads). 1964.
Synthetic polymer paint and silkscreen on wood,
17 1/16 x 17 x 14" (43.3 x 43.2 x 36.5 cm).
Gift of Donald and Doris Fisher

By 1964 Warhol was an art-world success; his studio (The Factory) was the center of the cultural underground, and his gallery shows were extremely popular, often selling out. At his 1964 opening at the Stable Gallery, people lined the streets outside waiting to get in. Inside, as recounted by Calvin Tomkins, Warhol had filled the gallery with some 400 "wooden boxes made to his order and silk-screened on all sides to look exactly like the cartons of Brillo pads and Mott's Apple Juice and Heinz Tomato Ketchup that you saw in the supermarkets. Visitors threaded their way through narrow aisles between the piled-up boxes."[1] What to the uninitiated might easily have been mistaken for a super-market warehouse, was for the art world far more than an exhibition — it was an event. Arthur Danto recalled "the feeling of lightheartedness and delight people evinced as they marveled at the piles of boxes, laughing as they bought a few and carried them out in clear plastic bags."[2]

Danto's account evokes a department-store clearance sale rather than an art-gallery transaction. Warhol's embrace of media hype and innovative display — conventional

Installation view, *Warhol*, Stable Gallery, New York, April–May 1964.

marketing strategies — demonstrated the artist's ongoing exchange with the world of commerce and his commitment to what he termed "business art." According to Warhol: "Business art is the step that comes after Art. I started as a commercial artist, and I want to finish as a business artist. . . . Making money is art and working is art and good business is the best art."[3]

As with *Campbell's Soup Cans*, each box was considered an individual artwork, selling from $200 to $400, depending on size. The idea of "re-creating" consumer items and selling them as art was also conceived of in 1961 by Claes Oldenburg in The Store. Set up in a storefront on the Lower East Side of Manhattan, the paper-maché "items" in Oldenburg's store (shoes, panties, hamburgers, etc.) were splashed, slathered, and dripped on with paint. Each item was idiosyncratic, with a crude and palpated surface quality that suggested use, similar to objects found in a thrift shop or a mom-and-pop store.

The clean lines of Warhol's Brillo Boxes, by contrast, are unsullied and completely devoid of signs of artistic intervention. Even the *Campbell's Soup Cans*, enlarged and framed, were distinguishable from the "real thing." Almost as if by a process of elimination Warhol had progressively rid the art object of "art": first, by embracing mass culture (as in *Water Heater*), then by removing any trace of the artist's hand (as in *Campbell's Soup Cans*), and finally by eliminating artistic devices such as frames and pedestals. Empty of soap pads, as well as "art," *Brillo Box* may also summon notions related to its use as a cardboard container that is "ubiquitous, disposable and part of America's itinerant mode of life. It was the container of choice for shipping and storing books, dishes, clothing, or for bringing kittens home in. It was what everyone threw away."[4]

Like Duchamp, Warhol questioned assumptions about what art is, but, unlike the earlier artist's found objects, his boxes were not ready-made. Instead, they were fabricated one by one by Warhol and his team of studio assistants in a sort of assembly-line production at The Factory. "The reason I'm painting this way," Warhol once said, "is that I want to be a machine, and I feel that whatever I do and do machine-like is what I want to do."[5] Presented with the

marketing savvy described above, Warhol's efficiently "manufactured" art "products" appear to mimic fundamental American business strategies in a gesture that for some suggested an affirmation of capitalism, for others, its critique.

Such crass commercialism clearly parodied the business of art. Nonetheless, what may have started out as a joke subsequently had profound effects on the "ideas" of art. Warhol's negation of traditional art practices begs the question, "Why is *Brillo Box* art when the Brillo cartons in the warehouses are merely soap-pad containers?"[6] For Arthur Danto, the issue is not one of quality, aesthetics, or originality but of philosophy. Warhol's work raises questions concerning not only the nature of art, but also its history and the canon of aesthetics in general. Art could no longer be judged on the basis of visual criteria alone. "*Brillo Box* not only made the philosophy of art at last thinkable, it brought an end to a period in which art could be made in ignorance of its philosophical nature."[7] — L.J.

Like many artists before him, Warhol revisited the self-image throughout his career. Between 1962 and 1966 Warhol's popularity escalated from art-world renown to international stardom. In the same year as this *Self-Portrait* was made Warhol and socialite companion Edie Sedgwick were mobbed at the opening of his one-person exhibition at the Institute of Contemporary Art, Philadelphia; his film *The Chelsea Girls* was released and widely distributed; and rock musicians Brian Jones, Bob Dylan, and especially Lou Reed and the Velvet Underground frequented The Factory. In recognition of his new-found celebrity status, that same year Warhol placed the following advertisement in *The Village Voice*: "I'll endorse with my name any of the following: clothing, AC-DC, cigarettes, small tapes, sound equipment, Rock 'N Roll records, anything, film, and film equipment, Food, Helium, WHIPS, Money; love and kisses Andy Warhol. EL 5-9941."[1]

This tongue-in-cheek announcement sought to "sell" Warhol's "signature." In *Self-Portrait* he markets a visual image of himself. In a contrived manner with his hand to his mouth and eyes askance, Warhol strikes the pose of a thinker or intellectual. Similar to an actor's head shot or an author's book-jacket photograph, Warhol's self-image has sales appeal — its reproducibility connoted by the multiple panels that repeat the image over and over again. In portraying himself, as in his portraits of others, Warhol

constructed an ideal image. "When I did my self-portrait," Warhol said, "I left all the pimples out because you always should. . . . Always omit the blemishes — they're not part of the good picture you want."[2] One also gets the impression that Warhol is only giving us his "good" side, the other half bathed in shadow.

This blemish-free representation of the artist as a cool-headed, dandy-intellectual stands in stark contrast to his 1964 *Self-Portrait* as a criminal, shown here. Executed the same year as *The Thirteen Most Wanted Men* — a mural of police photographs of thirteen wanted fugitives — Warhol's mug-shot self-portrait suggests an identification with the criminal through his outsider status as an artist or as a homosexual. Warhol may also be parodying the "tough guy" persona associated with Abstract Expressionists such as Jackson Pollock, whose expansive and gestural painting style and hot-headed temperament were often equated with masculine virility and thus with heterosexuality. As recalled by Warhol: "You'd have to have seen the way all the Abstract Expressionist painters carried themselves and the kinds of images they cultivated, to understand how shocked people were to see a painter coming on swish. I certainly wasn't a butch kind of guy by nature, but I must admit, I went out of my way to play up the other extreme."[3] Fueled by political rights movements, a cool, calm, and "queer" alternative to the "myth of masculinity" surrounding Abstract Expressionism had developed in the New York art world by the mid-1960s. In *Self-Portrait* Warhol's contrived pose, enhanced by the dramatic lighting, verges on the theatrical.

Over his mannered self-image, Warhol has layered a variety of boldly artificial colors that not only emphasize the portrait's theatrical nature but also evoke the psychedelic. At the same time that Warhol played host to the artistic underground and to pill parties at The Factory, his palette became remarkably electrified. Like Mel Ramos, he sought out new colors that reflected the cosmetic mood of the day. The vivid pinks, reds, acidic yellows, and greens applied to his face, as seen in *Self-Portrait*, evoke everything from the colors of candy-coated pills to kaleidoscopic light effects. And, corresponding with Warhol's cinematic explorations, the repeated image may also suggest the successive frames of a filmstrip — each capturing a moment in time under the pulsating lights of a discotheque. — L.J.

Andy Warhol. *Self-Portrait*. 1964. Silkscreen ink on synthetic polymer paint on canvas, two panels, each 20 x 16" (50.8 x 40.6 cm). Collection Sandra and Gerald Fineberg

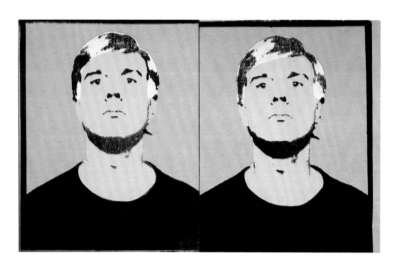

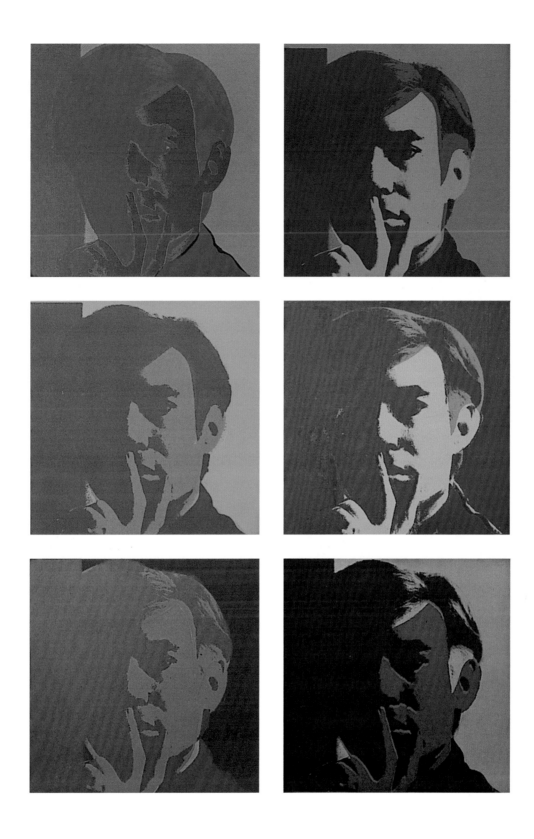

Andy Warhol.
Lita Curtain Star. 1966.
Synthetic polymer paint silkscreened on eight canvases,
each 27 x 26 ⅞" (68.6 x 68.3 cm), overall 55 ½" x 9' 3"
(141 x 282 cm).
Gift of Lita Hornick

Andy Warhol contributed greatly to the tradition of portraiture in twentieth-century American art. Beginning with a small, single silkscreen image in black and white of the actor Troy Donahue completed in 1962, he subsequently made celebrity portraits of Elizabeth Taylor, Jacqueline Kennedy, and Marilyn Monroe based on publicity photographs collected from tabloids and fan magazines. In 1963 Warhol accepted his first portrait commission from collector Ethel Scull (*Ethel Scull 36 Times*, The Metropolitan Museum of Art). Over the years, commissions increased so that by the 1970s and 1980s portraiture would become a primary aspect of his artistic production.

Warhol never painted from life; the basis of his portraits was the photograph, and in the 1960s his camera was the local Photomat. According to Lita Hornick, collector, literary patron, and subject of *Lita Curtain Star*: "In 1966 he did my portrait, first taking me down to a photo-booth on Forty-second Street and taking five dollars' worth of three-for-a-quarter photos. From these he selected one image."[1] In the chosen shot, Hornick raises her chin and casts a downward glance with a slight air of pretension, her aristocratic mien emphasized by strands of pearls and her "high brow." Warhol often enlarged his photographic source so that the face filled the canvas in a manner similar to a publicity photograph. He also preferred high-contrast images that conveniently washed out blemishes and double chins. And once the photograph had been transferred to an acetate for the silkscreen, Warhol continued to remove wrinkles and to thin necks and backs. Then, with layers of varying colors, he could "make up" the face. In *Lita Curtain Star* the eyelids are "lifted" with a thick application of eyeshadow, the lips filled out, and the hairpiece rendered in a variety of designer colors.

The traditional portraitist's concern with capturing the sitter's psychological likeness, or inner self, was not one shared by Warhol. While it is true that his portraits were often superficial idealizations, Warhol did not necessarily pander to the egos of his clients. Instead, he imbued his noncelebrity portraits with the very qualities he sought out and memorialized in his celebrity subjects — beauty and glamour. As Carter Ratcliff observed: "He is an artist who self-consciously transforms himself into a fan."[2]

But, like his images of celebrities, Warhol's portraits display idealized notions of the public self that are merely superficial. Like masks they occasionally slip, shifting silkscreened eyeshadow into the eye and lipstick onto the chin. The array of flat, brightly colored headbands crowning Lita's prominent brow suggests costume cutouts for paper dolls, while her hairline, upon closer observation, can be seen to verge on the receding, "washed out" by the high-contrast image. Any possible claim to naturalism is dismissed by Warhol's selection of high-keyed colors from a psychedelic rainbow.

Warhol's "society," not unlike that of his nineteenth-century predecessors, was the social elite — the rich, the famous, the glamorous, or anyone who could pay the twenty-five thousand dollars he requested for the initial portrait (and fifteen thousand for each additional painting from the same silkscreen). By the 1970s Warhol was as famous as his sitters, if not more so. Alan Solomon once remarked, "Andy is the first real art celebrity since Picasso and Dalí."[3] His own celebrity status imbued him with the power not only to paint celebrities, but also to make celebrities. Over time, many of Warhol's celebrity sitters may be forgotten by name, but they will likely retain a trace of their previous fame as "Warhols." — L.J.

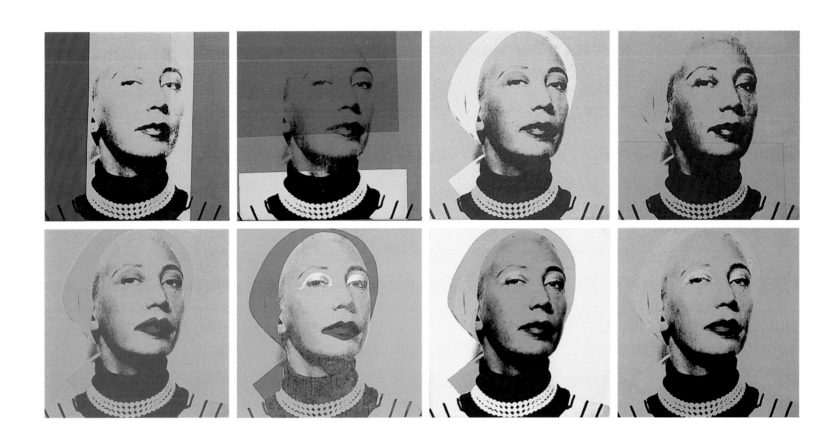

Tom Wesselmann

(American, born 1931)

Tom Wesselmann.

Great American Nude, 2. 1961.

Synthetic polymer paint, gesso, charcoal, enamel, oil, and collage on plywood, 59 ⅝ x 47 ½" (151.5 x 120.5 cm).

Larry Aldrich Foundation Fund

From Titian to Rubens and Manet to Matisse, the female nude persistently recurs in the history of art. With Pop art and a return to figuration following years of Abstract Expressionist predominance, the representation of the nude once again emerged in the works of Tom Wesselmann and Mel Ramos, among others. Wesselmann's *Great American Nude, 2* is a reclining nude or odalisque — the quintessential representation of eroticized female passivity. The figure is lounging in a domestic setting, complemented with additional sensory delights, including a bowl of fruit and a velvety curtain backdrop. As the title suggests, however, Wesselmann distinguished his nudes from European predecessors by inserting distinctly American references into the predominantly red, white, and blue color scheme (which supposedly came to him in a dream). A reproduction of Grant Wood's 1931 painting *Midnight Ride of Paul Revere* hangs above the sofa, while in the window a travel poster depicting the rugged landscape typical of the American west has been affixed. A field of white stars on red joins the nude's upper arm and torso, like a patch, creating a banner of the female body as an American emblem of the material comforts that surround her.

Flat, bold, and garishly intense, the colors evoke the eye-catching strategies of advertising that disrupt the normal tranquillity associated with the odalisque theme. According to one critic, "If a commercial advertising firm had a mind really to knock the public out for a hard sell they might use one of Wesselmann's pictures. *The Great American Nude* series, each with its curving voluptuous section of rose-pink female arching or lolling across her vivid American environment, is more appealing than any Miss Rheingold poster."[1] Advertising also provided Wesselmann with many of his collage elements: the window scene is from a travel poster, the painting clipped from an art magazine, and the fruit still life cut from a poster he found in the subway. He also used real linoleum for the floor, red fabric for the bed, and light blue velvet for the drapery. The tactile diversity of the pasted areas, in addition to flat expanses of bright color, negate space and activate the painting's surface in an attempt to "lift the image off the canvas" and to "disintegrate the central images."[2] According to the artist, he "tried to mildly disintegrate the nude into the picture and spread her over it . . . [demonstrating a] relationship to Pollock and [the] all-over picture flow."[3]

In *Great American Nude, 2*, for example, the nude is spread into an unnatural pose — torso tilted forward, legs stretched open, and left arm raised — so that the body is aligned in a single plane. This exaggerated pose, while purportedly adopted for formal reasons, also evokes conventions of erotic display typical of pornography. Faceless and thus anonymous, *Great American Nude, 2* contorts her body to maximize its visibility — the erogenous zones (breasts, navel, and vagina) marked in charcoal are her only features. As cleverly stated by Gene Swenson: "Wesselmann's nudes are not really traditional, or if so they are less in the salon than in the saloon tradition."[4] The so-called erotic side of Pop was featured in the *First International Girlie Exhibit* at Pace Gallery in 1965, which included Wesselmann's nudes and interpreted the pornographic (rather than high art) references as characteristic of Pop art's interest in the common — in low art. For some a pinup, for others a nude, Wesselmann's *Great American Nude, 2* blurs distinctions of high and low, while drawing attention to the erotic content often veiled in traditional discussions of the nude female body in art. — L.J.

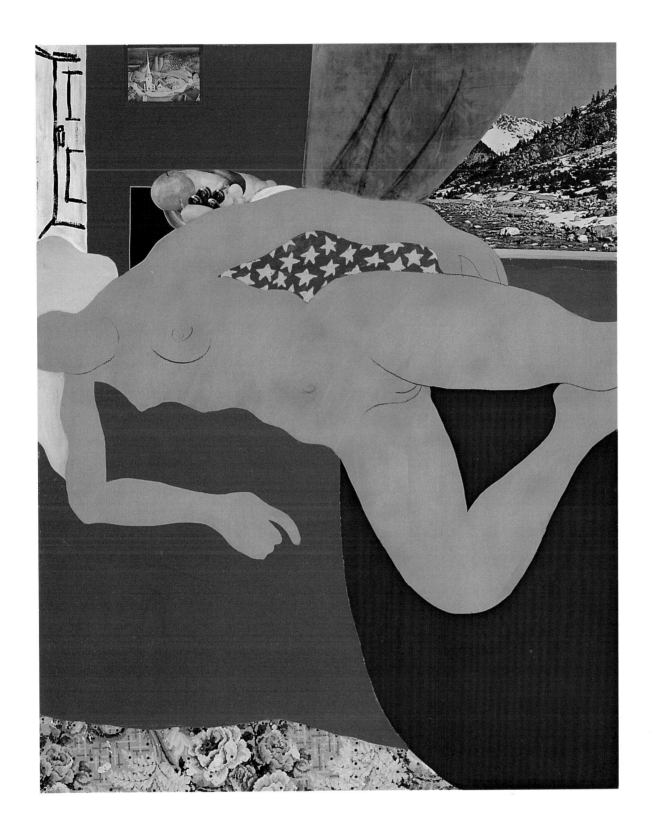

Tom Wesselmann.
Still Life #30. 1963.
Assemblage: oil, enamel, and synthetic polymer paint on
composition board with collage of printed advertisements,
plastic artificial flowers, refrigerator door, plastic replicas of 7UP
bottles, glazed and framed color reproduction, and stamped metal,
48 ½ x 66 x 4" (122 x 167.5 x 10 cm).
Gift of Philip Johnson

Following his 1961 exhibition of Great American Nudes, Wesselmann initiated his second major series based on a traditional theme — the still life. Like the nudes, the still life featured in *Still Life #30* is set in a contemporary domestic interior; from the bedroom to the kitchen (and eventually the bathroom), Wesselmann's paintings of the early to mid-1960s depict the private spaces of "typical" middle-class homes in postwar America. Displayed within a meticulously clean, orderly, and color-coordinated kitchen, a cornucopia of mass-produced food items spills onto the blue-and-white checkered tablecloth. Like Warhol in his series of thirty-two *Campbell's Soup Cans* (page 109), Wesselmann depicts brand name processed foods — Kellogg's Rice Krispies and Dole Hawaiian pineapple, for example. His consumer products are shown arrayed in the home, rather than as found on the supermarket shelf: *Still Life #30* displays items of the ideal consuming life. In addition to advertising images of food products culled from posters and billboards pasted onto the canvas, a General Electric refrigerator door, plastic replicas of 7UP bottles, a glazed and framed reproduction of Picasso's *Seated Woman* (1927), plastic flowers, and a piece of pressed metal project from the painting's surface. To complete his designer kitchen, Wesselmann painted in a matching pink sink and a four-burner stove. The contents of *Still Life #30* represent an inventory of mass-produced appliances and food that in the postwar years signified American economic prosperity, while the distant vista of New York City seen through the window locates the home in the suburbs.

The incorporation of three-dimensional objects combined with pasted and painted images presents the viewer with three different layers, literally and figuratively, of representation. For Wesselmann, the hand-painted and machine-made elements "traded off" against one another, heightening the visual tension of the painting surface. By juxtaposing "real" objects, photomechanically reproduced

products, and other conventionally painted accoutrements, Wesselmann may also have intended to suggest the disparity between the idealized image of American domesticity portrayed in the media and actual domestic life. Upon close examination, even the three-dimensional elements included in *Still Life #30* are "fake": the 7UP bottles and roses are plastic replicas, the Picasso is a reproduction, and the refrigerator door, a mere facade.

As homemakers, it was, of course, women who were implicated in the maintenance of the American domestic ideal. In addition to the pink color scheme, Wesselmann calls attention to the notion of the kitchen as a "feminine" space by painting two perfectly round oranges which, in his other paintings, are often matched with female breasts. These same two oranges, however, combine with the skyscraper that appears above them to suggest male genitals, insinuating a "masculine" presence within this private, feminine realm.[1]

In this and other paintings in the Still Life series, Wesselmann decorates his domestic interiors with reproductions by great modern painters. Juxtaposed with 7UP, the Picasso may be perceived as just one more brand name product to be consumed by American society. Or, hung as it is within a middle-class home, it may attest to the democratization of high art brought about by mechanical reproduction. In either case, Picasso has been subsumed by mass culture. Another high-art reference in *Still Life #30* are the yellow, red, and blue panels characteristic of Mondrian's explorations into pure abstraction which, in Wesselmann's painting, function purely as interior design. In the context of the kitchen, Picasso and Mondrian become decorator items; in the context of the museum, Wesselmann's kitchen becomes art. The interplay between high and low in *Still Life #30* raises questions concerning both the nature of art and idealized notions of domesticity. — L.J.

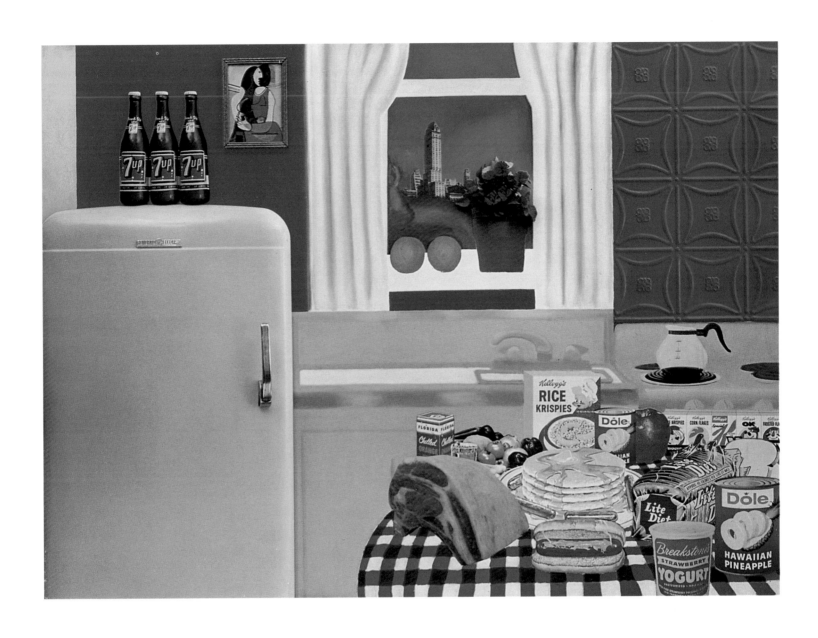

Tom Wesselmann.
Smoker, 1 (Mouth, 12). 1967.
Oil on shaped canvas, in two parts,
overall 9' ⅞" x 7' 1" (276.6 x 216 cm).
Susan Morse Hilles Fund

Big, bold, and sexually provocative, Wesselmann's *Smoker, 1 (Mouth, 12)* confronts the viewer with the graphic clarity of an advertising billboard. While Wesselmann had consistently appropriated imagery from mass consumer culture, using it as collage, it was not until the mid-1960s that he began to grossly enlarge its scale. Similar in strategy to works by billboard-painter-turned-artist James Rosenquist, Wesselmann's gigantic mouths are also related to the artist's ongoing exploration of the female body. Beginning with the Great American Nudes, Wesselmann subsequently localized his interest on the erogenous zones: vagina, mouth, and breasts. *Smoker, 1 (Mouth, 12)* belongs to the Mouth series started in 1965. According to the artist, writing under the pseudonym Slim Stealingworth, the series was inspired by the following incident: "One day he was drawing mouths from a friend, Peggy Sarno, when she took a break and smoked a cigarette. Wesselmann continued drawing but included the cigarette. This began the Smoker series, a sub-division of the Mouth series."[1]

The mouth as subject has a history that extends back to when the Surrealist artists exploited cropping techniques to produce uncanny and erotic images of the female body. Often intimate in scale and ambiguous in content, the mysterious erotic works by the Surrealists are exploded by Wesselmann, who creates mouths with a bold and brassy directness evocative of pornography. When asked about the influence of pornography in his work, the artist stated: "I am

Tom Wesselmann. Study for *Marilyn's Mouth*. 1967. Oil on canvas, 9 x 12" (22.9 x 30.5 cm). The Museum of Modern Art, New York. Frances Keech Bequest

interested in pornography and certain aspects of my work are pornographic. . . . There are things I want to say, in paintings, about the validity of doing it, the fact that these things are suppressed and they shouldn't be."[2]

By isolating and enlarging the beckoning, ruby-red, lipstick-painted mouth and dangling cigarette, Wesselmann not only magnified their erotic connotations, but also called attention to the manner in which such connotations are exploited by the advertising industry to sell cigarettes with sex. In a related work, Study for *Marilyn's Mouth* (1967), shown here, Wesselmann addressed the selling of celebrities with sex, as did Andy Warhol's series of Marilyn's lips. Unlike Warhol, however, in works such as *Smoker, 1 (Mouth, 12)* Wesselmann employed the shaped canvas which, in the mid- to late 1960s, was associated predominately with abstract painters such as Ellsworth Kelly and Frank Stella engaged in formalist explorations into color and shape. Deliberately or not, Wesselmann's mouth-shaped canvases suggest a gesture of bawdy irreverence directed toward the more abstract pursuits of his contemporaries.

In scale and content, Wesselmann's *Smoker, 1 (Mouth, 12)* is far from passive. "Blunt and aggressive" are the words the artist used to describe his billboard-sized body parts in contrast to conventional renderings of the female nude. By concentrating on the primary sexual signifiers, Wesselmann claimed that "he is not painting any specific woman or mouth, or any specific type of woman, but just woman."[3] The reduction of "woman" to her erotic "essence" is far from new in the history of art. Nonetheless, Wesselmann's colossal mouths-cum-vaginas coincide historically with the rise of feminism and subsequently with a feminist art practice that advocated increasing the visibility of female sexuality not only as a sign of difference but of power and pride. While far from feminist in intent, Wesselmann's quasipornographic depictions of the female body may also represent a defiant naughtiness parallel to one vein of feminist strategy. — L.J.

Notes to the Plate Commentaries

Pages 26–27: D'Arcangelo. *U.S. Highway 1, Number 5*. 1962.
1. Allan D'Arcangelo, "An Interview: Allan D'Arcangelo and Stephen Prokopoff," in *Allan D'Arcangelo: Paintings 1963–1970* (Philadelphia: Institute of Contemporary Art; Buffalo: Albright-Knox Art Gallery, 1971).
2. Sidra Stich, *Made in U.S.A.: An Americanization in Modern Art, The '50s & '60s* (Berkeley, Los Angeles, and London: University of California Press, 1987): 69.

Pages 28–29: Dine. *Tattoo*. 1961.
1. Barbara Haskell, *Blam! The Explosion of Pop: Minimalism and Performance, 1958–1964* (New York: Whitney Museum of American Art and W. W. Norton, 1984): 32.
2. Rosalind Krauss first used the expression "myth of masculinity" in "Jasper Johns," *Lugano Review* 1, no. 2 (1965): 97.
3. Jim Dine, quoted in Jean E. Feinberg, *Jim Dine* (New York, London, and Paris: Abbeville, 1995): 19.
4. Jim Dine, quoted in David Shapiro, *Jim Dine: Painting What One Is* (New York: Harry N. Abrams, 1981): 203.
5. Alan R. Solomon, "Jim Dine and the Psychology of the New Art," *Art International* 8, no. 8 (October 1964): 54.

Pages 30–31: Dine. *Five Feet of Colorful Tools*. 1962.
1. Jim Dine, quoted in John Gordon, *Jim Dine* (New York: Whitney Museum of American Art, 1970).
2. Ibid.
3. David Shapiro, *Jim Dine: Painting What One Is* (New York: Harry N. Abrams, 1981): 25.

Pages 32–33: Dine. *Still Life Painting*. 1962.
1. Öyvind Fahlström, *Jim Dine* (New York: Sidney Janis Gallery, 1963): 1–2.
2. Graham W. J. Beal, *Jim Dine: Five Themes* (Minneapolis: Walker Art Center; New York: Abbeville, 1984): 17.

Pages 34–35: Dine. *Untitled Black Suit Picture*. 1964.
1. Jim Dine, quoted in Graham W. J. Beal, *Jim Dine: Five Themes* (Minneapolis: Walker Art Center; New York: Abbeville, 1984): 11.
2. Ed Ruscha, cited in Elizabeth Armstrong, "Interviews with Ed Ruscha and Bruce Conner," *October* 70 (Fall 1994): 56.
3. Ibid.

Pages 38–39: Fahlström. *Eddie (Sylvie's Brother) in the Desert (Collage)*. 1966.
1. Artist's questionnaire, dated February 29, 1968 (Collection Files, Department of Painting and Sculpture, The Museum of Modern Art, New York).
2. Öyvind Fahlström, "Take Care of the World," in *Manifestos* (New York: A Great Bear Pamphlet, 1966): 10; repr. in *Öyvind Fahlström* (Valencia: Institut Valencià d'Art Modern [IVAM] Centre Julio González, 1992).
3. Öyvind Fahlström, "Manipulating the World" (1964); repr. in *Öyvind Fahlström* (Valencia).
4. Dore Ashton, "New York," *Studio International* (London) 173, no. 888 (April 1967): 210.

Page 40: Fahlström. *Notes 4 (C.I.A. Brand Bananas)*. 1970; Plan for *World Trade Monopoly*. 1970.
1. Mike Kelley, "Myth Science," in Sharon Avery-Fahlström, ed., *Öyvind Fahlström: Die Installationen; The Installations* (Bremen: Gesellschaft für Aktuellekunst; Cologne: Kölnischer Kunstverein, 1995): 20.
2. Öyvind Fahlström, "On Monopoly Games" (1971); repr. in *Öyvind Fahlström* (Valencia: Institut Valencià d'Art Modern [IVAM] Centre Julio González, 1992).
3. Daniel Birnbaum, "Öyvind Fahlström's Final Manipulations," *Parkett* 46 (1996): 154.

Pages 42–43: Indiana. *Moon*. 1960.
1. Artist's questionnaire, signed and dated December 11, 1961 (Collection Files, Department of Painting and Sculpture, The Museum of Modern Art, New York). "Orb Moon" is an "Indianaism" for "moon."
2. Ibid.

Page 44: Indiana. *The American Dream, I*. 1961.
1. Artist's questionnaire, signed and dated December 11, 1961 (Collection Files, Department of Painting and Sculpture, The Museum of Modern Art, New York). Some years later, in his "Autochronology," in *Robert Indiana* (Philadelphia: Institute of Contemporary Art, 1968): 53, the artist added that the title *The American Dream* was "ignited by Edward Albee's play [*The American Dream*]."
2. Barbara Rose, "Dada, Then and Now," *Art International* 7, no. 1 (January 1963): 25. Rose refers to Sidney Tillim, "Month in Review: New York Exhibitions," *Arts Magazine* 36, no. 5 (February 1962): 34–37.
3. G. R. Swenson, "What Is Pop Art? Answers from 8 Painters, Part I," *Art News* 62, no. 7 (November 1963): 27.
4. Wall label and press release for *The American Dream, I* in the exhibition *Recent Acquisitions: Painting and Sculpture*, The Museum of Modern Art, December 19, 1961–February 25, 1962.
5. Artist's questionnaire.
6. Ibid.
7. Swenson, "What Is Pop Art?": 27.
8. Robert Rosenblum, "Pop Art and Non-Pop Art," *Art and Literature*, no. 5 (Summer 1965): 80–93.

Pages 46–47: Johns. *Flag*. 1954–55.
1. Robert Morris, "Notes on Sculpture: Part 4, Beyond Objects," *Artforum* 7, no. 8 (April 1969): 50.
2. Cited in Lilian Tone, "Chronology," in Kirk Varnedoe, *Jasper Johns: A Retrospective* (New York: The Museum of Modern Art, 1996): 124.
3. Robert Rosenblum, "Castelli Group," *Arts Magazine* (May 1957): 53. See also *Art News* 56, no. 9 (January 1958): cover.
4. Alan R. Solomon, "Jasper Johns," in *Jasper Johns* (New York: The Jewish Museum, 1964): 8.
5. Fred Orton, *Figuring Jasper Johns* (Cambridge, Mass.: Harvard University Press, 1994): 131.
6. "Interview with David Sylvester," in Richard Francis, ed., *Jasper Johns Drawings* (London: Arts Council of Great Britain, 1974): 13.
7. Tone, "Chronology": 124.
8. Jasper Johns, quoted in "His Heart Belongs to Dada," *Time* 73 (May 5, 1959); repr. in Kirk

Varnedoe, ed., *Jasper Johns: Writings, Sketchbook Notes, Interviews* (New York: The Museum of Modern Art, 1996): 82.
9. Varnedoe, *Jasper Johns: A Retrospective*: 25.
10. Robert Rosenblum, "Jasper Johns," *Arts Magazine* (January 1958): 53, and Ben Heller, "Jasper Johns," in B. H. Friedman, ed., *School of New York: Some Younger Artists* (New York: Grove Press, 1959): 34.

Page 48: Kienholz. *The Friendly Grey Computer — Star Gauge Model #54*. 1965.
1. From "Directions for Operation" on computer console; repr. in Maurice Tuchman, *Edward Kienholz* (Los Angeles: Los Angeles County Museum of Art, 1966): 47.
2. Ibid.
3. Edward Kienholz, quoted in Robert L. Pincus, *On a Scale that Competes with the World: The Art of Edward and Nancy Reddin Kienholz* (Berkeley, Los Angeles, and Oxford: University of California Press, 1990): 36.
4. Carrie Rickey, "Unpopular Culture (Travels in Kienholzland)," *Artforum* 21, no. 10 (Summer 1983): 48.
5. Edward Kienholz, quoted in Roland H. Wiegenstein, "Ed Kienholz, the 'Volksempfängers' and the 'Ring,'" in *Edward Kienholz: Volksempfängers* (Berlin: Nationalgalerie Berlin, 1977): 12.
6. Edward Kienholz, quoted in Donald Factor, "A Portfolio of California Sculptors: Edward Kienholz," *Artforum* 2, no. 2 (August 1963): 24.
7. Edward Kienholz, quoted in Arthur Secunda, "Interview with John Bernhardt, Charles Frazier and Edward Kienholz," *Artforum* 1, no. 5 (October 1962): 30.
8. Anna Indych, "The Tableaux of Edward Kienholz: The Darker Side of Pop" (paper delivered at The Institute of Fine Arts, New York University, 1995): 12.

Pages 50–51: Lichtenstein. *Drowning Girl*. 1963.
1. Roy Lichtenstein, quoted in John Coplans, "An Interview with Roy Lichtenstein," *Artforum* 2, no. 4 (October 1963): 31; repr. in John Coplans, ed., *Roy Lichtenstein* (New York: Praeger, 1972): 51.
2. Coplans, "An Interview with Roy Lichtenstein": 31; repr. in idem, *Roy Lichtenstein*: 52.
3. John Coplans, "Talking with Roy Lichtenstein," *Artforum* 5, no. 9 (May 1967); repr. in idem, *Roy Lichtenstein*: 91.
4. Lawrence Alloway, *Roy Lichtenstein* (New York: Abbeville, 1983): 31.
5. Ibid.

Page 52: Lichtenstein. *Brushstrokes*. 1966–68.
1. Roy Lichtenstein, quoted in John Coplans, "Talking with Roy Lichtenstein," *Artforum* 5, no. 9 (May 1967); repr. in idem, ed., *Roy Lichtenstein* (New York: Praeger, 1972): 88.
2. Coplans, *Roy Lichtenstein*: 44–45.
3. Coplans, "Talking with Roy Lichtenstein"; repr. in idem, *Roy Lichtenstein*: 88.

Page 54: Marisol. *The Family*. 1962.
1. V[alerie] P[etersen], "Reviews and Previews: Marisol Escobar," *Art News* 61, no. 3 (May 1962): 10. Jukes is the fictitious name of a family featured in a nineteenth-century sociological

study of hereditary tendencies to crime, immorality, disease, and poverty.

2. Quoted in Avis Berman, "A Bold and Incisive Way of Portraying Movers and Shakers," *Smithsonian* 14, no. 11 (February 1984): 60.

Pages 56–57: Marisol. *Love*. 1962.

1. Clara Diament de Sujo, "The Itinerary of Marisol," in *Marisol: XXXIV Biennale di Venezia* (Venice: Instituto Nacional de Cultura y Bellas Artes, 1968).
2. Lawrence Campbell, "Marisol's Magic Mixtures," *Art News* 63, no. 1 (March 1964): 40.
3. Grace Glueck, "It's Not Pop, It's Not Op — It's Marisol," *The New York Times Magazine* (March 7, 1965): 34.
4. Paul Gardner, "Who Is Marisol?" *Art News* 88, no. 5 (May 1989): 148.
5. Gloria Steinem, "Marisol: The Face Behind the Mask," *Glamour* 51, no. 4 (June 1964): 137.

Page 58: Marisol. *LBJ*. 1967.

1. Lucy R. Lippard, *Pop Art* (New York and Washington, D.C.: Praeger, 1966): 101.
2. Nancy Grove, "A Point of View: The Portraits of Marisol," in *Magical Mixtures: Marisol Portrait Sculpture* (Washington, D.C.: National Portrait Gallery, 1991): 60.
3. Edward Leffingwell, "Latin Soliloquies," *Art in America* 81, no. 12 (December 1993): 80.
4. Quoted in Daniel Chapman, "Marisol . . . A Brilliant Sculptress Shapes the Heads of State," *Look* 31, no. 23 (November 14, 1967): 78.

Pages 60–61: Oldenburg. *Empire Sign—With M and I Deleted*. 1960.

1. Allan Kaprow, "The Legacy of Jackson Pollock," *Art News* (October 1958); repr. in Ellen H. Johnson, *American Artists on Art: 1940 to 1980* (New York: Harper & Row, 1982): 57.
2. Claes Oldenburg, *Store Days: Documents from The Store (1961) and Ray Gun Theater (1962) Selected by Claes Oldenburg and Emmett Williams* (New York: Something Else Press, 1967): 83.
3. Claes Oldenburg, "Ray Gun" (1959); repr. in *Claes Oldenburg: An Anthology* (New York: Solomon R. Guggenheim Museum, 1995): 42.
4. Ibid.
5. Oldenburg, *Store Days*: 39.
6. Gene Baro, "Claes Oldenburg, or the Things of This World," *Art International* 10 (November 20, 1966): 41–42.

Page 62: Oldenburg. *Store Poster, Torn Out Letters, Newspaper, Pie, Cup Cakes, and Hot Dog*. 1961.

1. Claes Oldenburg, *Store Days: Documents from The Store (1961) and Ray Gun Theater (1962) Selected by Claes Oldenburg and Emmett Williams* (New York: Something Else Press, 1967): 13.
2. Ibid.
3. Ibid.: 27. Oldenburg is referring to New York's Times Square.

Page 64: Oldenburg. *Pastry Case, I*. 1961–62.

1. Sidney Tillim, "Month in Review: New York Exhibitions," *Arts Magazine* 36, no. 5 (February 1962): 37.
2. Claes Oldenburg, *Store Days: Documents from The Store (1961) and Ray Gun Theater (1962)*

Selected by Claes Oldenburg and Emmett Williams (New York: Something Else Press, 1967).
3. John Coplans, "The Artist Speaks: Claes Oldenburg," *Art in America* 57 (March 1969): 75.
4. Ibid.
5. Tillim, "Month in Review": 37.
6. Claes Oldenburg, quoted in Jeanne Siegal, "How to Keep Sculpture Alive and Out of a Museum: An Interview with Claes Oldenburg on His Retrospective Exhibition at The Museum of Modern Art," *Arts Magazine* 44 (September–October 1969): 26.

Page 66: Oldenburg. *Two Cheeseburgers with Everything (Dual Hamburgers)*. 1962.

1. Claes Oldenburg, quoted in John Coplans, "The Artist Speaks: Claes Oldenburg," *Art in America* 57 (March 1969): 70.
2. Claes Oldenburg, quoted in Helen M. Franc, *An Invitation to See* (New York: The Museum of Modern Art, 1992): 153.
3. Claes Oldenburg, quoted in Gene Baro, "Claes Oldenburg, or the Things of This World," *Art International* 10 (November 20, 1966): 42.

Pages 68–69: Oldenburg. *Floor Cake (Giant Piece of Cake)*. 1962.

1. Barbara Rose, *Claes Oldenburg* (New York: The Museum of Modern Art, 1970): 13.

Page 70: Oldenburg. *Floor Cone (Giant Ice-Cream Cone)*. 1962.

1. John Canaday, "Art: By Claes Oldenburg: An Exhibition of Food and Other Things at the Sidney Janis Gallery," *The New York Times* (April 7, 1964): 32.
2. Ibid.
3. Calvin Tomkins, "Profiles: Look What I've Got Here," *The New Yorker* 53 (December 12, 1977): 59.
4. Öyvind Fahlström, in idem and Ulf Linde, "Claes Oldenburg: Two Contrasting Viewpoints," *Studio International* (London) 172 (December 1966): 329.
5. Ibid.

Page 72: Oldenburg. *Giant Soft Fan*. 1966–67.

1. "Bucky's Biggest Bubble at Canada's Expo," *Architectural Forum* 124 (June 1966): 78.
2. Ibid.: 74.
3. Claes Oldenburg, "Some Program Notes About Monuments, Mainly" (typescript published by Sidney Janis Gallery, New York, April 26, 1967): 6.
4. Oldenburg, quoted in *Three Generations of Twentieth-Century Art: The Sidney and Harriet Janis Collection of The Museum of Modern Art* (New York: The Museum of Modern Art, 1972): 158.

Page 74: Oldenburg. *Colossal Fagend, Dream State*. 1967.

1. Claes Oldenburg, quoted in Suzi Gablick, "Take a Cigarette Butt and Make It Heroic," *Art News* 66 (May 1967): 31.
2. Dan Graham, "Oldenburg's Monuments," *Artforum* 6 (January 1968): 31.

3. Claes Oldenburg, quoted in *Claes Oldenburg: New Works* (New York: Sidney Janis Gallery, 1967): 2.
4. Graham, "Oldenburg's Monuments": 30.
5. Gablick, "Take a Cigarette Butt": 31.
6. Harris Rosenstein, "Climbing Mt. Oldenburg," *Art News* 64 (February 1966): 58.
7. Claes Oldenburg, quoted in Jonathan Price, "Claes Oldenburg," *Yale Alumni Magazine* 32 (December 1968): 31.

Pages 76–77: Oldenburg. *Notes*. 1968.

1. Claes Oldenburg, *Notes* (Los Angeles: Gemini G.E.L., 1968): 1.
2. Claes Oldenburg, quoted in Suzi Gablick, "Take a Cigarette Butt and Make It Heroic," *Art News* 66 (May 1967): 30.
3. Claes Oldenburg, quoted in Barbara Haskell *Oldenburg: Object into Monument* (Pasadena: Pasadena Art Museum , 1971): 34.
4. Calvin Tomkins, "Profiles: Look What I've Got Here," *The New Yorker* 53 (December 12, 1977): 56.

Pages 78–79: Pettibone. *Andy-Warhol—Marilyn Monroe*. 1968; *Andy-Warhol—Marilyn Monroe*. 1968; *Jackie*. 1968.

1. Interview with Catherine Kord, in "Richard Pettibone," Press release, Galerie de Poche, Paris, 1988: 2.
2. Richard Pettibone, quoted in Kim Levin, "Too Little, Too Much," *The Village Voice* (October 20, 1987): 104.

Pages 80–81: Ramos. *Chic*. 1966; *Miss Comfort Creme*. 1966.

1. Douglas M. Davis, "The New Eroticism," *Evergreen Review* 12, no. 58 (September 1968): 49, 50.
2. Quoted in Elizabeth Claridge, *The Girls of Mel Ramos* (Chicago: Playboy Press, 1975): 15.
3. Ibid.: 47.
4. Ibid.: 82.
5. Ibid.: 60.
6. Thomas B. Hess, "Pinup and Icon," in idem and Linda Nochlin, eds., *Woman as Sex Object: Studies in Erotic Art, 1730–1970* (London: Allen Lane, 1973): 223–24.

Page 82: Rauschenberg. *First Landing Jump*. 1961.

1. First cited in Dorothy Miller, ed., *Sixteen Americans* (New York: The Museum of Modern Art, 1959): 58.
2. Robert Rauschenberg, quoted in Dorothy Gees Seckler, "The Artist Speaks: Robert Rauschenberg," *Art in America* 54, no. 3 (May–June 1966): 76.
3. Brian O'Doherty, "Rauschenberg and the Vernacular Glance," *Art in America* 61, no. 4 (September–October 1973): 84.
4. J[ack]. K[roll]., "Robert Rauschenberg," *Art News* 60 (December 1961): 12.
5. Rosalind Krauss, "Rauschenberg and the Materialized Image," *Artforum* 13, no. 4 (December 1974): 37.
6. Robert Rauschenberg, quoted in Calvin Tomkins, "Profiles: Moving Out," *The New Yorker* 40, no. 2 (February 29, 1964): 31.

7. Robert Rauschenberg, in "Interview de Robert Rauschenberg," *Arts Magazine,* no. 821 (May 10, 1961); repr. in *Rauschenberg* (Paris: Ileana Sonnabend, 1963).

Page 84: Rivers. *The Last Civil War Veteran.* 1959.
1. "The Last Survivor of the Civil War," *Life* (May 11, 1959): 49.
2. Phone conversation with Rivers, November 13, 1962 (Collection Files, Department of Painting and Sculpture, The Museum of Modern Art, New York).
3. Larry Rivers and Carol Brightman, *Drawings and Digressions* (New York: Clarkson N. Potter, 1979): 111.
4. Larry Rivers, "A Discussion of the Work of Larry Rivers," *Art News* 60, no. 1 (March 1961): 46, 53.

Pages 86–87: Rivers. *Jim Dine Storm Window.* 1965.
1. Sam Hunter, *Larry Rivers* (New York: Harry N. Abrams, 1969): 14.
2. Larry Rivers with Arnold Weinstein, *What Did I Do? The Unauthorized Autobiography* (New York: HarperCollins, 1992): 422.
3. Hunter, *Larry Rivers:* 22.

Pages 88–89: Rosenquist. *Doorstop.* 1963.
1. James Rosenquist, quoted in Jeanne Siegal, "An Interview with James Rosenquist," *Artforum* 10, no. 10 (June 1972): 31. Rosenquist was referring here to *Floor Plan,* a version of *Doorstop.*
2. Ethel Scull, quoted in Camille Duhe, "The Chandelier Is a Floor Plan," *New York Herald Tribune* (January 31, 1965): sec. 2, p. 5.
3. James Rosenquist, letter to author, March 18, 1998.

Pages 90–91: Rosenquist. *F-111.* 1964–65.
1. "Art (Pop: Bing-Bang Landscapes)," *Time* 85, no. 22 (May 28, 1965): 80.
2. Lucy R. Lippard, "James Rosenquist: Aspects of a Multiple Art," *Artforum* 4, no. 4 (December 1965): 43.
3. James Rosenquist, quoted in G. R. Swenson, "The *F-111,*" *Partisan Review* 32, no. 4 (Fall 1965): 599.
4. James Rosenquist, quoted in Peter Schjeldahl, "Entretien avec James Rosenquist," *Opus International,* no. 29/30 (December 1971): 115.
5. Ibid.: 114.
6. James Rosenquist, quoted in Mary Anne Staniszewski, "James Rosenquist," *Bomb,* no. 21 (Fall 1987): 27.
7. James Rosenquist, quoted in G. R. Swenson, "What Is Pop Art? Part II," *Art News* 62, no. 10 (February 1964): 41.
8. James Rosenquist, quoted in Phyllis Tuchman, "Pop! Interviews with George Segal, Andy Warhol, Roy Lichtenstein, James Rosenquist and Robert Indiana," *Art News* 73, no. 5 (May 1974): 28.
9. Swenson, "The *F-111*": 590, 600, 601.
10. Ibid.: 589-590.
11. James Rosenquist, quoted in Craig Adcock, "An Interview with James Rosenquist," in Susan Brundage, ed., *James Rosenquist: The Big Paintings, Thirty Years/Leo Castelli* (New York:

Leo Castelli Gallery in association with Rizzoli, 1994).
12. Swenson, "The *F-111*": 597.
13. Kirk Varnedoe and Adam Gopnik, *High & Low: Modern Art and Popular Culture* (New York: The Museum of Modern Art, 1990): 367.
14. Swenson, "The *F-111*": 597.
15. Swenson, "What Is Pop Art?": 64.
16. James Rosenquist, quoted in Jeanne Siegal, "An Interview with James Rosenquist," *Artforum* 10, no. 10 (June 1972): 33.
17. Swenson, "The *F-111*": 595.
18. Henry Geldzahler, "James Rosenquist's *F-111,*" *The Metropolitan Museum of Art Bulletin* 26, no. 7 (March 1968): 280.
19. Max Kozloff, "Art," *The Nation* 206, no. 18 (April 29, 1968): 579.
20. Sidney Tillim, "Rosenquist at the Met: Avant-Garde or Red Guard?" *Artforum* 6, no. 8 (April 1968): 49.
21. Neil A. Levine, "Reviews and Previews," *Art News* 64, no. 4 (Summer 1965): 14.
22. Lawrence Alloway, "Derealized Epic," *Artforum* 10, no. 10 (June 1972): 37.

Pages 92–93: Ruscha. *OOF.* 1962–63.
1. Dave Hickey, quoted in Michael Dooley, "Ed Words: Ruscha in Print," *Print* 48, no. 5 (September–October 1994): 36.
2. David Bourdon, "A Heap of Words About Ed Ruscha," *Art International* 15, no. 9 (November 20, 1971): 25.
3. Artist's questionnaire (Collection Files, Department of Painting and Sculpture, The Museum of Modern Art, New York). Attached to this questionnaire is a copy of Ruscha's diary entry, dated May 28, 1962, including the note, "began working on the series of OOF paintings."

Page 94: Ruscha. *Standard Station.* 1966; *Twentysix Gasoline Stations.* 1969.
1. John Coplans, "Concerning 'Various Small Fires': Edward Ruscha Discusses His Perplexing Publications," *Artforum* 3, no. 5 (February 1965): 25.
2. Andy Warhol and Pat Hackett, *POPism: The Warhol '60s* (New York and London: Harcourt Brace Jovanovich, 1980): 39.
3. Dave Hickey, "Available Light," in *The Works of Edward Ruscha* (New York: Hudson Hills Press; San Francisco: San Francisco Museum of Art, 1982): 24.
4. Coplans, "Concerning 'Various Small Fires'": 25.
5. Ibid.
6. Ibid.
7. Benjamin H. D. Buchloh, "Conceptual Art 1962–1969: From the Aesthetic of Administration to the Critique of Institutions," *October* 55 (Winter 1990): 119.

Page 96: Ruscha. *Every Building on the Sunset Strip.* 1966.
1. David Bourdon, "Ruscha as Publisher (or All Booked Up)," *Art News* 71, no. 2 (April 1972): 34.
2. Christopher Finch, "Scanning the Strip," *Art & Artists* 1, no. 10 (January 1965): 67.
3. Bourdon, "Ruscha as Publisher": 34.

4. Christopher Knight, "Ruscha in Context: In the Beginning was the Word," in *Edward Ruscha: Words Without Thoughts Never to Heaven Go* (Lake Worth, Fla.: Lannan Museum, 1988): 54.
5. Marco Livingstone, *Pop Art: A Continuing History* (New York: Harry N. Abrams, 1990): 71.
6. Bourdon, "Ruscha as Publisher": 32.

Page 98: Ruscha. *1984.* 1967; *Wax.* 1967.
1. David Bourdon, "A Heap of Words About Ed Ruscha," *Art International* 15, no. 9 (November 20, 1971): 27.
2. Hilton Kramer, "Ruscha Is Keeping His Powder Wry," *The New York Times* (December 16, 1967): 47.
3. Bourdon, "A Heap of Words": 27.

Page 100: Segal. *The Bus Driver.* 1962.
1. George Segal, quoted in Jan van der Marck, *George Segal* (New York: Harry N. Abrams, 1975): 34.
2. George Segal, quoted in Henry Geldzahler, "An Interview with George Segal," *Artforum* 3, no. 2 (November 1964): 26.
3. "Art: The Silent People," *Newsweek* 25 (October 1965): 27; cited in Phyllis Tuchman, "George Segal," *Art International* 12, no. 7 (September 20, 1968): 51.
4. Van der Marck, *George Segal:* 31.
5. George Segal, quoted in Sam Hunter and Don Hawthorne, *George Segal* (New York: Rizzoli, 1984): 35.
6. Allan Kaprow, "Segal's Vital Mummies," *Art News* 62, no. 10 (February 1964): 32.
7. Ibid.: 30.

Page 102: Segal. *Portrait of Sidney Janis with Mondrian Painting.* 1967.
1. George Segal, quoted in Jan van der Marck, *George Segal* (New York: Harry N. Abrams, 1975): 147.
2. George Segal, quoted in John Gruen, "Art: A Quiet Environment for Frozen Friends," *New York Herald Tribune* (March 22, 1964): 32; cited in William S. Rubin, ed., *The Sidney and Harriet Janis Collection: A Gift to The Museum of Modern Art* (New York: The Museum of Modern Art, 1968): 166.
3. Transcript of "Interview with Sidney Janis," conducted by Helen M. Franc, Senior Editor, Department of Publications, June 15, 1967 (Museum Archives, The Museum of Modern Art, New York).
4. George Segal, quoted in "Art: They Paint; You Recognize," *Time* (April 3, 1964): 74; cited in Phyllis Tuchman, "George Segal," *Art International* 12, no. 7 (September 20, 1968): 51.
5. Alfred H. Barr, Jr., quoted in Grace Glueck, "Not One Boring Picture," *The New York Times* (January 28, 1968): D33.

Pages 104–105: Warhol. *Water Heater.* 1960.
1. Bradford Collins, "The Metaphysical Nosejob: The Remaking of Warhola, 1960–1968," *Arts Magazine* 62, no. 6 (February 1988): 49.
2. Ibid.: 47.

Page 106: Warhol. *Before and After*. 1961.
1. Andy Warhol, *The Philosophy of Andy Warhol: From A to B and Back Again* (New York and London: Harcourt Brace Jovanovich, 1975): 63.

Pages 108–109: Warhol. *Campbell's Soup Cans*. 1962.
1. Marcel Duchamp, quoted in Rosalind Constable, "New York's Avant Garde and How It Got There," *New York Herald Tribune* (May 17, 1964): 10.
2. Arthur C. Danto, "Art," *The Nation* 248, no. 155 (April 3, 1989): 458–61; repr. in Alan R. Pratt, *The Critical Response to Andy Warhol* (Westport, Conn., and London: Greenwood Press, 1997): 203.
3. Calvin Tomkins, "Raggedy Andy" (1970); repr. in idem, *Reports on Post-Modern Art* (New York: Viking Press, 1976): 47.
4. Bradford Collins, "The Metaphysical Nosejob: The Remaking of Warhola, 1960–1968," *Arts Magazine* 62, no. 6 (February 1988): 50.
5. Kenneth Silver, "Modes of Disclosure: The Construction of Gay Identity and the Rise of Pop Art," in *Hand-Painted Pop: American Art in Transition, 1955–1962* (Los Angeles: Museum of Contemporary Art, 1992): 197.
6. Andy Warhol, *The Philosophy of Andy Warhol: From A to B and Back Again* (New York and London: Harcourt Brace Jovanovich, 1975): 100–101.

Pages 110–111: Warhol. *Roll of Bills*. 1962.
1. Calvin Tomkins, "Raggedy Andy" (1970); repr. in idem, *Reports on Post-Modern Art* (New York: Viking Press, 1976): 46–47.
2. Andy Warhol, *The Philosophy of Andy Warhol: From A to B and Back Again* (New York and London: Harcourt Brace Jovanovich, 1975): 130.
3. Ibid.: 133–34.

Page 112: Warhol. *Orange Car Crash Fourteen Times*. 1963.
1. Henry Geldzahler, quoted in Victor Bockris, *The Life and Death of Andy Warhol* (City: Publisher, 1989): 126.

2. Andy Warhol, quoted in G. R. Swenson, "What Is Pop Art? Answers from 8 Painters, Part 1," *Art News* 62, no. 7 (November 1963): 60.
3. Andy Warhol, quoted in Roger Vaughan, "Superpop, or a Night at the Factory," *New York Herald Tribune* (August 8, 1965); cited by Benjamin H. D. Buchloh, "Andy Warhol's One-Dimensional Art: 1956–1966," in Kynaston McShine, ed., *Andy Warhol: A Retrospective* (New York: The Museum of Modern Art, 1989): 48.

Pages 114–115: Warhol. *Brillo Box (Soap Pads)*. 1964; *Brillo Box (Soap Pads)*. 1964.
1. Calvin Tomkins, "Raggedy Andy" (1970); repr. in idem, *Reports on Post-Modern Art* (New York: Viking Press, 1976): 48.
2. Arthur C. Danto, "Art," *The Nation* 248, no. 155 (April 3, 1989): 458–61; repr. in Alan R. Pratt, *The Critical Response to Andy Warhol* (Westport, Conn., and London: Greenwood Press, 1997): 204.
3. Andy Warhol, *The Philosophy of Andy Warhol: From A to B and Back Again* (New York and London: Harcourt Brace Jovanovich, 1975): 92.
4. Arthur C. Danto, "Warhol," *The Nation* 248, no. 155 (April 3, 1989); repr. in idem, *Encounters & Reflections: Art in the Historical Present* (New York: Farrar Straus Giroux, 1990): 289.
5. Andy Warhol, in G. R. Swenson, "What Is Pop Art? Answers from 8 Painters, Part 1," *Art News* 62, no. 7 (November 1963): 26.
6. Arthur C. Danto, "Andy Warhol, Brillo Box," *Artforum* 32, no. 1 (September 1993): 128.
7. Ibid.

Page 116: Warhol. *Self-Portrait*. 1966.
1. See Marjorie Frankel Nathanson, "Chronology," in Kynaston McShine, ed., *Andy Warhol: A Retrospective* (New York: The Museum of Modern Art, 1989): 411.
2. Andy Warhol, *The Philosophy of Andy Warhol: From A to B and Back Again* (New York and London: Harcourt Brace Jovanovich, 1975): 62.
3. Andy Warhol and Pat Hackett, *POPism: The Warhol '60s* (New York and London: Harcourt Brace Jovanovich, 1980): 13.

Page 118: Warhol. *Lita Curtain Star*. 1966.
1. Cited in Kynaston McShine, ed., *Andy Warhol: A Retrospective* (New York: The Museum of Modern Art, 1989): 429.
2. Carter Ratcliff, "Starlust, Andy's Photos," *Art in America* (May 1980); repr. in Alan R. Pratt, *The Critical Response to Andy Warhol* (Westport, Conn., and London: Greenwood Press, 1997): 138.
3. As quoted in Calvin Tomkins, "Raggedy Andy," (1970); repr. in idem, *Reports on Post-Modern Art* (New York: Viking Press, 1976): 48.

Page 120: Wesselmann. *Great American Nude, 2*. 1961.
1. J. J., [Tom Wesselmann at Green Gallery], *Art News* 61, no. 7 (November 1962): 15. Miss Rheingold refers to a popular beer ad of the time.
2. Wesselmann's formal objectives, according to Thomas H. Garver, *Tom Wesselmann: Early Still Lifes, 1962–1964* (Newport Beach, Calif.: Newport Harbor Art Museum, 1971).
3. Slim Stealingworth, *Tom Wesselmann* (New York: Abbeville, 1980): 20.
4. Gene Swenson, "The Honest Nude — Wesselmann," *Art & Artist* 1, no. 2 (May 1966): 56.

Page 122: Wesselmann. *Still Life #30*. 1963.
1. See Cécile Whiting, "Wesselmann and Pop at Home," in idem, *A Taste for Pop: Pop Art, Gender, and Consumer Culture* (Cambridge: Cambridge University Press, 1997): 50–99.

Page 124: Wesselmann. *Smoker, 1 (Mouth, 12)*. 1967.
1. Tom Wesselmann and Slim Stealingworth, *Tom Wesselmann* (New York: Abbeville, 1980): 52.
2. Tom Wesselmann, quoted in J. A. Abramson, "Tom Wesselmann and the Gates of Horn," *Arts Magazine* 40, no. 7 (May 1966): 47.
3. Ibid.: 46.

Acknowledgments

In addition to the people mentioned in the Foreword, numerous staff members at The Museum of Modern Art and the High Museum of Art have played crucial roles in the organization of this exhibition and catalogue.

At The Museum of Modern Art, we are grateful to Wendy Weitman, Associate Curator, Robin Reisenfeld, Associate Curator, and Jennifer Roberts, Study Center Supervisor, in the Department of Prints and Illustrated Books; Kathleen Curry, Curatorial Assistant, Department of Drawings; Christopher Mount, Assistant Curator, Department of Architecture and Design; and Janis Ekdahl, Chief Librarian, Administration, Museum Library, for their expert assistance with the selection and presentation of works on paper. The logistics of transporting the exhibition were overseen by Ramona Bronkar Bannayan, formerly Associate Registrar, succeeded by Linda Karsteter, Senior Assistant Registrar. Cora Rosevear, Associate Curator, Department of Painting and Sculpture, and Maria DeMarco, Associate Coordinator of Exhibitions, also played key roles in the planning process. Mari Shinagawa, Production Manager/Frame Shop Coordinator, Department of Exhibition Design and Production; John Martin, Lead Framer, and Pedro Perez, Conservation Framer, Frame Shop; and David Moreno, Preparator, Department of Drawings, assisted with framing. Anny Aviram, Conservator; Michael Duffy, Associate Conservator; Erika Mosier, Associate Conservator; Patricia Houlihan, Associate Conservator; and Lynda Zycherman, Associate Conservator, assessed the physical condition and provided helpful insights into many of the works in the exhibition.

Sincere appreciation is extended to Donald and Doris Fisher whose gift in honor of Roy Lichtenstein provided protective framing for his painting *Drowning Girl,* included in this exhibition. Mary Lou Strahlendorff, Director of Communications, Department of Communications, and Jessica Ferraro, Press Assistant, worked ably with their counterparts in Atlanta. Stephen W. Clark provided essential legal guidance in his capacity as Acting General Counsel. Catalogue photography would not have been possible without the invaluable support of the Department of Photographic Services and Permissions under the direction of Mikki Carpenter, assisted by Jeffrey Ryan, Senior Assistant, Photographic Archives, and Museum photographers Kate Keller, Erik Landsberg, Tom Griesel, and John Wronn.

Harriet Schoenholz Bee, Managing Editor, Department of Publications, skillfully edited the manuscript of the catalogue and coordinated the complex publication process. The catalogue was designed by Bethany Johns; Christopher Zichello, Associate Production Manager, Department of Publications, oversaw its long journey from layout to print. Delphine Dannaud, Administrative Assistant, Department of Painting and Sculpture, helped to coordinate photographic materials for the catalogue, and interns Claire Deroy and Kirsten Giese greatly facilitated access to research materials. Key assistance with research was provided by Rona Roob, former Chief Archivist, Museum Archives; Lillian Tone, Curatorial Assistant, Department of Painting and Sculpture; Susan Kismaric, Curator, and M. Darsie Alexander, Curatorial Assistant, Department of Photography; and John Calvelli, Director, Graphics. Kirk Varnedoe, Chief Curator, Carolyn Lanchner, Curator, and Kynaston McShine, Senior Curator, Department of Painting and Sculpture, provided essential advice and support. Amy Hamlin, Administrative Assistant, Department of Painting and Sculpture, contributed her exemplary skills to every aspect of this project. Without the exceptional dedication and talent of Leslie Jones, Curatorial Assistant, Department of Painting and Sculpture, neither exhibition nor catalogue would have been possible. She not only handled many aspects of the exhibition organization but also managed to contribute many of the plate texts to the catalogue; thanks also go to Beth Handler, Curatorial Assistant, Painting and Sculpture, and Laura Hoptman, Assistant Curator, Drawings, for their texts on Rosenquist and Oldenburg, respectively.

At the High Museum of Art, we are grateful to Adrienne Cleere, Director of Marketing and Communications, Rhonda Matheison, Director Finance and Operations, Anne Morgan, Director of Development and Membership, Julia Gómez, Curatorial Assistant for Modern and Contemporary Art, H. Nichols B. Clark, Eleanor McDonald Storza Chair of Education, Jody Cohen, Associate Registrar, Jim Waters, Chief Preparator, Kelly Morris, Manager of Publications, Marcia Mejia, Retail Operations Manager, and Charles Wilcoxson, Chief of Security. Very special thanks are due to Marjorie Harvey, Manager of Exhibitions and Design, and Carrie Przybilla, Curator of Modern and Contemporary Art, who made every aspect of this collaborative project a personal and professional pleasure.

Anne Umland

Photograph Credits